PIANOS
AND THEIR MAKERS
VOLUME II.

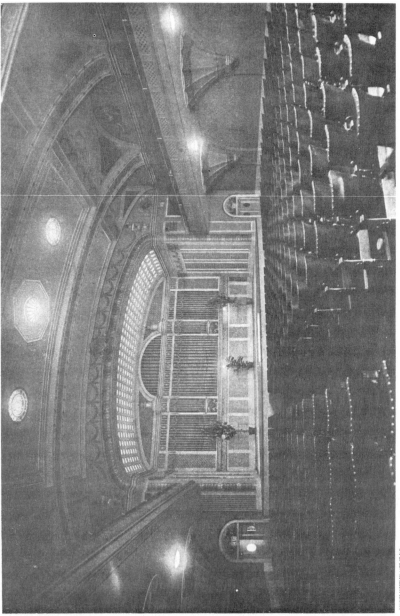

AEOLIAN CONCERT HALL, NEW YORK

ii

PIANOS

AND THEIR MAKERS

✤

By Alfred Dolge

VOLUME II.

DEVELOPMENT *of* THE PIANO INDUSTRY
IN AMERICA SINCE THE CENTENNIAL
EXHIBITION AT PHILADELPHIA, 1876

*Eighty-five Portraits from Original
Drawings by J. M. Gaspard*

Sixty Illustrations of Patented Improvements

COVINA PUBLISHING COMPANY
COVINA, CALIFORNIA 1913

Reprinted by The Vestal Press Vestal, New York 13850

"Meister ist wer was ersann,
Geselle ist wer etwas kann,
Lehrling ist Jedermann."

GERMAN PROVERB.

———

And step by step, since time began,
I see the steady gain of man.

JOHN G. WHITTIER.

Library of Congress Cataloging in Publication Data

Dolge, Alfred, 1848–
 Men who have made piano history.

 Original title: "Pianos and Their Makers—(Development
of the piano industry in America since the Centennial Exhi-
bition at Philadelphia, 1876.)"
 Reprint of the 1913 ed. published by Covina Pub. Co.,
Covina, Calif., which was issued as v. 2 of the author's Pianos
and their makers.
 1. Piano makers—United States—Biography. 2. Piano—
History. I. Title. II. Series: Dolge, Alfred, 1848– Pianos
and their makers; v. 2.
 ML404.D64 1980 681'.81'6210922 [B] 79-25229
ISBN 0-911572-18-X

FOREWORD TO THE VESTAL PRESS REPRINT EDITION

Alfred Dolge was a remarkable man, and in a day when the piano industry was of major importance in the industrial life of America, he was one of the great captains. German born, he developed a sizable business in supplying soundboards, hammers, and all sorts of components and parts to piano makers although he himself did not make the complete instruments.

He was a pioneer in industrial decency, and took good care of his workmen in his Adirondack factories, with such innovations as pension plans and a variety of benefits almost unheard of in the late 1800's. His name was one to be reckoned with in the halls of pianodom, and the trade journals of the period are full of references to him, his business, and his influences.

Unfortunately, he apparently became financially over-extended shortly after the turn of the Century, and he lost the business, although to this day spruce soundboards are made in the factories he built in Dolgeville, New York.

After losing his business, he wrote an excellent book titled PIANOS AND THEIR MAKERS in 1911, a volume which sums the history of the instrument to that date from a technical and manufacturing standpoint with emphasis on American works. Reprints of this book have been sold by the thousands. However, little-known to many readers, he also published a sequel in 1913, which you are now holding in its reprinted form. This book concentrates on the men he knew and with whom he worked and associated, and it forms an important body of knowledge in America's musical history.

In this Vestal Press reprint edition, the pages have been re-numbered, and we've used his sub-title "MEN WHO HAVE MADE PIANO HISTORY" to avoid confusion with the earlier work.

Harvey N Roehl
Vestal, New York 13850

v

Chas H Steinway

FOREWORD

AFTER Volume I of "Pianos and their Makers" had been published and found an appreciative reception by members of the piano trade as well as the musical world at large, I was importuned by leading piano manufacturers to write the history of the piano industry from 1876 to the present date. I entered upon that work with great diffidence, being conscious of the serious difficulties which have to be met in any attempt to record the activities and accomplishments of leaders in the industry who are still among the living and who each of them are fighting the daily battle of industrial and commercial warfare.

At first it appeared to be an impossible task to do justice to every one who has been useful in the upbuilding of the industry as a whole, without injuring the many and various competitive interests. To avoid this as far as it is possible in a historical record, I have refrained from the use of classification and comparisons giving only a brief historical review of the development of the industry since 1876, followed by biographical sketches of men who have either by their creative or business ability benefited the industry at large.

Many prominent firms and individuals who belong in this class could not be mentioned because their record is given in Volume I.

Since it is not the province of the historian to assume the role of a judge as to the merits of inventions or wisdom of

FOREWORD

business policy, I have confined myself strictly to the recording of facts as I know them or as they have been given to me from authoritative sources. While it is possible that in the opinion of some readers I may be guilty of sins of omission or commission, I wish to state that I have scrupulously avoided paying any attention to the activities of men who are contented to copy the work of *creators* for their own benefit, without themselves contributing in any way to the betterment and uplift of the industry. Mere imitators and copyists have always been active in all walks of life, and will be for all time to come, but their activity is not sufficiently injurious to deter the optimistic idealists from continuing their efforts for improvements and betterments.

The achievements of the present day leaders of the piano trade are fully as inspiring as those of the past, and I dedicate this work to the young aspirants for honor and distinction, in the hope that they will profit by the inspiration which the records of our present day leaders carry with them.

With pardonable pride the publishers offer this volume not only as a history, but also as a gallery of portraits of the leading men of the Piano Industry of today.

The statement may be boldly made that this work stands unique in its collection of portraits of the highest artistic order, all of them emanating from the genius of Mr. Jules M. Gaspard, than whom there is no greater master of portraiture.

Covina, California
September 1913

CONTENTS

PAGE

INTRODUCTORY . **xix**

WORLD'S FAIR EXHIBITIONS London, 1851; Paris, 1867; Vienna, 1873; Philadelphia, 1876; Chicago, 1893; St. Louis, 1904 . . . **1**

AEOLIAN COMPANY Aeolian Concert Hall; Votey's Elongated Grand Player Piano . . . **6**

BALDWIN COMPANY Model Organization **9**

JULIUS BAUER AND COMPANY Wm. M. Bauer's Sound Board Construction **12**

BEHNING PIANO COMPANY Player Piano **15**

BEHR BROTHERS AND COMPANY. . System of Stringing **16**

GEORGE P. BENT COMPANY Adjustable string frame for upright pianos **21**

WILLIAM L. BUSH. National League for the Maker's Name . **23**

BUSH AND GERTS PIANO COMPANY John Gerts . **26**

BUSH AND LANE PIANO COMPANY. . Sound Board Construction. Laminated frame and string plate for upright piano **28**

BUTLER BROTHERS PIANO MANUFACTURING COMPANY Sound Board Construction. Pianissimo Device **33**

THE CABLE COMPANY George J. Dowling. J. Frank Conover. Grand Scale. Paul B. Klugh. The Carola Inner Player. . **36**

HOBART M. CABLE COMPANY . . . Hobart M. Cable, Hobart M. Cable, Jr. Howard B. Morenus. . **46**

CABLE-NELSON COMPANY Fayette Shepard Cable **47**

A. B. CHASE COMPANY Artistano. L. L. Doud **49**

CHICKERING BROTHERS Clifford C. Chickering. Sound Board Construction, String Frame. Fred W. Chickering. Wallace Wiley Chickering **50**

MELVILLE CLARK Recording Machine. Metronome Motor. Down-touch for player piano . **57**

FRANCIS CONNOR Pioneer . **60**

DAVENPORT-TREACY COMPANY . Daniel Francis Treacy **61**

CONTENTS

PAGE

DECKER AND SON............. Frank C. Decker and Frank C. Decker, Jr..................... 63

JACOB DOLL AND SONS........ Jacob Doll. Otto Doll. George Doll. Jacob Doll, Jr. Fred Doll. Charles Doll.................... 63

ENGELHARDT AND SONS Alfred Dolge Engelhardt. Walter Ludwig Engelhardt............ 66

EVERETT PIANO COMPANY...... John Anderson. Grand Scale.... 68

JESSE FRENCH AND SONS PIANO COMPANY Jesse French. H. Edgar French. Jesse French, Jr................ 75

GRAM-RICHTSTEIG PIANO C O M-PANY...... Edmund Gram. Max Richtsteig. Technical school for Piano makers. Steel Angle Rail Action Frame.... 80

GRINNELL BROTHERS........... Ira L. Grinnell. Clayton A. Grinnell. S. E. Clark.......... 87

HADDORFF PIANO COMPANY .. Charles A. Haddorff. Sound Board Construction. String Plate. Wrest Plank Shoulder on String Plate........................ 89

HALLET AND DAVIS PIANO COM-PANY E. N. Kimball, Jr., E. E. Conway. C. C. Conway.................. 93

HARDMAN, PECK AND COMPANY... Leopold Peck. Alfred L. Peck. Carl E. Peck. Wm. Dalliba Dutton. Fred W. Lohr............ 97

BEN H. JANSSEN Manufacturer and Composer..... 101

ROBERT C. KAMMERER........ Geo. Steck & Co. Aeolian Co.... 102

KELLMER PIANO COMPANY..... Geo. W. Kellmer.............. 103

W. W. KIMBALL COMPANY...... Curtis N. Kimball............ 104

KINDLER AND COLLINS Oscar L. Kindler. Wm. P. Collins....................... 108

THE KNABE BROTHERS COMPANY Ernest J. Knabe, Jr. William Knabe III..................... 109

KRAFT, BATES AND SPENCER.... Theodore J. Kraft............. 111

KRANICH AND BACH Helmuth Kranich. Jacques Bach. Frederick Kranich. Alvin Kranich. Louis P. Bach............ 112

THE KRELL PIANO COMPANY.... Albert Krell................... 116

C. KURTZMANN AND COMPANY .. Christian Kurtzmann, Sr. J. Hackenheimer. G. H. Moessinger. I. E. Deveraux......... 117

THE LAFFARGUE COMPANY Joseph Oktavec. Laverne M. Ide. 122

LAWSON PIANO COMPANY....... Charles B. Lawson.............. 125

HENRY AND S. G. LINDEMAN.... Samuel G. Lindeman........... 126

x

CONTENTS

PAGE

FRANK B. LONG............ Melodigrand Sound Board Construction..................... 127

LOUISMANN-CAPEN COMPANY.... Louis S. Kurtzmann. Christian Kurtzmann, Jr................ 130

LUDWIG AND COMPANY........ John Ludwig. Charles A. Ericsson. Lycus D. Perry........... 132

MASON AND HAMLIN COMPANY.. Richard W. Gertz. A. M. Wright. Henry L. Mason. Resonator. Tone sustaining pedal and damper frame....................... 134

PAUL G. MEHLIN AND SONS.... Paul G. Mehlin. H. Paul Mehlin. Charles Mehlin. Otto Mehlin. Grand Piano Scale. Inverted Grand...................... 148

NATIONAL PIANO COMPANY..... A. L. Jewett................. 154

THE PACKARD COMPANY........ Albert Sweetser Bond........... 155

THE POOLE PIANO COMPANY ... William H. Poole.............. 156

RICCA AND SON Luigi Ricca.................... 157

SCHILLER PIANO COMPANY...... Fred Geo. Jones. Geo. H. Jones. Edgar B. Jones. Cyrus F. Jones. Reinforced Back for Upright Piano....................... 158

SCHUMANN PIANO COMPANY Willard Naremore Van Matre. Sound Board Construction....... 160

J. P. SEEBURG PIANO COMPANY. Justus Percival Seeburg........ 163

M. STEINERT AND SONS COMPANY Alexander Steinert. A. H. Hume.. 164

STEINWAY AND SONS........... Charles H. Steinway. Frederick T. Steinway. Henry Ziegler. William R. Steinway. Theodore E. Steinway. Theodore Cassebeer. F. Reidemeister. Nahum Stetson. Ernest Urchs. Sound Board Construction. Sound Board Support. Separated Capo d'astro bar. Connection of wooden frame with iron string plate in Grand Pianos.......... 167

STRICH AND ZEIDLER.......... William Strich. Paul M. Zeidler.. 187

HORACE WATERS AND COMPANY. Horace Waters. Samuel T. White. Merrill K. Waters.............. 190

WESER BROTHERS John A. Weser. Feeder bellows and expression device for player piano....................... 193

WILCOX AND WHITE COMPANY... Frank C. White. Controlling device and expression controlling mechanism for player pianos..... 196

WINTER AND COMPANY........ Julius Winter. Gottlieb Heller... 199

OTTO WISSNER Otto Wissner. William Otto Wissner. Otto R. Wissner....... 202

xi

CONTENTS

PAGE

J. B. WOODFORD Merchandizing 204

RUDOLPH WURLITZER COMPANY. . Howard E. Wurlitzer. Rudolph
H. Wurlitzer. Farny R. Wurlitzer.
Edward H. Uhl. Unit Orchestra.
Harp. Player Piano 207

THE COMSTOCK, CHENEY AND
COMPANY Samuel Merritt Comstock. Geo.
L. Cheney. Robert H. Comstock.
Archibald W. Comstock. C. G.
Cheney . 215

STAIB-ABENDSCHEIN COMPANY . . . Albert Staib. Geo. F. Abend-
schein. Fred. H. Abendschein.
Mastertouch. Upright Action. . . . 216

DAVID H. SCHMIDT Piano Hammers 219

STRAUCH BROTHERS Peter D. Strauch. Albert T.
Strauch. William E. Strauch 220

WESSELL, NICKEL AND GROSS . . Arthur Wessell. Fernando Wes-
sell. Henry Nickel. Patented
Grand Piano Action 221

WOOD AND BROOKS Charles Raymond Wood. N. R.
Luther. Warren B. Thayer.
Hubert O. Fox 225

PORTRAITS

	PAGE
Anderson, John	69
Bach, Jacques	114
Baldwin, D. H	10
Bauer, William M.	13
Beach, William H.	32
Behr, Henry	17
Behr, William J.	19
Bent, George H.	20
Bent, George P	20
Bush, William L.	24
Butler, James H.	36
Cable, Fayette S.	48
Cassebeer, Theodore	182
Chickering, Clifford C.	51
Chickering, Fred W.	54
Chickering, Wallace W.	55
Clark, Melville	56
Collins, William P.	109
Connor, Francis	60
Conover, J. Frank	38
Conway, Carle C.	96
Conway, Earle E.	95
Devereaux, Irving E.	118
Doll, Jacob, Sr.	64
Doud, L. L.	50
Dutton, Wm. Dalliba	99
Engelhardt, Alfred D.	66
Engelhardt, Walter L.	66
Ericsson, Charles A.	132

PORTRAITS

	PAGE
French, H. Edgar	74
French, Jesse, Sr.	74
French, Jesse, Jr.	74
Gerts, John	26
Gertz, Richard W.	135
Gram, Edmund	80
Hackenheimer, Jacob	118
Haddorff, Charles A.	90
Heller, Gottlieb	201
Ide, Laverne M.	124
Kammerer, Robert C.	103
Kimball, Curtis N.	105
Kimball, Edwin N., Jr.	94
Kindler, Oscar L.	109
Klugh, Paul B.	44
Knabe, Ernest J.	110
Knabe, William	111
Kranich, Helmuth	113
Krell, Albert	117
Kurtzmann, Christian	118
Kurtzmann, Christian, Jr.	131
Kurtzmann, Louis S.	130
Lane, Walter	27
Lindeman, S. G.	126
Lohr, Fred W.	100
Long, Frank B.	127
Mehlin, Paul G.	147
Meikle, Ernest G.	20
Moessinger, George	118
Oktavec, Joseph	123
Peck, Carl E.	98
Perry, Lycus D.	133
Reidemeister, Frederick	189

PORTRAITS

		PAGE
Ricca, Luigi	157
Richtsteig, Max	83
Schmidt, David H.	219
Seeburg, J. P.	164
Steinert, Alexander	165
Steinway, Charles H.	vi
Steinway, Fred T.	174
Steinway, Theodore E.	182
Steinway, William R.	182
Stetson, Nahum	189
Treacy, Daniel F.	62
Urchs, Ernest	189
Van Matre, Willard N.	161
Waters, Horace	190
Waters, Merrill K.	192
Weser, John A.	193
Wessell, Arthur	222
Wessell, Fernando	223
White, Frank C.	198
White, Samuel T.	191
Winter, Julius	200
Wissner, Otto	203
Wright, Adin M.	142
Ziegler, Henry	177

ILLUSTRATIONS

PAGE

AEOLIAN HALL . *Frontispiece*

STEINWAY AND SONS Plate of Decorations 173

ACTIONS

Frank B. Long Improved Upright Action 128

Gram-Richtsteig Steel Angle Rail Action Frame 86

Gram-Richtsteig Metal Flange Upright Action 86

Staib-Abendschein Mastertouch Upright Action 218

Wessell, Nickel and Gross Patented Grand Piano Action 224

FALL BOARD

Mehlin and Sons (Paul G.) Grand Fall Board. Touch Regulator . 149

GRAND SCALES

Conover (J. Frank) Grand Scale 41

Everett Piano Company . . . Grand Scale 72

Mehlin and Sons (Paul G.) Grand Scale 150

HARP

Rudolph Wurlitzer Company . . Harp . 211

INVERTED GRAND SCALES

Mehlin and Sons (Paul G.) Inverted Grand Scale 151

PEDALS

Butler (James H.) Pianissimo Device 35

Mason and Hamlin Company . . Tone Sustaining Pedal and Damper Frame 141

PLAYER PIANOS

Clark (Melville) Down Touch Action 59

Clark (Melville) Metronome Motor 58

Clark (Melville) Recording machine attached to Grand Piano 57

Hupfeld Company Elongated Grand Player Piano . . . 8

Votey (Edwin S.) Elongated Grand Player Piano . . . 8

Weser Brothers Expression Device for Player Piano . 195

Weser Brothers Feeder Bellows for Player Piano . . 195

White (Frank C.) Controlling Device for Player Piano . 197

White (Frank C.) Expression Controlling Mechanism for Player Piano 197

ILLUSTRATIONS

		PAGE
REINFORCED BACK		
Schiller Piano Company	Reinforced Back for Upright Piano........................	159
SOUND BOARD CONSTRUCTION		
Bauer (William M.)	Sound Board Construction......	14
Bush and Lane..	Sound Board Construction.......	30
Bush and Lane..	Laminated Frame for Upright Piano........................	31
Butler (James H.)...........	Sound Board Construction	34
Chickering Brothers..........	Sound Board Construction.......	53
Long (Frank B.)............	Melodigrand Sound Board Construction	128
Schumann Piano Company....	Laminated Sound Board Frame...	162
Schumann Piano Company....	Sound Board and Wrest Plank Construction...................	162
Steinway and Sons....	Sound Board Construction.......	178
Steinway and Sons..........	Sound Board Support..........	178
STRING FRAMES		
Bent Company (George P.) ...	Adjustable String Frame for Upright Piano...................	23
Bush and Lane..	String Frame for Upright Piano...	31
Chickering Brothers..........	String Frame...................	53
Haddorff Piano Company.....	Wrest Plank Shoulder on String Frame.......................	92
Haddorff Piano Company.....	String Frame	92
Schomacker Piano Company ..	String Frame for Grand Piano....	206
Schumann Piano Company....	String Plate...................	162
Steinway and Sons..	String Frame with Separated Capo d'Astro Bar...................	179
Steinway and Sons....	Connection of Wooden Frame with Metal String Frame in Grand Pianos.......................	179
SYSTEM OF STRINGING		
Behr Brothers and Company...	System of Stringing............	19
TECHNICAL SCHOOL		
Richtsteig (Max)............	Technical School for Piano Makers	85
TENSION RESONATOR		
Mason and Hamlin Company..	Tension Resonator, October, 1900	137
Mason and Hamlin Company..	Tension Resonator February, 1905	140

ILLUSTRATIONS

TUNING PINS
 Conover (Frank J.) Tuning Pin 42 PAGE

UNIT ORCHESTRA
 Wurlitzer Company (Rudolph) Console for Unit Orchestra 210

UPRIGHT PIANOS
 Conover (J. Frank) Upright Piano 40
 Schomacker Piano Company . . Upright Piano Construction 207

INTRODUCTORY

THE foundation, success, and life of any industry depend primarily upon the well-directed activity of the inventor and constructor, upon minds which can create, and put into practice ideas which permanently improve the existing.

CHRISTOFORI invented the piano.

SEBASTIAN ERARD by his ingenious inventions elevated the piano to a plane whereby it became the favorite instrument for the expression of the tone poems of all great composers.

THEODORE STEINWAY pressed science into service and developed the piano to its utmost possibilities regarding volume as well as production of tone and extending the limit of durability, as demonstrated in his Centennial Concert Grand Pianos, and it seemed at the Exposition of Philadelphia in 1876 as if the acme of piano construction had been reached.

The human mind has ever been restless, continually endeavoring to put the stamp of progress on everything that human hands produce. Indeed some accomplishments of those who have devoted their genius to the development of the piano, especially during the past twenty years, as recorded in this book, show that the progressive movement has never stopped.

While the American piano of 1876 stood without a peer as to volume and carrying power of tone, the eminent constructors of the present time have succeeded in adding to this powerful tone a refined, soulful quality, which gives the advanced player of the piano opportunities of demonstrating temperament not dreamt of twenty years ago.

INTRODUCTORY

Faults of construction, such as breaks in the scale, unevenness in the different registers, false harmonics, and other shortcomings caused by improper scale designing, which were overlooked and forgiven as long as a powerful tone was produced, are not tolerated nowadays in any good piano, because all of these shortcomings have been overcome by the successful efforts of the leading constructors.

Sound Board — That there still is and perhaps always will be a great field for the thinking constructor in piano building is clearly shown by the numberless efforts of our best constructors to improve, next to the scale, the sound-board in the piano. Indeed, it is perhaps true to say that during the past twenty years the leading minds among the piano constructors have devoted themselves more to intense study for the improvement of the sound-board than to any other part of the piano, and most noteworthy results have been achieved.

Piano Action — Coming to the more mechanical part of the piano, where exact science can be applied, namely: the piano action, the following pages will also show that efforts of improving the grand as well as the upright action, more especially the latter, however, have not relaxed, and accordingly some successful efforts can be recorded in the direction of improving the positive attack and more reliable repetition—improvements which are especially of value in connection with the player mechanism, the increasing use of which in the piano is, of course, much more trying for the piano action than manual playing.

Player — The introduction of the player piano mechanism has opened up a market for the piano which cannot be measured at the present time, as it seems to be almost unlimited. Music has more and more become the property of all the people and the fact that any one without any musical education can by the aid of a player piano produce for himself all kinds of music, from playing ragtime to getting acquainted with Beethoven's

INTRODUCTORY

"Sonatas" and other classics, will eventually make the piano a veritable necessity for every household.

The player attachment having passed the stage of experiment has finally been accepted by the majority of the piano makers as a part of their own business.

Most wonderful and astonishing results have been achieved in the improvement of the player mechanism and the player music rolls, and consequently due consideration is given to the leaders in that branch of the industry.

Player Mechanism

The surprising development of the piano industry during the past forty years, and more especially the twenty years last past, must, however, be credited to a large extent to the able men who created and directed the great factory organizations as we know them today.

Factory Organizers

Compared to almost any other industry, the organization and management of a large modern piano factory make much greater demands upon managerial talents and versatility. The piano industry has not been lacking in producing men capable of coping with the problems that offered themselves in this direction.

Equal strength and genius were required to create, maintain and increase the market for the products created by the constructor and produced by the factories. Comprehensive and novel methods have been discovered and developed by the leaders, and the distribution of the factory products is becoming more and more the province of the specialists who will have to follow and broaden out the lines of the leaders of the present day.

Distributors

As a natural consequence of the increased production and marketing, the expert in finances found a great field for his genius in the piano industry, and he has as such become as important a factor in the general development of the industry as the constructor, organizer and distributor of the goods.

Financiers

WORLD'S FAIR EXHIBITIONS

London, 1851.
Paris, 1867.
Vienna, 1873.
Philadelphia, 1876.
Chicago, 1893.
St. Louis, 1904.

WORLD'S FAIR EXHIBITIONS

London
1851

T HE beginning of the piano industry in America, as an industry, can historically be dated from the first World's Exhibition held at London, England, in 1851. At that exhibition, pianos made in America were first shown by Chickering and Gilbert of Boston, Nunns and Clark of New York, and Meyer of Philadelphia. All of these pianos were of such construction and quality that they attracted the attention of the old makers of Europe, and the exhibitors were rewarded for their enterprise with adequate distinctions.

Paris
1867

At that London Exhibition of 1851, the American manufacturers had nothing to show in their pianos which in any way differed from the European product, but at the great World's Exposition held at Paris in 1867, America boldly assumed the position as leader in the progressive movement of piano construction. With Steinway and Sons as the great champions of the overstrung system in the lead, America commenced to battle for that innovation which made the piano of today a possibility. The propaganda for the overstrung system was most forcefully combatted by nearly all the great houses, whether they were represented at the Paris Exposition or not, but the Americans were awarded distinguished honors by the jury of that Exposition, and the overstrung system was eventually adopted by piano manufacturers in all parts of the world.

Vienna
1873

At the great World's Exposition held at Vienna in 1873, the American piano industry was represented by only one firm, George Steck and Company. This came about because of an agreement between the two leading firms of America not to

1

exhibit in that Exposition, consequently all other American manufacturers kept aloof, rather willingly, because of the great expense connected with such an Exposition without prospect of any benefits to be derived. It is, however, noteworthy that the International Jury of that Exposition embodied in its report a regret that the leading American firm was not represented with an exhibit of their pianos, illustrating in what high regard the products of the American piano industry were then held by European judges.

Philadelphia
1876

At the great Centennial Exposition held at Philadelphia in 1876, the showing made by the piano industry was equal in importance to that of any other American industry, and, of course, far in advance of that of any other nation. One of the greatest compliments to the American piano industry was, however, the fact that all of the exhibits of the German piano manufacturers were built on the American system, namely, overstrung. In contrast to the European exhibits, which consisted of only upright and grand pianos, the square piano still dominated in the American division, although some excellent upright pianos were also shown. The American grand piano was unanimously declared to be the best of all those exhibited.

It was not to be wondered at that the American division should show the highest development in the art of piano making at that exhibition, because just then the strife for supremacy, for the first rank among the piano makers, was at its very height. A narration of all the various phases of the intense battle waged at Philadelphia would make very interesting reading even at this date.

Perhaps at no Exposition where piano makers struggled for official distinction and endorsement of their products was it so difficult for the appointed judges to do full justice to every exhibitor, than at Philadelphia in 1876. All of the pianos exhibited showed most intelligent construction and the very best of workmanship, and in their totality a very close following

of the leaders down to the last particular. The imposing display at the Centennial Exposition established once for all the superiority of the American piano as an *industrial* product, in comparison with similar products of other countries.

The amazing development of the piano industry in America dates from the Centennial Exposition of 1876. It is not overstating to say that up to that time and in spite of the propaganda made for the piano by all the leading manufacturers, neither the public at large nor the world of finance or commerce had any conception of the magnitude of the industry, nor had the dealers or the makers of pianos the proper vision as to its possibilities of future development.

The pianos exhibited at Philadelphia showed conclusively that the piano industry had passed through its experimental stages, and appeared before the world as an industry in deed and in fact.

In all former World's Expositions, beginning at London, 1851, the pianos exhibited were the products of comparatively few establishments, and the art of piano building had not assumed what is understood as "industrial" proportions. In the building of pianos up to that date, the piano maker had not had many opportunities to benefit by the scientific researches in acoustics, chemistry, metallurgy, etc., nor could he take advantage of using machinery and power to an extent which would aid him in improving the volume and quality of the piano tone.

The assembling of hundreds of pianos of different makes at the Centennial Exposition in 1876 opened the eyes of all thinking men to the fact that the zenith of piano building, so far as powerful tone, proper response of the action, and solidity of construction were concerned, had been reached, and that from then on the alert and progressive piano maker could build upon that foundation with the assurance of legitimate success.

We therefore find at the Chicago Exposition of 1893 a large number of new names among the exhibitors in the piano division, all of them showing fine products of the art, but none of them with any such epoch-making innovations as were shown at Philadelphia in 1876. In other words, no radical changes or improvements had taken place in the industry during those seventeen years, but at the Chicago Exhibition there was sufficient evidence of a greater conformation to industrial conditions in the piano department than ever before, as was best illustrated by the extensive exhibits of the supply branches, such as actions, plates, etc. In its totality, the Piano Exhibit at the Chicago Exposition demonstrated in a graphic manner the magnitude which the industry had achieved since 1876, and it was especially the western piano manufacturers who appealed for recognition.

At the World's Fair held at St. Louis in 1904, the Baldwin Company of Cincinnati carried off the highest award, the Grand Prix, for their products. Richard W. Gertz acted as technical expert for the International Jury on musical instruments.

While at the Philadelphia Exposition the American piano constructor was primarily triumphant, at Chicago in 1893 the factory organizer and distributor of pianos, in other words, the industrial magnate of pianodom, received recognition for the first time. It is this combination of the constructive with the organizing and commercial genius which has brought about during the past twenty years the unprecedented development of the piano industry in America; unprecedented, inasmuch as America, with about one quarter of the population, produces more pianos than Europe, and twice as many as Germany, where the piano was first developed. The accomplishment of such startling results emphasizes the fact that the destiny of the piano industry of America is in the hands of strong men, and the request that its history be written is its own justification.

TECHNICAL,
HISTORICAL
and
BIOGRAPHICAL

6 TECHNICAL, HISTORICAL and BIOGRAPHICAL

To strive and still strive—such is life.
—Ary Scheffer.

A EOLIAN COMPANY*, New York.
Individuality has been a dominant factor in the beginning of almost all commercial and industrial enterprises, and in none more so than in the piano industry. With the advent of self-acting machinery driven by steam or electricity, individualism is gradually crowded to the rear by collectivism and co-operation.

The tremendous advances made during the past fifty years in ways and means of transportation and communication, by steam propelled ships and vehicles, the harnessing of electricity for power, telegraph and telephone, has had its effect upon industrial development, inviting and finally compelling the use of large capital in order to employ modern methods by the aid of costly machinery and organization beyond the reach of the individual. Factories turn out products superior in quality and far below in cost to the hand made goods. Organization has become a necessity in the new order of industrial development. Capital is invited to invest independent of the personal activity of the capitalist. Commercial and mechanical ability is bought in the open market, at prices higher than it can command by individual effort, and results adequate to the investment are obtained through a system of specializing, making the most intense and profitable use of individual ability, as well as of the power which is wrung from nature in multifarious forms and ways.

*Vol. I, pp. 147, 150, 152, 182, 199, 299, 319, 326, 327, 329, 332, 334, 372.

To what extent modern methods can be successfully applied in the piano industry is demonstrated by the Aeolian Company, an institution which with its twelve mammoth factories employing a capital of over fifteen million dollars occupies the proud position of being the largest manufacturer of musical instruments in the world. To attain such a position, organizing ability of the highest order is necessary; to maintain it for any length of time, the activity of superior talents is demanded in the various divisions and subdivisions of the huge institution. Every person employed acts as an integral part of the great mechanism, and is more or less important, according to his ability, but none is so influential as to create any disturbance, if he should drop out of the organization at any time.

Every head or leader of a department, financial, commercial, or industrial, in such an organization has his corps of assistants capable of advancing at any time, because they have taken part in the work of their chief from day to day. Their counsel is sought, their ideas are adapted if found practicable, and are generally welded with the ideas and suggestions of their confreres when thus adapted. Consequently the progress achieved is not the product of one man's talent or genius, but the final result of an amalgamation of many minds, directed upon the object sought. The many progressive changes, therefore, which are continually noticeable in the Weber Concert Grand, as well as in the Steck pianos, or any of the Pianola pianos, not to mention the Orchestrelle and pipe organs of the Aeolian Company, are the outcome of careful consideration and final adjustment of the experimental department of the Company. In this department we find some of the brightest minds actively engaged in reducing to a workable basis new ideas in piano and player-construction. Among the patentees whose inventions have thus been utilized we find such names as Votey, Pain, Kelley, Young, Schnabel and many others.

Votey's elongation of the Grand Piano case by reason of which the player mechanism can be embodied as an integral part of the Grand Piano, instead of being merely an outside attachment, may be considered as an important innovation.

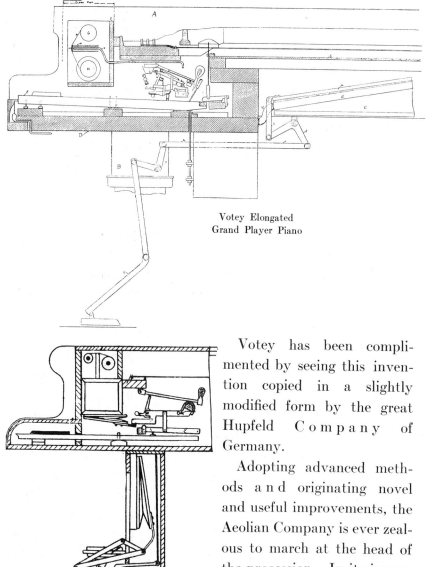

Votey Elongated
Grand Player Piano

Hupfeld Player Action for Grand Pianos

Votey has been complimented by seeing this invention copied in a slightly modified form by the great Hupfeld Company of Germany.

Adopting advanced methods and originating novel and useful improvements, the Aeolian Company is ever zealous to march at the head of the procession. In its imposing new home on Forty-second

street, the Aeolian Company has given New York, next to Concert Hall Carnegie Music Hall, the only home for Symphony and Choral Concerts or piano recitals, opening its doors for any competent artist, irrespective of the name of the piano which he may prefer for his performance. In the various recital rooms of the building free lectures are periodically given on music, with particular reference to the proper use of the player piano, while the major part of the eighteen-story building is given up to attractive show rooms for pianos, etc., and studios for musicians and singers.

Aeolian Hall has become the rendezvous of all people interested in music, from the world-famed virtuoso to the amateur enthusiast. It is in deed and in fact the musical center of the great city of New York.

THE BALDWIN COMPANY*, Cincinnati.
One of the pioneer houses in the piano trade is The Baldwin Company of Cincinnati.

In the early days when the newspaper, magazine and schools of education were few and available to only a small portion of the then new West, one of the most valuable educative personalities beside the minister, the lawyer, and the physician, was the singing teacher, he who traveled by stage coach and horseback to the various towns and taught the violin, the melodeon, but more especially forming the communities into singing classes. The "Singing School", therefore, was the one great educational and entertaining feature of that day.

Probably the foremost man of the Ohio Valley as a teacher Dwight H. of music was DWIGHT H. BALDWIN, who did much in the develop- Baldwin ment of music and the musical history of this section. His sterling character was recognized by all who knew him. He was often called upon to select the melodeon or the reed organ (just coming into use) for his many patrons, which led naturally to his going into the business of selling musical instruments. In 1862 he established a store in Cincinnati, Ohio, out of which

*Vol. 1., pp. 64, 74, 181, 191, 345-6-7-8.

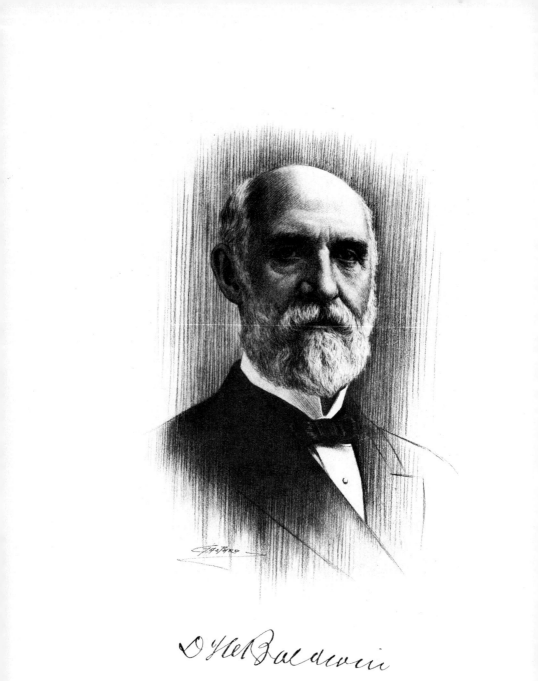

has grown one of the great industrial corporations of the world for the manufacture and sale of pianos, organs and player pianos—The Baldwin Company.

The history of this house may be divided into three epochs during its existence of over a half century. During the first twenty-five years they gradually developed into large jobbers and retailers of pianos and organs, selling the products of the foremost factories in the east and establishing stores and agencies throughout the Middle West. It was natural that with the rapidly increasing growth of this great section of the United States and of their business that the progressive men of this house should turn to the manufacture of their own product, and this came within the first twenty-five years, marking the beginning of the second epoch.

The manufacturing development of The Baldwin Company has been one of the marvels of the trade. As jobbers and retailers of many other makes they had learned valuable lessons to be applied to their own product. Beginning in a modest way, they have developed one of the great manufacturing and selling organizations of this country, whose output is one of the largest and the character of the product of the highest. This was recognized in the year 1900 at the great International Exposition in Paris, where the Baldwin Piano was awarded the Grand Prix, the highest honor to be attained, being the only American piano ever so honored. Again in 1904 the Grand Prize was awarded the Baldwin Piano at the International Exposition at St. Louis. All this manufacturing development and recognition of the product was attained within the first twenty-five years of their period of manufacturing. Today the Baldwin Piano is sold universally in the United States and is exported to thirty-two different countries. It is also used in concert by the greatest artists and is recognized as one of the artistic pianos of the world.

Grand Prix
Paris 1900

Grand Prize
St. Louis
1904

Manualo
Player
Piano

The third epoch is marked by the announcement to the public of the "Manualo", the player piano that is "all but human." For more than twelve years they had been engaged in producing an original creation founded on their own patents, and the finished product, the "Manualo", is now marketed widely, and has proven its value by exciting the attention and admiration of discriminating critics as to its artistic and practical merits.

Could we but look forward to the beginning of the fourth epoch of this honored house, what would it reveal to us! We have not dealt with what is an interesting part of their history, that is, the personalities of the men who have been instrumental in its development. Though disagreeing, perhaps, with their attitude, yet we respect, as others do, one of the traditions of this house, namely, that all personalities are subordinate to the one ideal of making a great and honored reputation for The Baldwin Company.

Civil
Service in
Organization

It is quasi-civil service in its organization, each one knowing that in time, by loyalty and efficiency, he may have larger and greater opportunities. It is an interesting fact that the stock of this corporation is owned by those active in the operation of The Baldwin Company and is not dependent on or responsible to outside interests in any way. It employs more than six millions of dollars in working assets, and has one of the most efficient and unique financial systems of operation in the industry. A model house, with well defined policies, it will enjoy a solid and enduring history.

JULIUS BAUER AND COMPANY*, Chicago.

William
Max Bauer

Born in Chicago in 1870, WILLIAM MAX BAUER, son of Julius Bauer, attended the public schools and graduated from the Manual Training School of his home city at the age of eighteen. He then traveled extensively in Europe and upon his return entered his apprenticeship in the piano factory founded by his father. Endowed with an inventive mind, and leaning

*Vol. I, p. 362.

primarily towards mechanical activity, William M. Bauer also demonstrated ability in commercial directions, and in 1900 was elected vice-president and general manager of the corporation of Julius Bauer and Company.

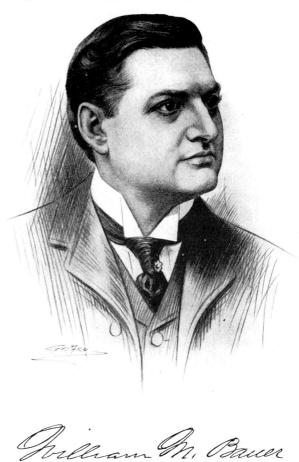

Imbued with the highest ideals for the art of piano building, naturally modest and conservative, W i l l i a m M. Bauer's ambition is not to manufacture a large number of pianos and to accumulate money quickly, but rather in the direction of making his mark as an originator and constructor. Consequently his attention centered mainly upon the improvements of t h e Bauer piano as he found it, and as a result a number of p a t e n t s are recorded in his name, all of which are useful. The embodiment of these improvements in the Bauer pianos has brought the same into the front rank of artistic productions.

A noteworthy innovation is William M. Bauer's construction of an upright piano, in which he uses a wooden plate instead of the conventional iron plate, and in connection therewith a very ingenuous system of agraffes fastened to the sound board bridge, in consequence of which, according to Mr. Bauer's claim, the vibrations of each corps of strings are individualized,

Wooden
Plate

when the vibrations are transmitted to the sound board, producing a better quality of tone than when the strings rest altogether directly upon the sound board bridge. The wooden plate covers the entire front of the upright piano basic structure, serving at the upper part as pin block. To afford circulation of air between the wooden plate and the sound board, large holes are provided in the plate below the hitch pins. The plate itself

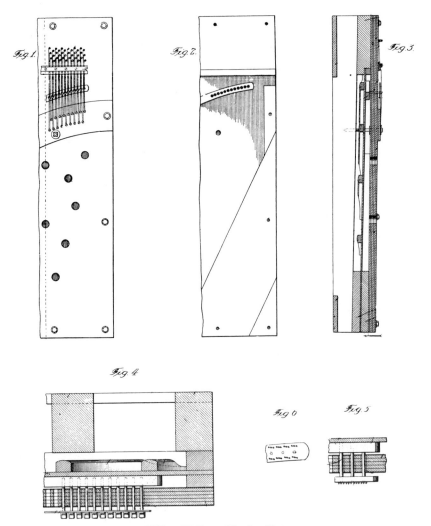

William M. Bauer Wooden Plate

is built up by five thicknesses of quarter-inch veneers, glued together crosswise, which assures the necessary strength to withstand the strain of the strings.

It has been William M. Bauer's study for years to build a piano entirely free from what is generally called a "metallic" tone, and he has undoubtedly solved that problem with this invention. The tone quality of his piano with the wooden plate, as compared with the same piano having the iron plate, is much more mellow and has a certain sensuous quality. At all events, the invention has the merit of strict originality, and is the promise of further thoughtful and meritorious invention to be looked for from William M. Bauer.

The patents allowed him for a novel fall-board, swinging music desk, improved pedal, pedal action, and action bolt are evidences that the minor parts of the piano also receive his thoughtful attention.

BEHNING PIANO COMPANY*, New York.

Henry Behning

HENRY BEHNING, president of the corporation, was born at Bridgeport, Conn., in 1859. After attending the public schools, he learned piano-making under his father's instruction, and was admitted to partnership in 1880. When the firm was changed into a corporation in 1894, Henry Behning was elected president and general manager.

Gustav Behning

His brother, GUSTAV BEHNING, was born in New York, in 1868. After graduating from the public schools he also learned the trade of piano-making, and became a partner in the firm of Behning and Son in 1890, being elected secretary and treasurer of the corporation in 1894.

Both being thorough piano makers, they were among the first who took up the manufacture of the player piano with great zeal, and up to this time the corporation controls eighteen patents on player piano improvements, some of them of sufficient merit to place the Behning Player Piano among the best of the present day.

*Vol. I, pp. 319-320.

The combination of well-constructed grand and upright pianos, possessing excellent tonal qualities, with a responsive player action of original design, has established the name of Behning as a factor in the industry at the present time.

BEHR BROTHERS AND COMPANY*, Newark, N. J. Fate and circumstances beyond the individual's control, are oftentimes responsible for the forming of a character, and give the strength to overcome the adversities of life, culminating in final success.

Henry
Behr

HENRY BEHR was born at Hamburg, Germany, in 1848, as the scion of a family prominent among the aristocratic merchants of the old Hansa town. His father was engaged in the hardware business, having a large export trade with the United States, which assumed such proportions as to induce him to establish a business in New York City in 1846. Being successful in this enterprise, he concluded to cast his fortunes with the new country, and settled with his family in New York in the year1849.

Henry Behr was just one year old when the family landed in New York. He attended the public schools, but as misfortune had overtaken his father, he had to leave school at the age of twelve in order to assist in his father's business of manufacturing skates. The outbreak of the Civil War made matters worse, and Henry Behr enlisted in January, 1864, as a private in the 169th regiment of the New York National Guards. He participated in five of the large battles and a number of skirmishes, and was one of the very few who were saved in that great catastrophe when Fort Fisher was blown up, destroying almost the entire 169th regiment. In April, 1865, while lying in the hospital at Davis Island, New York, Henry Behr received his honorable discharge from the army.

Obliged to make his own way in the world, he started out to sell varnish on commission, later on adding glue to his line. This brought him into connection with the manufacturers of

*Vol. I, p. 336.

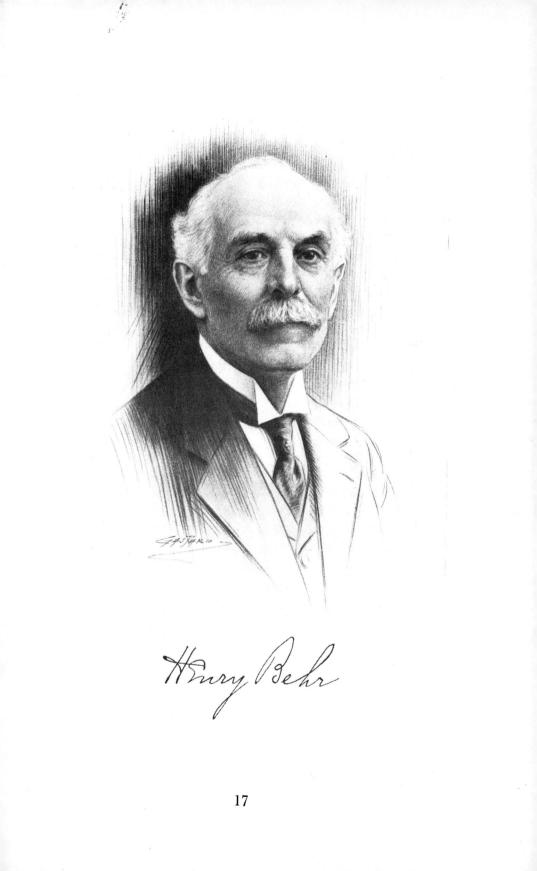

Henry Behr

piano cases. One of his largest customers went into bankruptcy in 1875, and Henry Behr was appointed receiver. Observing the possibilities of that business he bought the stock and machinery, and with Leopold Peck as partner, under the firm name of Behr and Peck, entered upon the manufacture of piano cases on an enlarged scale. When in 1876 Henry Behr's brother Edward bought out Peck's interest, the firm name was changed to Behr Brothers.

Behr and Peck

Ambitious for a larger field of activity, Henry Behr decided to manufacture pianos, and in 1881 Paul G. Mehlin joined the firm, which was then changed to Behr Brothers and Company, confining itself in the course of time entirely to the manufacture of the Behr Brothers piano. The scales being designed by Paul G. Mehlin, it was but natural that the piano should at once assume a strong position among the leaders. The partnership with Mehlin was dissolved in 1886, and Siegfried Hansing, was appointed technical director and superintendent of the factory, in which capacity he served for six years.

Behr Brothers and Company Piano

Siegfried Hansing

It was Henry Behr's ambition to see his grand piano on the concert platform, and in 1901 he had the great satisfaction of having the Behr Brothers grand piano used by Xaver Scharwenka in the Philharmonic concert in New York City, and also on Scharwenka's concert tour through the United States. He furthermore introduced his grand piano at the imperial conservatories of music at Berlin and St. Petersburg.

Xaver Scharwenka

With indomitable energy and determination, Henry Behr succeeded in overcoming the most serious difficulties and setbacks, maintaining under most trying circumstances his high reputation for integrity. He has now the great satisfaction of looking back upon a business activity of nearly forty years as one of the most respected leaders in the piano industry, having realized his dream to build really artistic pianos in a model factory which embodies all the advantages of modern construction with special reference to up-to-date requirements for piano-making.

His son, WILLIAM J. BEHR, born in Brooklyn, New York, on
January 5, 1872, graduated from the Polytechnic school in 1890 and studied piano-making in all its branches in his father's

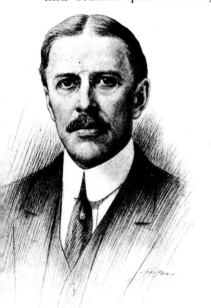

factory. Qualifying as a thorough piano expert, he was admitted to partnership in 1899, and in 1902 the management of the factory and sales department was entrusted to him. Inheriting his father's progressiveness, William J. Behr succeeded in improving the Behr piano steadily, achieving particular results in the construction of the Player Piano, which has become an important branch of the business.

Adhering strictly to the policy, inaugurated by the founder, of producing the very best piano possible, William J. Behr's efforts have assured the Behr Brothers piano a permanent place among the high-grade productions of the art.

Among the various patents controlled by Behr Brothers and

Company is one for a system of stringing, according to which the strings of one note are strung to the right and the strings of the adjoining note to the left on the sound board bridge, to neutralize the strain which is caused upon the sound board bridge if the strings all press in one direction.

20

GEORGE P. BENT COMPANY*, Chicago, Ill.

Intending to follow a professional career, GEORGE PAYNE BENT, born at Dundee, Ill., on June 16, 1854, entered Wheaton College after graduating from the public schools, and was finally enrolled as a student at Grinnell College, Iowa.

Compelled to earn his living, he came to Chicago in 1870 and hired out to David C. Cook, a dealer in sewing machines, as a general utility man, intermittently attending college. But business had a stronger attraction for young George than studying books, and in 1878 he bought out his employer, Mr. Cook, and entered the ranks of that army of enterprising business men who have done so much to build up the industries and commerce of the great city of Chicago.

Bent possesses a poetic soul. Selling sewing machines was profitable, but altogether too prosaic, and we soon find him selling organs specially built for him. It is a short step from organs to pianos, and when he had established a reputation for his "Crown" organs, he found himself compelled to bring out the "Crown" piano, an instrument equally as well built as the "Crown" organ.

An indefatigable worker, Bent made himself familiar with piano construction, and soon feeling the desire to build a piano according to his own ideas, began in 1889 to manufacture pianos. Ambitious to lead, he surrounded himself with experts in all branches of piano-making, and with ease conveyed his extraordinary enthusiasm to the men who were building the "Crown" piano.

College training had impressed the value of system upon Bent's mind. Appreciating the importance of applying scientific methods to industrial propositions, he instigated systematic methods for scientific research in piano construction, as well as in examining and analyzing the materials used in building pianos.

His earnest labors received their reward in the form of a diploma from the jury of the World's Fair in Chicago, 1893,

*Vol. I, pp. 362, 410.

where his pianos were installed in thirty-two state buildings erected on the exhibition grounds. Among the various pianos exhibited by Bent, an upright having a chromatic keyboard attracted general attention.

In 1894, George P. Bent erected his mammoth factory. Considering that in 1870 he had to work for small wages to earn the money to attend college, it speaks volumes for the man's energy and business sagacity that he should find himself after twenty-four years at the head of a manufacturing concern owning one of the largest factories in Chicago and doing a business of over one million dollars per annum. A man of positive character, unswerving courage instilled by conviction, positively fearless in attack or defense, Bent has always taken a firm stand for ethics in business. He is a great believer in printer's ink, exhibiting unusual originality in his advertising, and has succeeded in building up such a large export trade that "Crown" pianos can be found in all parts of the world.

The George P. Bent Company controls twenty-seven patents for improvements in piano construction. Like so many of the thinking piano makers, Bent and his assistants have given the subject of sustaining the tone quality in the piano considerable thought, and as a result have devised for their upright pianos a system by which the iron plate can be pressed down by means of a series of strong bolts at the lower end, thus giving a new bearing to the strings upon the sound board, restoring in a way the effectiveness of the original arching of the sound board.

It was but natural that Bent should not overlook the great possibilities of the Player piano, and the "Crown" Combinola is the latest creation in the long list of Bent productions.

When the National Association of Piano Manufacturers was organized in 1897, George P. Bent was elected treasurer, and in 1904 his brother manufacturers elected him to the presidency

of the Association. George P. Bent is an excellent judge of men and has succeeded in surrounding himself with a corps of very able assistants.

Geo. P. Bent Co. Adjustable String Frame for Upright Piano

ERNEST G. MEIKLE, born November 25, 1865, at Pecatonica, Ill., entered service for Bent in 1887. Demonstrating his ability as a salesman, he was appointed in 1899 manager of the sales and advertising departments. In 1908 he was elected secretary of the corporation and in 1912 vice-president and treasurer of the great concern. Ernest G. Meikle

Bent's son, GEORGE H. BENT, was born at Chicago on October 11, 1878. After attending the public schools, he graduated in 1897 from the Chicago Manual Training School, and became a post-graduate of the University of Chicago in 1900. He then went to Europe to acquaint himself with the methods of piano manufacturing in the leading centers there, and upon his return entered his father's factory to study piano making under Joseph G. Kuntze. After finishing his studies, he acted as traveling salesman and in 1905 was appointed manager of the retail department of the George P. Bent Company. In 1912 he was elected secretary of the corporation, to succeed his brother-in-law, Mr. Meikle. George H. Bent

BUSH AND GERTS*, Chicago.
 The practice introduced by Joseph P. Hale in 1870 of stenciling pianos with any kind of a name has in the course of time assumed such a magnitude that it has become a positive William L. Bush

*Vol. I, pp. 355-357.

menace to the entire piano industry. It has opened the door to fraud and deception by unscrupulous dealers and caused the mushroom growth of a large number of concerns, more or less

irresponsible, who use the cheapest kind of materials, e m p l o y the l o w e s t-priced labor, and compile so-called pianos, market-ing their stuff under all sorts of names, prefer-ably such as would have resemblance to the names of makers of good pianos. The piano-buying p u b l i c has no means of judg-ing the intrinsic value of a good piano, as compared to a cheap stencil piano, and fre-quently low-grade in-struments are foisted upon the p u b l i c as superior goods at high-grade prices.

For over forty years, strenuous efforts have been made by manu-facturers of good pianos to put an end to the nefarious traffic in stencil pianos, and no one in the piano trade has been more earnest and active in this respect than WILLIAM L. BUSH. However, all efforts in this direction have been in vain, simply for the reason that this traffic in cheap pianos yields large profits,

not only to the manufacturer of such products, but more especially to the dealer; and because of the stencil or fictitious name on the piano, no one can be held responsible for the deception and fraud, so long as there is no law on the statute books forbidding such practices.

It is to the lasting credit of William L. Bush that in his endeavors to benefit the industry, he finally succeeded in convincing Hon. Phil. P. Campbell, representing the third district of Kansas in Congress, of the importance and necessity of putting upon the statute books of the United States a law, resembling the Pure Food Law, which would effectually prevent such deceptions in future. It required considerable courage on the part of any member of Congress to father such a bill, considering the wide-reaching interests which are thereby attacked, but on January 4, 1912, Mr. Campbell introduced *Law against* his bill, according to the provisions of which "It shall be unlawful *Stencil* for any person, firm, company or corporation to place upon the *Piano* market for interstate or foreign commerce any product of manufacture, without printing, embossing, or stenciling the name and address of the manufacturer upon such article or commodity." In order to arouse interest in this movement to compel every manufacturer to assume full responsibility toward the purchasing public for the goods which he produces, Mr. Bush promoted and financed the "National League for the *National* Maker's Name", of which Dr. Harvey W. Wiley, father of the *League for* Pure Food Bill, is president, and William L. Bush acting secre *Maker's* tary and treasurer. It is the sole purpose of the "National *Name* League for the Maker's Name" to sustain the agitation and active campaign until a proper law shall be placed on the statute books which will protect the purchaser against fraud. The importance of such legislation in its effect upon the piano industry can scarcely be measured at this time. The law, as drawn up by Mr. Campbell, does not prohibit the use of trade names, nor the stamping or stenciling of the dealer's name upon a piano,

but every piano must bear primarily the name of the maker in a conspicuous place and easily discernible to the buyer. This law will reinstate the personal responsibility of the manufacturer for

every piano which he offers for sale, and will therefore be the strongest uplift that the industry can possibly experience. It is as heartily welcomed by the legitimate piano-maker as by the honest piano merchant, and when this movement inaugurated by William L. Bush has come to a successful conclusion, which it no doubt will, Mr. Bush's name will go down in the history of the piano industry as one of its great benefactors.

John Gerts *John Gerts*

Among the self-made men of the western pioneers in the piano trade, JOHN GERTS occupied a very prominent position. Born in Germany in 1845, he attended the public schools up to his fourteenth year of age, and served an apprenticeship of three years as cabinet-maker, after which he learned piano making with Otto Börs, the renowned piano-maker of Hamburg, Germany. In 1870 he came to Chicago and worked for twelve years with C. A. Gerold as a piano-maker, after which he started in business on his own account. In 1885, William H. Bush, John Gerts and William L. Bush formed a co-partnership under the name of W. H. Bush and Company, with a total investment of $20,000. In 1890 this was changed to a corporation under the name of Bush and Gerts Piano Company, with $400,000 capital.

John Gerts was a piano-maker of the old school, a thorough expert who had mastered all branches of the art, and the success of the concern is just as much due to the fine pianos which he produced as to the aggressive and energetic business policy

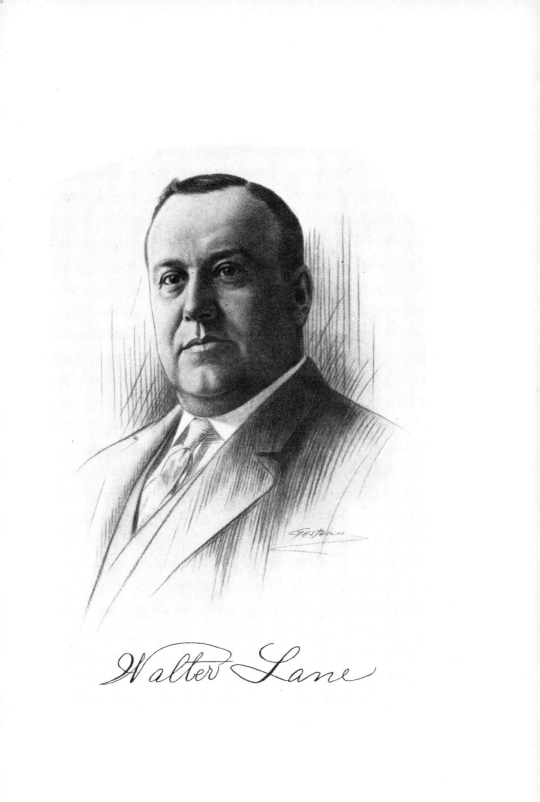

Walter Lane

pursued by William L. Bush in his capacity as president and business manager of the corporation.

John Gerts died on May 14, 1913. His son, John Gerts, Jr., succeeded him as secretary and treasurer of the company, the capital of which has been increased now to $700,000.

B USH AND LANE PIANO COMPANY*, Holland, Mich. It sometimes takes almost a lifetime for the born genius to obtain recognition, and when modesty is one of the inherent faults of a man, so that he permits only his creations to speak for him, the world at large is the loser.

Walter
Lane

WALTER LANE, born in Berkshire, England, in 1868, came to Toronto, Canada, in 1885, and had the good fortune to find as a teacher in the art of piano-making that past-master and father of the piano industry of Canada, Theodore A. Heintzmann, under whose personal instruction he studied piano-making for five years. Even at that early date, Lane's talent was recognized beyond the shop where he was working, and in 1891 the A. B. Chase Company, of Norwalk, Ohio, made him a tempting offer to assist in grand piano construction. After remaining about four years with this company, Walter Lane formed with the Bush brothers a corporation under the name of Victor Piano and Organ Company, of Chicago, which in 1904 was changed to the Bush and Lane Company.

Victor
Piano and
Organ
Company

More or less handicapped during the first few years of the existence of this company by the commercial tendencies of his partner, Lane's genius and desire for producing artistic pianos in the fullest sense of the word was given free rein to develop when in 1906 William H. Beach took charge of the commercial and financial management of the company. This permitted Lane to devote himself entirely to the designing and construction of pianos.

Walter Lane is original in everything that he undertakes and does. A deep student, quiet and conservative, he is not given to revolutionary changes, but has exceptional ability for

*Vol. I, p. 362.

discovering new methods along conventional lines. In all of his work the desire for solidity and massiveness dominates. Starting with the foundation, Lane believes in a very strong framework for his pianos, which he supplements with an unusually massive iron plate, carefully designed to withstand every possible strain or atmospheric influence. For his iron frames he prefers the cupular form, to give more freedom to the sound board. His preference for massiveness shows itself very strongly in all the case designs of Walter Lane, which are always as original as they are artistic and impressive. Perhaps no other piano case models have been so extensively copied by piano manufacturers as those designed by Walter Lane.

Original Case Designs

Confident that the solidity of his foundation, frame and iron plate is such as to permit the fullest freedom in the further development of the piano, Lane proceeds to build a super-structure which seems to justify the granting of an unlimited guarantee for reliable wearing qualities.

Aside from his ability for designing a positively reliable framework and artistic exterior to his pianos, Lane has demon-strated a peculiar genius in his studies for the improvement of details which affect tone quality. His aim has always been to obtain a forceful, but mainly a musical, liquid, mellow quality of tone. He has succeeded admirably in obtaining this desirable quality through the peculiar and more or less original construc-tion of his sound board. Lane gives his sound board a convex or arched form to the extent that the surface of the sound board bridge is five-sixteenths of an inch above the surface of the plate in the center of the sound board, tapering down to one-sixteenth of an inch at the treble end of the bridge. In constructing the sound board, Lane has the ribs shaped in accordance to the convexity of the board, and the thus shaped ribs are glued to the board in a form-press, strengthening the convex shape of the sound board sufficiently to withstand the pressure of the strings upon it. The result is a firm, positive and yet musical,

Sound Board Construction

mellow quality of tone not often to be found in upright pianos. That Water Lane is one of the present day masters of the art he Grand Piano has fully demonstrated in his grand piano, which although only five feet eight inches long, surpasses in volume and quality of tone many similar instruments of much larger size.

It is needless to state that a man of such a serious nature as Walter Lane would insist that every part of the piano which bears his name must be of the highest order, and the true merit of the product of the Bush and Lane Company is unhesitatingly admitted by all competent judges of piano making.

Bush and Lane Sound Board Construction

William H. Beach While Walter Lane thoroughly understands how to make a superior piano, it required the exceptional commercial and financial genius of William H. Beach to accomplish such a wonderful feat as to increase the capital stock of the Bush and Lane Company from $112,500 in 1906 to $400,000, with a surplus of $300,000, in 1913.

WILLIAM H. BEACH, born at Mt. Morris, N. Y., on April 4, 1851, is one of those strong men whose activity is bound to make itself felt in whatever they undertake. Attending the public schools and graduating at the age of sixteen from the high school at Port Huron, Mich., he gathered varied experience as clerk in offices and stores. To restore his health, impaired by overwork, Beach went to Colorado, in 1871, following the exciting and health-giving occupation of a cowboy. No doubt the two years

Walter Lane Laminated Frame for Upright Piano

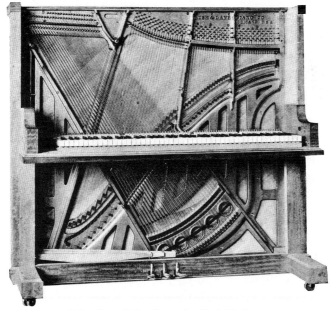

Walter Lane String Frame for Upright piano

spent on the plains of Colorado not only were beneficial to his
health, but mainly gave him that self-reliance and strength of
character which Beach has demonstrated later on in his business
career. He returned
to Port Huron, and
after being associated
with his father for a
couple of years in the
insurance business, he
entered the employ of
a large grain firm as
bookkeeper. In 1878
he started in the grain
business on his own
account at Holland,
Mich., with a capital
of $150. Daring and
enterprising, he soon
built an elevator and
began to operate as
g r a i n merchant all
along the line of the
railroad with g r e a t
success. In 1893 he
organized in Holland a
company for the pur-
pose of running steam-
boats between Holland
and Chicago. After

William A. Beach

the first large steamer was built, the Chicago competitors found
it advisable to buy out the Beach Company at a rather profitable
price for the latter. Taking an active interest in the building
up of the city of Holland, Beach became a stockholder and
director in the Holland City State Bank in 1891, and since 1910

he has directed the affairs of the same as president. He was very instrumental in inducing the Bush and Lane Company, of Chicago, to move their factory, in 1905, from Chicago to Holland, and in 1906 bought $15,000 worth of stock in the Bush and Lane Company, obtaining a controlling interest the same year through the purchase of the shares owned by B. F. Bush. From that time on Mr. Beach took charge of the commercial and financial departments, devoting himself entirely to the management of the growing business. Enthusiastically believing in the work of Walter Lane, William H. Beach applies all legitimate means to procure for his piano the proper recognition as an artistic product of the first order.

An equally good citizen as he is a business man, William H. Beach served the city of Holland for twelve years as a member of the Board of Education, six years of which he acted as president of the Board. He was further honored by being elected mayor of the city of Holland for three consecutive terms.

BUTLER BROTHERS PIANO MANUFACTURING COMPANY, Cincinnati, O.

James H. Butler

JAMES H. BUTLER, born at Frankfort, Ky., in 1867, learned the art from the renowned German pioneers of piano making in the West, Hinzen and Rosen, of Louisville, Ky., and then took a position in the repair shop of the old house of Smith and Nixon, at Cincinnati.

The opportunities which he had in that position to study the characteristics of nearly all the leading American makes of pianos aroused his thirst for learning in that direction, so that he took a course in physics at the Mechanics' Institute of Cincinnati, and afterward went to New York to study scale drawing under Henry Kroeger. In 1893 Butler was appointed superintendent of the Smith and Nixon factory, which position he held until 1909, when that firm went out of business, and he started making pianos on his own account.

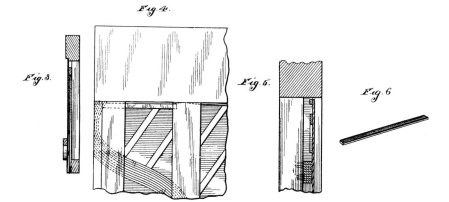

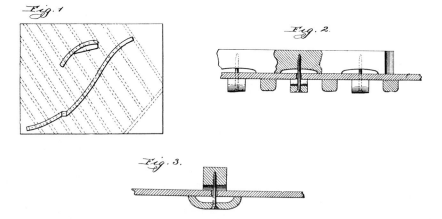

James H. Butler's Sound Board Improvements

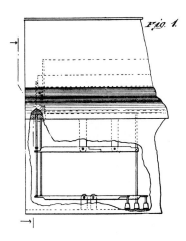

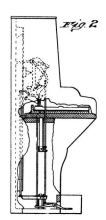

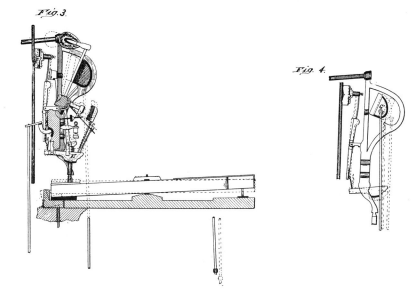

James H. Butler's Pianissimo Device

Sound
Board
Construction Like all thinking constructors, James H. Butler has ever been seeking the betterment of tone quality through improvements in the construction of the sound board. His experiments led him to adopt in 1896 a frame in the shape of a palette, for the sound board to rest upon. To afford a freer vibration of the short strings in treble and to obtain a more liquid tone quality, this frame is so constructed as to leave an opening or slot at the treble section, and the sound board is strengthened at this point by a straight strip of wood glued onto the back of the same. For this device Butler obtained a United States patent on October 27, 1898.

In his further efforts in this direction, Butler designed a sound board bridge with a series Sound
Board
Bridge of curved recesses to permit greater vibration of the sound board and to eliminate fundamental tones. This improvement was patented on November 27, 1900. An ingenious pianissimo device by aid of pedal-lifting of the hind end of keys was patented on March 3, 1903.

James H. Butler supervises with loving care the manufacture of all pianos which bear his name, while his brother, R. H. Butler, assists him effectively in managing the commercial end of the business.

THE CABLE COMPANY*, Chicago.
Geo. J.
Dowling Called to the right place at the right time, can be said of GEORGE J. DOWLING, president of The Cable Company. Born

*Vol. I, pp. 543-44-45.

at Cambridge, Mass., in 1864, Dowling enjoyed the fine opportunities offered by Boston schools, graduating at the age of fifteen. Musically inclined, he chose piano-making as a profession and served a thorough apprenticeship under that exacting master, Theodore J. Neff, at the Emerson Piano Works. In 1885 he engaged with Vose and Sons as repair man, in order to get intimately acquainted with the products of other manufacturers. There is no greater school for the studious piano maker than the repair shop of a large concern. It was here that Dowling laid the foundation for his later successes. He made the best possible use of comparing strong and weak points of construction in the many pianos passing through his hands, thus becoming an expert by thorough practical experience. However, the work bench was not the acme of Dowling's ambition. He felt that his talents pointed more strongly to the commercial field and we soon find him in charge of Vose and Sons' retail sales room in Boston.

In 1893 he took up the wholesale end, traveling until 1898, when he was appointed manager of Vose and Sons' Western branch at Chicago. This was a stepping stone to a larger sphere of activity.

The Cable Company of Chicago, a corporation employing a total capital of nearly five million dollars in its business, had from year to year improved its products and pushed to the front, as makers of high-class pianos. It needed high class men and in its search for such, made most tempting offers to Dowling, who finally accepted the office as vice-president of the company in 1908, and took charge of the sales department of the huge institution. He proved to be the right man in the right place. His thorough knowledge of piano making, his experience as retail and wholesale salesman, and later on manager of the only eastern piano firm which could permanently maintain a branch house at Chicago, had fitted him most eminently to become the directing genius of an institution which had demonstrated its

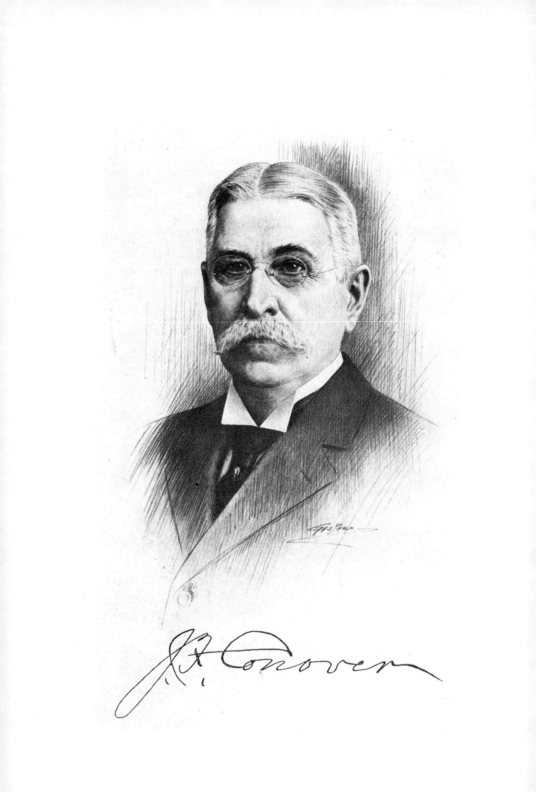

38

ability to march in the front ranks of the procession. On February 3, 1913, he was elected president of the Cable Company.

A man of the world, clever, yet serious, almost austere, Dowling has the faculty of making friends who stay friends. Exacting as a leader, he is just and fair, and knows how to arouse the enthusiastic co-operation of his associates.

J. Frank Conover

The fascination which art and science exert upon fine-strung natures is as delightful as it is tyrannical. It draws its disciples irresistibly to earnest pursuit and devotion, even at the cost of sacrifices. It is stronger than man. The born scientist never rests until he finds cause and reason for existing facts, and cheerfully devotes his lifetime to the studies thereof, not thinking of compensation other than his own satisfaction, and the benefits which may accrue to the world at large because of his discoveries. The painter seeks the beautiful, desirous of giving it to the world in its most pristine purity. As he is gifted with the eye to see the beautiful and the power to transfer his impressions to the canvas, so must the musician be gifted with a well-attuned ear, besides the poetic instinct necessary for the pursuit of all arts.

J. Frank Conover has been exceptionally favored with so delicately attuned an ear that he can analyze a tone as soon as it reaches his ear, and definitely locate the cause for either good or bad quality—a gift very seldom found, almost confirming the existence of the much-disputed and discredited "Ear harp" of Helmholtz.

Born at Mount Morris, N. Y., in 1843, Conover began studying music at an early age, and just as soon as he had passed the high school, he entered upon an apprenticeship for three years under the direct tutelage of Albert Weber, paying $300 for the privilege. The following three years, from 1862 to 1865, Conover devoted exclusively to studying, paying special attention to music, counterpoint, harmony, composition, and

acoustics. This close application had awakened in the young man the desire to travel, and for five years he sold Weber and other pianos throughout the Southern States, with headquarters at Clarksville, Texas.

Conover
Brothers

In 1870 he formed a partnership with his brother and established the firm of Conover Brothers at Kansas City, Mo. Leaving his brother in charge of the Kansas store, Conover opened up a large piano store at St. Louis in 1879, with the

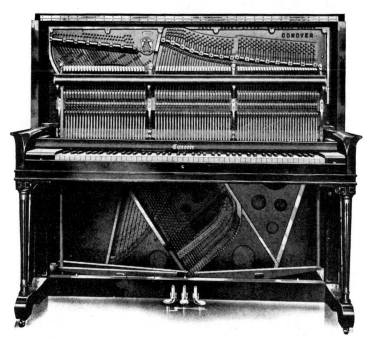

Conover Upright Piano

Steinway piano as leader. He is still proud of his banner day, on which he sold at retail five Steinway grand and two Steinway upright pianos in St. Louis.

However, all of his success as a piano merchant could not overcome his desire to build pianos. The blood of the artist was in him. He sold his business at St. Louis and Kansas City and came to New York in 1881 to build the Conover Brothers piano. At first Conover confined himself to the building of

upright pianos along original lines, studying mainly the sound board construction in its effects on tone production. Step by step he unravelled the mysterious and yet all-important relation of sound board and string vibration, the harmonious blending of which had more attraction for him than the mere production of a loud and powerful tone. His sensitive ear directed the

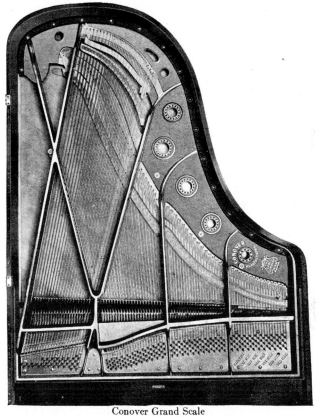

Conover Grand Scale

path for him to follow. Establishing a reputation as a designer of scientific piano scales, Conover attracted the attention of Herman D. Cable and in 1892 he merged his business with that of the great Cable Company. This move enabled him to devote his whole time to scale designing and construction problems. He remodeled and designed new scales for all the products of The Cable Company, centering his attention mainly upon the

Conover grand pianos. The grand pianos of Conover distinguish themselves by their pure musical tone, with exceptional carrying power and a most unusual evenness of scale. Conover's sound board construction permits so free a vibration of the board as to result in making the piano sing, a quality enchanting in pianissimo playing and very seldom found in modern pianos.

While Conover's genius is strongest in tone development, he has also contributed to the advance in the art with various mechanical inventions. The improvement of the upright action has claimed his attention as the patent records show. He has also invented a most effective metal bushing device for tuning pins. It is a scientific application of the power of friction between hard and soft metals which is constant because there is no grinding between the metals, and the resilient holding force is never impaired.

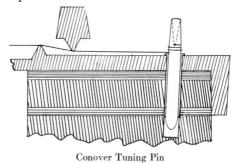

Conover Tuning Pin

The rarest combination in the general make-up of human beings is undoubtedly the blending of a decided commercial genius with equally strong and prominent inventive talent. Such a combination always produces practical and direct results, because it does not dwell in the realm of idealistic dreams and conceptions impossible of useful realization or application.

Of Holland descent, PAUL B. KLUGH was born at Detroit, in 1878. Attending the public and high schools until fifteen years of age, he took a position as errand boy in a music store, at a salary of three dollars a week. The commercial instinct of the Dutch blood, commingling with Yankee ingenuity, broke

through at once. Klugh's first invention was a tricycle with printing type on the two main wheels which would print upon the sidewalk the name of the firm for which he was working. Surely a very effective and economical way of advertising! But police regulations interfered. The tricycle could not be used upon the sidewalks, and therefore the boy did not commercialize his very first invention.

It was in 1893 that Klugh met William B. Tremaine, of what was then known as The Aeolian Organ and Music Company, whose enthusiasm over his self-playing organs found a receptive mind in Klugh. While Klugh was selling organs to the farmers of Michigan from his wagon, his mind was on self-playing instruments, so much so that several years later we find him devoting his entire time to selling self-playing instruments in Detroit. It was fortunate that through his friend Tremaine, Klugh saw a practical demonstration of the first cabinet piano player made. Subsequently the manufacture of piano players was started in Detroit, and Klugh, fascinated with the problem of piano players, improved the opportunity to study the mechanism and process of manufacture. Much spare time was used to perfect his piano playing, in which he became more than an amateur. Gifted with musical talent, he developed into a most interesting improviser on the keyboard. Upon the solicitation of Tremaine, Klugh went to St. Louis in 1902 in charge of the selling of his instruments in Missouri and Southern Illinois.

It was written in the book of Fate that the inventor of the tricycle printing adjunct should become enchanted with the possibilities in player piano mechanism and its development, and when The Cable Company, in 1904, decided to manufacture player pianos, Paul B. Klugh was chosen to design the same and organize the manufacturing department. The patent office was soon bombarded by Klugh with applications for all sorts of novel devices or improvements in player mechanism. A string of patents has been granted to him for his Carola Inner Player

Carola Inner Player

and Euphona player piano mechanisms too numerous to mention, all of them showing, however, that Klugh's inventive mind runs mainly in the direction of creating eminently practical devices, in order to obtain the most artistic effects without particular effort on the part of the performer.

With his miniature keyboard, patented in 1906, he obtains for the player mechanism an elastic, almost human, touch, while his transposing device, patented in 1907, makes the player piano an ever-ready instrument for accompaniments. The "Carola Inner Player", under which name the Cable player pianos are marketed, is also equipped with Klugh's patented accenting device, solo aid, and sliding wrist-rest. His latest and most remarkable invention is his automatic solo device, playing eighty-eight accompaniment and eighty-eight solo notes, struck simultaneously or independently at will, and using a standard width of music sheet of eleven and one-quarter inches. With this interesting device there is independent control of dynamic and accompaniment notes.

Automatic
Solo device

That Klugh has devoted himself intensely to the study of mechanics is shown by his various strictly mechanical devices, so helpful in operating the player piano, as for instance, his triplex pedal mechanism, patented in 1907, for moving the player pedals automatically out of and into the piano case by the use of a lever; also his application of the pneumatic clutch, and other important details of construction.

Enthusiastic for standardization in the piano player industry, Klugh had the satisfaction of calling together and acting as chairman of the joint meetings held by player and music roll manufacturers in 1910, when important principles and measurements were standardized to the benefit of the industry and player-buying public.

With all his activity as an inventor and manufacturer, Klugh never sidetracked his commercial abilities. He proved himself withal as a splendid "business getter", in proper

recognition of all which he was promoted to be director and vice-president of The Cable Company, in 1913.

HOBART M. CABLE COMPANY*, La Porte, Ind.

The Chicago Cottage Organ Company, founded by H. D. Cable, is the alma mater of several strong men who afterwards have become leaders in the piano industry.

Hobart M. Cable

HOBART M. CABLE started in life as a school teacher, later becoming School Commissioner for Delaware County, N. Y. He then settled in Boston, and served for three successive terms in the legislature of Massachusetts. After assisting his brother, H. D. Cable, in the management of the Chicago Cottage Organ Company for several years, he organized the Hobart M. Cable Company in December, 1900. A man of positive character, with boundless faith in his own ability, he forced success even under adverse conditions, and developed a large business within a remarkably short time. Too close application to business, however, undermined his strong constitution, and he died in December, 1909.

Hobart M. Cable, Jr.

His son, HOBART M. CABLE, JR., succeeded him as president of the company. Born at Boston on December 15, 1881, young Cable graduated from high school and attended the law course at Cornell University for one year, when he went with his father to Chicago to take up piano making as his life study.

Howard B. Morenus

HOWARD B. MORENUS, the vice-president and secretary, graduated from the high school at Walton, N. Y., at the age of sixteen and after four years of service in the National Bank of Walton, engaged with the Chicago Cottage Organ Company as auditor. Serving for six years in that position, he was entrusted with the management of the company's store at Atlanta, Georgia, from which he resigned in December, 1899, to join the Hobart M. Cable Company.

Edwin W. Schurz

EDWIN W. SCHURZ, who had been in a confidential position for ten years with the great house of Fairbanks, Morse and Company, was elected treasurer of the H. M. Cable Company in 1910.

*Vol. I, pp. 344, 362.

THE CABLE-NELSON COMPANY*, Chicago. Factories: Cableton, Mich.

Born in the little country town of Cannonsville, New York, on March 18, 1855, FAYETTE SHEPARD CABLE graduated from the Delaware Literary Institute at Franklin, N. Y., at the age of nineteen. After teaching school for a time, he was engaged by A. S. Barnes and Company to take charge of their school-book business in southeastern New York and New Jersey. In 1880 he came to Chicago and took charge of the western office of a large Philadelphia publishing house, which position he held until he joined his brother, H. D. Cable, in the management of the Chicago Cottage Organ Company, as secretary and manager of the sales department.

After the death of H. D. Cable in the winter of 1900, Fayette S. Cable was elected president of the Cable Company. An indefatigable worker, gifted with business perspicacity, and withal affable, considerate and eminently fair in all his dealings, F. S. Cable naturally makes friends of all with whom he comes in contact.

In 1903 he organized the Cable-Nelson Company, an enterprise which is counted among the leading institutions of its kind in Chicago. A good judge of men, he has surrounded himself wth a coterie of able assistants, imbuing them with his own enthusiasm. His inborn integrity stimulates the desire to produce as good a piano as possible, and he makes the most extensive use of modern machinery and methods in manufacturing. F. S. Cable has demonstrated extraordinary talent as an organizer. The excellent quality of his product and the broad-gauged business policy which he pursues are the explanation of the remarkably rapid growth and popularity of the Cable-Nelson Company.

Though public-spirited, F. S. Cable has no other ambition than to watch carefully over the destiny of his business and the welfare of his family. A railroad station near his factory has

F. S. Cable

Cable-Nelson Company

*Vol. I, pp. 344, 345.

been named "Cableton" in recognition of his beneficial activity for the development of the factory town, placing F. S. Cable among the few piano-makers whose names have been put on the map.

A B. CHASE COMPANY*, Norwalk, O.
Progressive, but always avoiding any questionable experiments, the A. B. Chase Company had a great reputation to maintain when it entered upon the player piano field. True to their traditional policy, the managers looked over the field very carefully and finally engaged William F. Cooper, a prolific inventor, with wide experience in the player field, to construct for them a player piano that would embody new and desirable features not yet found in other pianos. The result was the "Artistano", a mechanism which differs from other forms of player mechanism through being a unitary structure, easily placed below the keyboard and inside of the ordinary piano case, without increasing the size of the case. The "Artistano" is equally as well adapted to the grand as to the upright piano. It has proven fully as great a success as the A. B. Chase piano, which not only maintains but increases its strong position as a leader, improving continually in tone as well as construction and exterior designs. "Artistano"

Ever since the piano was invented, the individuality of one person has been impressed upon every product—not necessarily that of the designer and constructor, but quite often the so-called "silent worker" in a corporation, the man who never appears in the limelight, is the moving spirit, the master mind, who directs the very destiny of the enterprise.

L. L. DOUD was born seventy-five years ago in a log house, on his father's farm near Norwalk, O. His parents were of good old New England stock, such as have built up the great West. The boy Doud went through all the rugged experience of pioneer life, getting his education in the little school-house at the country cross roads. Desirous of improving his condition L. L. Doud

*Vol. I, pp. 374-75.

he managed to attend college a few terms and win his diploma in the commercial course. He then pursued a commercial career until he joined A. B. Chase, in 1875, to organize the

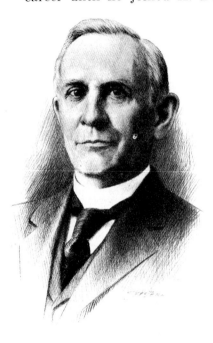

A. B. Chase Company. He assumed the responsibility of managing the financial and business affairs of the corporation, and has continued to do so to the present day.

Fair-minded, thorough in all that he does, sincere, and just, Doud believes in harmonious relationship between capital and labor. Paying liberal wages, he awakens the enthusiasm and interest of the employees in their w o r k by compensating them liberally for any invention or improvement benefiting the A. B. Chase piano, and this is the key to the steady progress of that instrument. Not one man, but all the men in the Chase factories are continually trying to build the very best piano. An organization of able men, built up by Doud and his associates, is behind the A. B. Chase piano, assuring a continued success for the future.

CHICKERING BROTHERS*, Chicago, Ill.
 CLIFFORD C., FRED W. and WALLACE W. CHICKERING, composing the firm of Chickering Brothers of Chicago, sprung from a sturdy line of old New England stock, dating their ancestry back as far as the seventeenth century to Nathaniel Chickering, one of the early pioneers of this country. Their father, JOSIAH B. CHICKERING, was one of Cincinnati's leading business men and educators. Compelled to earn his own living,

Josiah B. Chickering

*Vol. I, p. 362.

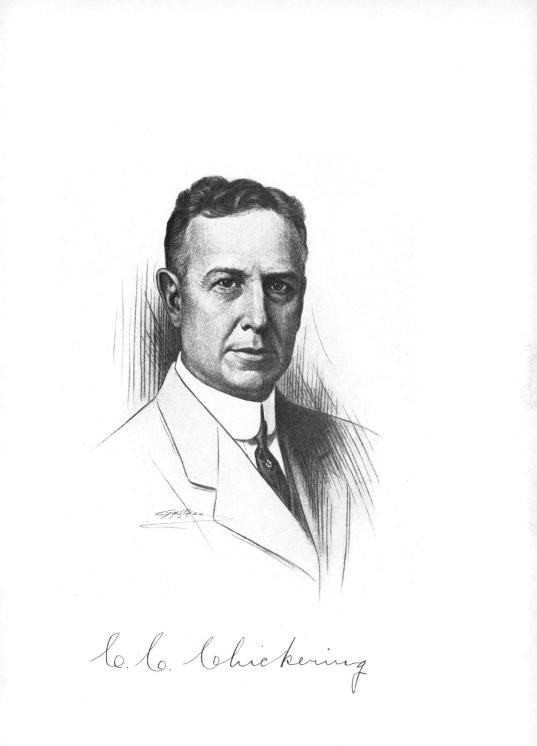

C. C. Chickering

he was at the age of eight bound out to a farmer near the little town of New Ipswich, N. H. Later we find him working his way through the academy at Leominster, Mass., and still later becoming one of the teachers and finally principal of this same academy.

Energetic and filled with ambition, Josiah B. Chickering went to Cincinnati with the intention of entering commercial pursuits, but the instinct of the instructor and teacher was so strongly imbedded in his nature that he soon established what was known as the Chickering Academy for Boys, which became later on one of the largest private schools for boys in the West, under the name of Chickering Institute. Many of Cincinnati's leading professional and business men are graduates of the old Chickering Institute.

Josiah B. Chickering's grandfather was ABNER CHICKERING, a farmer and blacksmith, while his father, SAMUEL CHICKERING, was a stone mason and farmer, living in Mason Village, N. H. He lost his life through an accident, in his forty-third year, leaving a large family of which Josiah was one.

In the year 1876, Josiah B. Chickering was importuned by Messrs. Frank and George Chickering, of Boston, Mass., to induce his sons to learn the piano business. This request on the part of the Boston Chickerings was due to the unfortunate circumstance that neither of them had sons to succeed them in the great piano business which had been established in Boston by their father, Jonas Chickering, and built up by him and his sons. In accordance with this arrangement, CLIFFORD C. CHICKERING, the senior member of the firm of Chickering Brothers, Chicago, entered the Boston factory in the fall of the year 1881, at the age of eighteen. For seven years he industriously worked at all branches of piano making. He was then called to New York to receive final instructions in scale-drawing. For two years he studied that branch of the art under the direct guidance of C. Frank Chickering, and the great honor fell to him

Clifford C.
Chickering

to put the finishing touches on the last scale which C. Frank Chickering had drawn some time before his death. It was a scale for a new grand piano and Clifford introduced the novelty

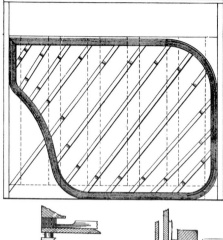

of discontinuing the use of covered strings beyond the over-strung section. It proved a valuable innovation, giving greater evenness to the scale.

Following the death of C. Frank Chickering in 1891, the business of Chickering and Sons was reorganized, and Clifford C. Chickering was thrown upon his own resources. Desirous

Sound Board having beveled face and ribs beveled at ends

of making a name for himself by carrying out his own ideas in the field of piano construction, he answered the call of the West, where he was born, and began to make pianos in Chicago in 1892, under the firm name of Chickering Brothers.

String Frame

Among those who have done telling work to establish for Chicago the reputation of fostering real art in piano making, equal to that of the older eastern cities, Clifford C. Chickering stands foremost as an inventor and constructor along original lines. At the beginning of his business, Chicago was not known as the home of high-class instruments, and it was left to the Chickering Brothers and a few others to fight the battle of obtaining for Chicago the prestige of equality with Boston, New York and other eastern cities in the production of high-class

pianos. Constantly improving his instruments, taking proper advantage of discoveries in the science of acoustics and the advancements made in all branches of piano manufacturing, Clifford C. Chickering's efforts culminated in perfecting a most remarkable scale which permits of the application of the patented features embodied in it to either the grand or upright piano.

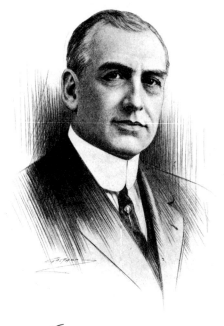

The laminated rim upon which the sound board rests is bevelled on the under face, the sound board having a bevelled face and the ribs being bevelled at the ends where they engage with the rim, as the illustrations show. The effect of this construction is a most powerful tone of pleasingly luscious and mellow quality, a quality ever sought for and seldom obtained by piano constructors. This great advance in modern piano construction is so telling in its musical effects that his confreres in piano construction willingly concede Clifford C. Chickering to be one of the present-day leaders and masters. He has demonstrated that he knows how to build and improve upon the theories of his tutor, C. Frank Chickering.

In order to distinguish his invention from all other pianos, C. C. Chickering coined the appropriate name "The Acousti-grande", which appears as their trade mark upon the fall board of all pianos made by Chickering Brothers of Chicago, followed by the firm name "Chickering Brothers" in smaller letters.

FRED WILBY CHICKERING, born in Cincinnati on March 1, 1865, followed his brother Clifford's example and entered upon

Sound Board Construction

Acousti-grande

Fred W. Chickering

his apprenticeship at the factory of Chickering and Sons in Boston, in 1882. For seven years he worked at the bench, mastering all branches of piano building, but being more inclined towards a commercial career, accepted an engagement as

salesman with the old house of Smith and Nixon at Cincinnati. Later on he became manager of the retail store of Mason and Hamlin, in Chicago, and acted also as manager of the retail department of the Weber Piano Company, in Chicago, until he joined his brother in the manufacture of pianos.

Full charge of the commercial end of the business naturally fell to him. A good musician, of optimistic and enthusiastic temperament, Fred W. Chickering is also an indefatigable worker, possessing striking magnetism and persuasive power. It is therefore not to be wondered at that the growth of the concern has surpassed the fondest hopes of the founders.

The third brother to join the firm, WALLACE WILEY CHICKERING, had originally chosen a professional career and graduated from the University of Michigan at Ann Arbor in the department of Mechanical Engineering, but was called in to assist his brothers in the management of the ever-growing business, and in 1907 was made a member of the firm.

Aiming successfully at the highest in the art of piano building, the Chickering brothers have won for their pianos an undisputed position in the front ranks.

Wallace W. Chickering

Melville Clark,

56

MELVILLE CLARK*, Chicago, Ill.

*"Oh wad some power the giftie gie us
To see oursel's as others see us!"*

Perhaps no inspired saying of any poet is so often quoted as Robert Burns' plea, not only for its loftiness of thought, but because of the truism that the realization of the individual wish

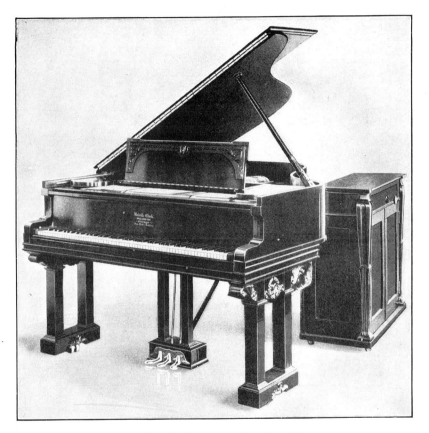

Recording Machine Attached to Grand Piano

will ever be an impossibility. So it has been likewise considered impossible that we could ever hear ourselves play on the piano as others hear us. But the inventive genius of MELVILLE CLARK has made the latter possible. His recording apparatus does more than the phonograph and photographic camera

*Vol. I, pp. 376-77-78.

combined, because it reproduces the *soul* of the performer, which he puts into his interpretation.

The invention of an apparatus which will photograph, so to speak, the execution of any kind of music on the piano keyboard immediately, and so correctly in all its phrasing and detail, even down to the eccentricities of the performer, that the player mechanism will reproduce it all, seems to be the acme in piano player inventions up to the present time. It is needless to enter into any speculations as to the new vistas and fields which this invention has opened. Of immeasurable value to the composer, it is equally important for the performance of living artists for future generations.

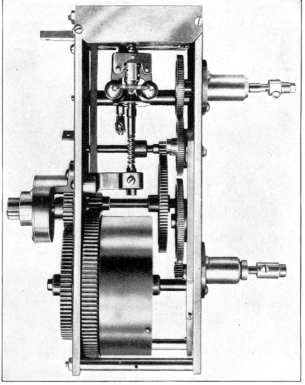

Metronome Motor

One of the main features which makes the positively correct reproduction possible is the application of the spring motor

invented by Clark, which admits of correct traveling of the music roll, independent of the pedaling. In other words, the music as photographed by the recording apparatus, will be reproduced at the correct tempo, no matter whether the performer may pedal in an even tempo or change off fast or slow.

Aside from the fact that Melville Clark was the first to perfect an eighty-eight-note player-mechanism as against the sixty-five-note, the world is indebted to him for the invention of the down-stroke on the piano keys in front of the fulcrum, which secures the human expression of touch; also for the self-acting metronome motor, which absolutely prevents jerky and inartistic effects caused by unconscious hard pedaling, and the adjusting and transposing device, by the aid of which the music can be changed to any key, in order to suit the voice or accompanying instrument.

Down Touch Action

To what extent these epoch-making inventions are the result of evolution is best illustrated by the fact that over 250 patents have been issued to Melville Clark for improvements in pneumatics and player piano mechanism.

Coming from a musical family, an expert tuner and tone regulator of organs and pianos, it is but natural that Melville Clark would not be content to build anything but pianos possessing tonal qualities which satisfy the most fastidious. It is generally conceded that the Apollo grand and upright player pianos are strictly in a class by themselves.

Like all earnest inventors who are absorbed in their specialty, his work is his life. A man of intense vitality, a physical condition which helps him wonderfully in his tasks, he thinks out his plans at any time or at any place, wherever he

may be; and whenever ideas come to him as an inspiration, he will make a rough draft or memorandum in his notebook for future development. Many of his most important improvements had their start in such a manner. Speaking of the man himself, it is freely granted that Melville Clark is an exceptional man. No individual in the industry has a higher sense of personal and business honor than he. The underlying principle of his career is an undeviating probity, and that is one of the secrets of his great business success. He takes a broad view of life, is in sympathy with every movement that stands for the betterment of the masses and the amelioration of human conditions. His

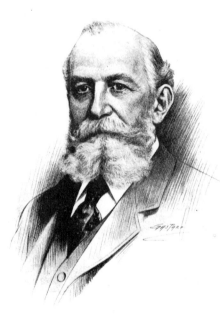

heart and his purse are always open to those who really deserve his aid. Frank and sincere, he is generally serious, although he possesses a keen sense of humor, and his modesty adds charm to his personality.

His work has assured him a niche in the Hall of Fame.

FRANCIS CONNOR, New York.

Born in the town of Ardee, near Dublin, Ireland, on June 19, 1843, FRANCIS CONNOR landed in New York at the age of seventeen, and immediately engaged as apprentice in the piano factory of Grovesteen and Hale. In 1865 he was called to James-

Francis Connor

town, New York, where he assisted in turning out the first pianos for A. Tallant and Company.

Desirous of seeing more of the world, he spent a number of years in the Southern States as tuner and repairer. Upon his

return to New York, he engaged with the well-known piano maker, John Hardman.

Desirous of realizing his ideals in piano construction, he started in business on his own account in 1877, and manufactured the "Francis Connor" grand, upright, and player piano, for which he has established an enviable reputation.

His enterprising nature is demonstrated by the fact that he was the pioneer piano manufacturer in that northern part of New York City which is known as the "Bronx", now the home of the larger number of New York piano factories, and furthermore by opening a piano wareroom in that great business thoroughfare, Forty-second street, near Fifth avenue, New York, at a time when that locality was strictly a residential section of the city.

D AVENPORT-TREACY COMPANY, New York, N. Y. Perhaps no other living member of the piano industry of today can look back upon such a romantic career as DANIEL FRANCIS TREACY. Born at New Brunswick in 1846, as one of a family of eight children, he attended and graduated from St. Michael's College at the age of sixteen. After the death of his father and mother in the Provinces, the family moved to St. Louis, excepting one of the brothers, who became an editor of the New York Tribune.

Of a restless disposition and desirous to see the world, Daniel F. Treacy shipped aboard a whaling vessel from New Bedford, Mass., in 1865. Returning after a three-year's cruise, he shipped on another vessel, serving another three years. On the homeward trip he was shipwrecked and cast away on the Isle of Trinidad, where he was forced to remain for about five months before he found opportunity to board a vessel, which was bound for Halifax, N. S. He finally made his way to Boston, where he went to work in an iron foundry. He remained in Boston for one year and then came to New York. Shortly after, he was the one successful applicant out of seventy-five

Daniel F. Treacy

chosen as foreman of the Achusent Iron Works of New Bedford, Mass. Evidently he had left an excellent record at New Bedford as a "whaler." Remaining a year and a half in that position, he

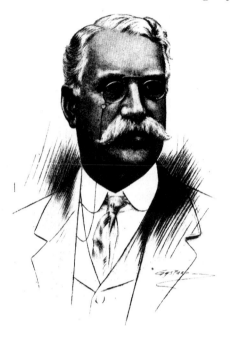

returned to New York and accepted the appointment as foreman for Davenport and Oothout, where he commenced to make piano plates, in 1872. Two years later he bought out the interest of Oothout and became half owner. The business prospered to such an extent that foundries were established at Boston, Mass., and Stamford, Conn., but in 1889 the three establishments were consolidated at Stamford, Conn., and the manufacture of piano hardware was added. At the same time Treacy commenced the manufacture of pianos in New York, of which branch he became the sole owner in 1906. Meeting with great success in his piano enterprise, to which he soon added player-pianos, Daniel F. Treacy organized in 1912 the Carter Piano Company, and is now manufacturing besides the Davenport-Treacy, also the Carter piano and player-piano.

Treacy has served the public as a member of the Board of Education of Jersey City for many years and also as tax-assessor. For the past fifteen years he has been foreman of the Grand Jury of New York County, before whom the celebrated life insurance and corporation cases were discussed. For eight years he was one of the Board of Governors of the Catholic Club of

New York and is a prominent member of the Knights of Columbus. A versatile writer, he has contributed largely to the *American Machinist* on foundry practice. Among his writings are essays on the use of coke in smelting iron and on other subjects appertaining to the foundry business.

DECKER AND SON*, New York, N. Y.

Frank C. Decker, born at Albany, in 1857, came with his father to New York in 1859. After attending public school, he served an apprenticeship under his father's tutelage and was admitted to partnership in 1878, and upon Myron A. Decker's death in 1891 he took over the business. Loyally continuing the policy upon which his father had founded the business, Frank C. Decker pursues conservative business methods, always sustaining the high reputation won for his pianos.

He has been honored by his brother manufacturers by being made president of the New York Piano Manufacturers' Association, in 1907–08, and finally president of the National Association of Piano Makers, in 1909–10.

His son, Frank C. Decker, Jr., born in New York, in 1889, graduated from business college at the age of seventeen, and took a regular course of piano making under his father's guidance.

Young Decker is rather exceptionally gifted in the use of tools, as illustrated by the fact that after working only one year at the bench, he designed and built a miniature upright piano only two feet square, a perfect replica of the regular Decker and Son upright piano.

The business of Decker and Son was incorporated in 1909, and Frank C. Decker, Jr., was elected secretary of the corporation in 1910.

JACOB DOLL AND SONS, New York, N. Y.

Among the men in the piano trade who carved their success unaided and by the force of sheer determination, Jacob Doll stands pre-eminent. Born at Rohrbach, in the Grand Duchy of Baden, Germany, in 1849, Doll left the fatherland just as soon

*Vol. I, p. 317.

as he had gone through the public schools, arriving in New York at the age of fourteen. He found employment in a wood-working establishment, the main business of which was to prepare lumber for piano manufacturers.

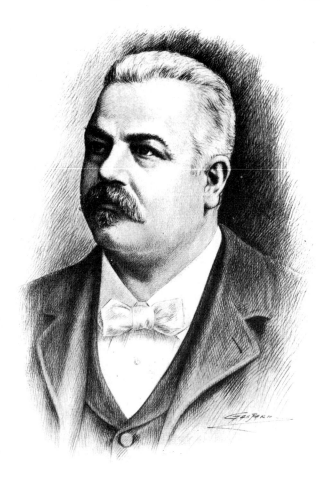

The author became acquainted with Doll in 1869, while manu-facturing portable music stands. Doll was then driving a delivery wagon for the mill in which the lumber for these music stands was prepared. Although he had not yet reached the age of twenty, Doll was even at that time planning to start in business on his own ac-count. A hard worker, by nature economical without being penur-ious, he accumulated sufficient money to start a planing mill of his own in 1871. His patronage came almost entirely from piano manufacturers, and consequently Doll had a splendid oppor-tunity to get well acquainted with the ins and outs of the piano business at that time.

Progressive and ambitious, he began in 1875 the manu-facture of entire piano cases, adding to this business also the

making of covered strings. By 1884 he had so thoroughly picked up and studied all phases of piano making that he felt encouraged to start a piano factory. The much broader field which he found for his activity developed all the latent forces in Doll's remarkably forceful nature. Adopting new methods of manufacturing as well as in selling pianos, he met with most substantial success, and when one after the other of his five sons entered the business and became his assistants, his operations assumed dimensions which in the course of time made the firm of Jacob Doll and Sons one of the leading factors in the piano industry of the United States.

Wrapped up in his business affairs to the extent of excluding any ambitions for prominence in public life, Jacob Doll was also intensely devoted to his family, providing for his five boys all the opportunities of a higher education, and likewise watching with loving care and a free hand the development of his five daughters. He died on November 13, 1911, leaving a fortune of over two millions to his family. The great business founded and built up by him is successfully carried on by his sons, every one of whom has been trained by his father as a practical piano maker.

In 1904 the business was turned into a close corporation, and the eldest son, OTTO DOLL, was elected vice-president, and since his father's death is acting president. GEORGE DOLL is the treasurer of the company with JACOB DOLL, JR., as his assistant, who is also the general superintendent of the factories, while FREDERICK DOLL has the management of their nine retail stores, assisted by the youngest son, CHARLES DOLL, who joined his brothers in 1910 and was elected secretary in 1911.

Jacob Doll and Sons have been among the pioneers in the manufacturing of player pianos and have always made a specialty of coin-operated electric pianos. The continued success of the concern is a telling illustration of the great results which can be accomplished by harmonious team-work.

F ENGELHARDT AND SONS*, St. Johnsville, N. Y.
 It is said that the exception proves the rule and it is usually
accepted as a rule that the sons do not follow in the footsteps
of their fathers, and that they scarcely ever agree with him on
business policies. The relations existing between Frederick
Engelhardt and his two sons are such as to call for congratulation
for the father and admiration for the sons, who willingly accept
their father's lead, invariably subordinating their own notions
and ideas to the matured judgment of the head of the firm.

A. D. ALFRED DOLGE ENGELHARDT was born in Dolgeville, N. Y.,
Engelhardt on December 14, 1881. At the age of eighteen he began to study
the making of piano actions, but soon found the complicated
mechanism of the electric player piano much more interesting,
and chose the construction of player pianos for his special study.

*Vol. I, pp. 378-79.

His brother, WALTER LUDWIG ENGELHARDT, born in New York, in 1884, entered his father's factory at the age of eighteen, and became likewise an expert in player piano construction. The great advantage of practical and technical knowledge of this comparatively new industry by both young men, backed up by the business prudence and experience of their father is the key to the great success which the firm has achieved.

W. L.
Engelhardt

Among the pioneer makers of coin-operated, electrical, self-playing pianos, F. Engelhardt and Sons have earned a world-wide reputation for their products. With the laudable ambition to out-do one another in creating something new, or to improve the old, the members of this firm have introduced perhaps more novelties in their particular line than any other house. Starting with the simple automatic player, having one music-roll, they are now building fourteen different models, among them being the "Peerless Orchestrion" with an entire keyboard of eighty-eight notes equipped with re-wind music drawer mechanism holding perforated rolls containing fifteen selections. The instrument is furthermore provided with thirty-two wood-pipes to produce either violin or flute effects, bass and snare drums, cymbal and triangle, tympani and crash cymbal effects, sets of castanets, and solo mandolin. All of these orchestra effects are produced automatically and correctly, direct from the perforated roll, true to the composer's interpretation.

Orchestrion

The factories of the concern, located at St. Johnsville, N. Y., are of the most modern construction, and are in charge of Walter L. Engelhardt, while Alfred D. Engelhardt attends to the business end of the enterprise, under the guidance of their father.

At the great Expositions at Buffalo, 1901, St. Louis, 1904, Portland, 1906, Jamestown, 1907, and Seattle, 1909, their player-pianos and orchestrions received invariably the highest award for excellency.

Expositions

Manufacturing an exceptionally good article, Engelhardt and Sons fully understand the value of proper publicity, and have always shown exceedingly good taste and ingenuity in presenting their claims for patronage to the piano-buying public.

<div style="float:left">John Anderson</div>

EVERETT PIANO COMPANY*, Boston, Mass.
The world of art owes most, perhaps, to men who were totally unconscious of the talents which they possessed and who in their sublime unconsciousness would pursue the search for the beautiful in nature as well as in their every day life. This desire reacts as an unconscious motive power in the selection of the calling to which they finally devote their lives.

JOHN ANDERSON, by his own initiative, secured a position at the age of twelve in the Royal Gardens of Stockholm under the personal guidance of the Director, doing "chores." He filled his soul with the beauties of the flowers, shrubs, and foliage, all of it unconsciously, but nevertheless impressively. He stored up these impressions, so to speak, to call them forth in later years for utilization in his artistic work.

Instinctively feeling an ability to create and build, he engaged at the age of fourteen as apprentice to Knut Egberg, cabinet-maker to the Court of Sweden. In that celebrated workshop Anderson found ample opportunity to feast his eye and mind on artistic productions in wood, and he profited thereby to such an extent that at the end of his five-year apprenticeship he was honored with the highest prize (a large silver medal) from the Society of Mechanics of Stockholm for his accomplishments.

It was not the ordinary "Wanderlust" which made him leave Stockholm in 1880, but rather the desire to study the art of cabinet-making and to come in contact with the living masters of the art. After remaining at Copenhagen for a time, he went to Berlin, and while there was agreeably surprised by receiving from the Swedish Chamber of Commerce (a quasi government institution) a stipendium of 500 crowns, in recognition of his

*Vol. I, pp. 337-338.

John Anderson

demonstrated ability. This stipendium is awarded only once a year to that journeyman of every trade in the Kingdom of Sweden who has shown the greatest efficiency, and is given for the purpose of enabling him to travel in foreign countries in order to widen his knowledge and experiences.

Travels

After a stay of eleven months in Berlin, Anderson worked in the leading art cabinet shops of Vienna, Munich, Zurich, and Paris, in which latter city he remained fourteen months. Stopping four months in London, he returned in 1883 to Stockholm. In his European travels he devoted himself entirely to the study of art furniture, developing into a master designer, as well as master builder. In 1884 he landed in New York. He found lucrative employment in leading cabinet shops and was soon called upon to make his first designs of art piano cases. He did not know that he was as much of a born musician as he was a designer, and yet after designing these piano cases he could not resist the desire of learning to put the soul into them, and consequently he engaged with Decker Brothers and later on with Albert Weber and Steinway and Sons, in order to become efficient in the various branches of piano building.

A new world dawned upon him when he heard piano makers discuss tone and tone qualities. He had fully taken in the beautiful forms and colors of flowers, become intoxicated with their aroma, and feasted his eyes and mind on the beautiful forms of artistic furniture, classic and decorative architecture, but the world of tone had been an unknown realm to him, although it was fully as strong in his soul as the knowledge, inspiration and appreciation for the beautiful in its various other forms and phases. To quote from one of his letters to the author: "I had long ago formed an idea for the beautiful in life, and although neither musician nor singer, also for the beautiful in sound. The roar of the ocean, the whisper of the leaves, the murmur of the brook, the mighty sound of storm in the woods, always had a charm for me, but when I heard men discuss piano

tone, at first I hardly knew much about it. But as time went on it became perfectly clear to me that tone, color, shade and light in a beautiful painting, the delicate molding in a statue, and the harmony produced by perfect piano tones are practically the same thing, for the reason that the whole must result in a harmonious perfection."

Anderson began to delve into the mysteries of acoustics, trying to find laws which would govern the production of tone in pianos, but soon found that he had to rely entirely upon his own creative ability. He drew his first piano scale in 1888 and embodied it in the Shaw piano formerly built at Erie, Pa. It was an upright piano of conventional form, but the tonal qualities were such as to attract the attention of piano students.

In 1892 he was invited, together with his brother Gustav, to start a piano factory at Rockford, Ill., but this enterprise was never consummated on account of the panic of 1893. Anderson followed a call from Minneapolis, in 1894, to build the Anderson piano for the Century Piano Company of that city. He remained there for five years, making his influence felt to such a degree that the Everett Piano Company of Boston made him a most tempting offer to take charge of their factories on January 1, 1899, and build for them the best piano which talent and money could produce. It was rather characteristic of Anderson that he accepted that position only after he was assured of permission to spend a large amount of money in remodeling the factory and promised positive control and freedom in the management of the same. He rearranged the entire factory system, adding a department for the manufacture of actions and hammers, not for economy's sake, but on the contrary, in order that, regardless of cost, he might have every part of the pianos he was going to make strictly in accordance with his own ideas, which differed materially, of course, from the conventional.

A keen observer, philosopher, independent thinker, and born artist, it is but natural that Anderson would not follow in the beaten track but strike out on paths of his own. His love

John Anderson's Scale of Everett Grand Piano

for the beautiful controlled his work, and a glance at the scale of the Everett concert grand piano designed by Anderson reveals in its easy flowing lines his genius for having the beautiful dominant even in a construction where apparently mechanical considerations seem to be paramount. A closer study of this

Everett
Concert
Grand
Piano

grand piano scale shows, however, even in the mechanical part, great originality. The masterly construction of having only two cross-bars at the striking point of the hammers assures such an evenness of the entire scale as is always sought for by advanced constructors and designers.

Anderson has learned to see the color of tone with his mental eye, just as he drank in the colors of the flowers when as a boy he worked in the king's garden at Stockholm, and with that gift he succeeded in designing scales and constructing pianos which produce a pure, rich, noble, brilliant, yet sweet tone, and withal so powerful that artists of the modern school, such as Gabrilowitsch, Teresa Carreno, and Dr. Otto Neitzel are warm in their praise of the Everett piano for concert work; and that great virtuoso, Alfred Reisenauer, known for his dynamic assaults upon the piano keyboard, crowns all the encomiums of his contemporaries by pronouncing the Everett concert grand piano "tadellos." What greater appreciation could any one desire?

Reviewing Anderson's career, it appears to be almost an ideal logical development of a highly esthetic nature. Drinking as a boy at the fountain of Nature's mysteries, learning to shape wood into artistic forms, and finally reaching the realm of tone, John Anderson developed into a master builder of pianos. He can not only draw the design of impressive art piano cases, as shown in the Sheridan Art Grand created by him (which has been given a place of honor in Volume I of "Pianos and their Makers"), but what is more, he can build with his own hands such an art case and put into it the mechanism of his own design to produce the tone which he has given to the instrument in its scale.

He is so thoroughly a master of his art that he prefers to teach personally every man whom he employs to assist in the building of Everett pianos and thus stamps his individuality upon every piano sent out from the Boston factory. His work carries with it poise and strength sufficient unto itself.

Jesse French

H. Edgar French *Jesse French Jr.*

grand piano scale shows, however, even in the mechanical part, great originality. The masterly construction of having only two cross-bars at the striking point of the hammers assures such an evenness of the entire scale as is always sought for by advanced constructors and designers.

Anderson has learned to see the color of tone with his mental eye, just as he drank in the colors of the flowers when as a boy he worked in the king's garden at Stockholm, and with that gift he succeeded in designing scales and constructing pianos which produce a pure, rich, noble, brilliant, yet sweet tone, and withal so powerful that artists of the modern school, such as Gabrilowitsch, Teresa Carreno, and Dr. Otto Neitzel are warm in their praise of the Everett piano for concert work; and that great virtuoso, Alfred Reisenauer, known for his dynamic assaults upon the piano keyboard, crowns all the encomiums of his contemporaries by pronouncing the Everett concert grand piano "tadellos." What greater appreciation could any one desire?

Reviewing Anderson's career, it appears to be almost an ideal logical development of a highly esthetic nature. Drinking as a boy at the fountain of Nature's mysteries, learning to shape wood into artistic forms, and finally reaching the realm of tone, John Anderson developed into a master builder of pianos. He can not only draw the design of impressive art piano cases, as shown in the Sheridan Art Grand created by him (which has been given a place of honor in Volume I of "Pianos and their Makers"), but what is more, he can build with his own hands such an art case and put into it the mechanism of his own design to produce the tone which he has given to the instrument in its scale.

He is so thoroughly a master of his art that he prefers to teach personally every man whom he employs to assist in the building of Everett pianos and thus stamps his individuality upon every piano sent out from the Boston factory. His work carries with it poise and strength sufficient unto itself.

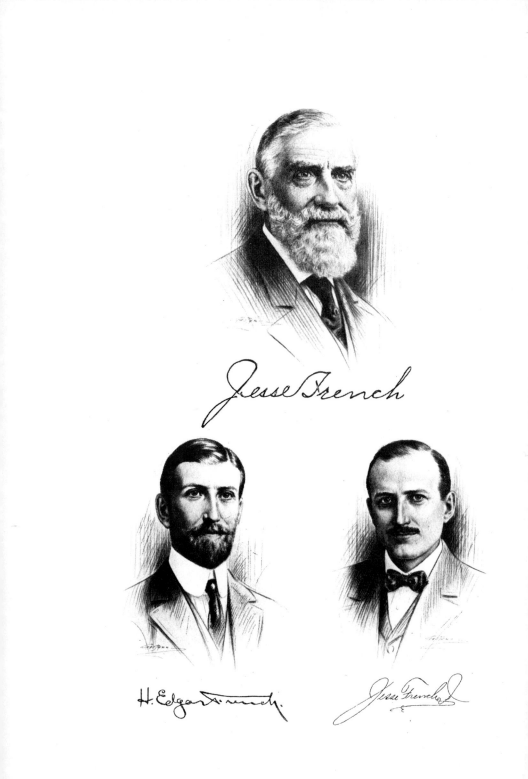

Jesse French

H. Edgar French

Jesse French Jr.

J ESSE FRENCH AND SONS PIANO COMPANY*, New Castle, Ind.

When a man is asked for a brief autobiography and he starts in by writing a page or two of all known endearing and laudatory terms in the vocabulary of filial love to his mother, it is safe to conclude that such a biography depicts the life of a strong and good man.

JESSE FRENCH, SR., comes from good old English stock. His forefathers were closely related to nobility and were most influential in their borough. His father's sister was quite a literary genius and had the proud distinction of being the first woman in England to petition Parliament to grant woman's suffrage. So much for the father's side. When referring to his mother, French writes the following: "Words would fail me to write a eulogy of mother, as I think she was one of the grandest characters I ever knew, of fine physique, ever bright and cheerful, kind and generous to a fault, much of her life was given to helping the poor and afflicted. Very fond of poetry, she was never at a loss to recite some beautiful lines to comfort and cheer the sorrowing. An accomplished singer (just as father was) I cannot forget the hallowed influence upon us children of the songs they had so often sung together at the close of day. . . ."

This quotation seems to be sufficient to characterize Jesse French, but we deal here with his activity and influence upon the piano industry. It is not to be wondered at that he is quite a clever rhymester, undoubtedly having inherited the poetic strain from his mother. We find in one of his poems the following lines:

"In striving to do the best he can,
The boy develops into the man."

Jesse French is a boy today, because he is still striving. He has always done so every day of his busy life. His father came to America about 1820 and in the course of time took the oath of allegiance as a citizen of the United States. After remaining

*Vol. I, p. 358.

a number of years, he returned to England to marry the sweetheart of his youth, and in 1848 came back to the United States to make his home in the new country. Jesse was two years of age when he arrived with his father in America. After leaving school, intending to follow the calling of his father, he started as a printer's devil, and worked himself up to the position of chief clerk in a printing office. Between times he served as route carrier and mail clerk.

When the Civil War broke out, young Jesse took a position in the United States post office at his home town, Nashville, Tenn. It was during this period that he had to show what stuff he was made of. His father and mother being compelled to go to England to settle an inheritance, left young Jesse in charge of the home and family. The hard times brought upon the country by the Civil War and especially upon the Southern States, forced the young man oftentimes to most heroic efforts to keep the wolf from the door, and many an interesting episode could be related as to how French manipulated to fill up the empty larder and provide the necessaries for his two sisters and younger brother, because money could not buy them.

Being zealous to do his full duty and more, the taxing work in the post office during those stormy days finally told upon the young man's health. Having saved up some money, he went to Peoria, Ill., taking a business and law course at the college there. He made such good use of his time at college that upon his return to Nashville, he was appointed Assistant Secretary of State of Tennessee. He served in that capacity for five years. His faithful services and the ability displayed in his work in the State Department, prompted his friends to urge him to become a candidate for the office of Secretary of State, rather a bold undertaking at that time for a Union man in a southern community. French lost the election by just one vote, which fact demonstrated his great popularity and the faith which his fellow citizens had in him. Although momentarily chagrined

over the defeat, he has ever since been thankful for this apparent set-back. On January 2, 1872, he had married Callie Lumsden, who as a good wife and mother was naturally averse to seeing her husband tossed about in the stormy sea of politics. Aside from that, French was by nature and character more of a doer and leader than one who could bend his back easily to the command of others, consequently he struck out for himself as a business man. His first venture was to buy out the sheet-music and small goods department of Dorman and Holmes, of Nash-ville, in 1873. In this move he was undoubtedly influenced by his musical proclivities. Three years later he was persuaded to take a one-third interest in the new firm of Dorman, French and Smith, who sold mainly the Bradbury piano, made by their partner, F. G. Smith. Buying out Smith's interest after a short while, the firm was changed to Dorman and French, and Dorman retiring a year later, French took entire control.

Dorman and Holmes

F. G. Smith

Thrown absolutely upon his own resources, with but scant means at his command, French had either to demonstrate unusual ability, energy and faith in himself, or fail. The word "fail" is not in the French vocabulary. He went on and on and became one of those path-breakers in piano merchandizing who started chains of stores directed from headquarters. He covered the Southern States thoroughly, and found it expedient to organize, in 1885, the Jesse French Piano and Organ Company, with a capital of $500,000. Pretty good work for one man who had started twelve years ago with a capital of hardly $3000!

Jesse French Piano and Organ Co.

Jesse French had worked himself up to being one of the most commanding figures of the piano trade. It was but logical that he should drift into piano manufacturing. In 1902 the Krell-French Piano Company was incorporated, with a capital of $550,000. Jesse French accepted the duties of vice-president of the corporation and in 1905 assumed the entire management as president.

Krell-French Piano Co.

With all this activity in the piano business French found time to be one of the organizers of the Union Trust Company and the Liberty Mills of Nashville, Tenn., and when he transferred his headquarters to St. Louis, Mo., he became a director in the Missouri-Lincoln Trust Company, having a capital and surplus of over $13,000,000. He likewise became a director of the Lincoln Trust and Title Company, of St. Louis, besides being active president of the Mercantile Metal Milling Company, a corporation capitalized at $400,000.

Whoever can appreciate what such an activity means in wear and tear on the nervous system will look for some source from which he could permanently draw the necessary inspiration. Jesse French found rest, recreation and inspiration in the ideal home life provided for him by his excellent wife, the mother of his three sons, whose very existence is wrapped up in the endeavor to make the home restful for her active husband, and who has succeeded in bringing up her boys to be most useful members of society. She implanted the love for music in her sons when they were still quite young, and whoever had the good fortune to be admitted to the French family circle will remember with pleasure the delightful evenings when Mrs. French would preside at the piano, young Jesse accompanying her with his cornet, her son Horace with the violin, and the oldest son, John, with his flute, playing quartets, generally of a classical character.

It is no wonder that boys brought up in such an atmosphere would naturally be inclined to follow in their father's footsteps, and we find HORACE EDGAR FRENCH, after leaving Warden's College, at Nashville, busily engaged in his father's music stores at Nashville and St. Louis. After spending some time at the Starr piano factory to learn piano construction, H. Edgar spent about one year as piano salesman on the road, returning to Nashville to take charge of the management of the Nashville store, and acted as secretary of the Jesse French Piano and

H. Edgar
French

Organ Company until 1903, when he was elected treasurer of the Krell-French Piano Company. When that corporation was changed to the Jesse French and Sons Piano Company, he became vice-president of the corporation and president of the French and Sons Piano Company, of Springfield, Ill. As a director, he is one of the most active members of the Commercial Club of New Castle, Ind., a city which has increased in population from 3,000 to 12,000 since the French piano factory has been established there.

Of genial disposition, fair and just in all his dealings, possessing a remarkably retentive memory, and familiar with all the details of piano construction, H. Edgar French is eminently fitted for the position which he occupies.

His brother JESSE FRENCH, JR., studied at the Wallace University of Tennessee and graduated from the St. Louis Business College at the age of nineteen, when he entered the employ of his father at St. Louis. He soon showed unusual ability as a salesman, in which capacity his musical ability is of great assistance, and having had thorough training in office work as well, he is filling the offices of secretary and treasurer and sales manager for the Jesse French and Sons Piano Company with ability and discretion.

Jesse
French, Jr.

The diversified experience which the father and sons have acquired in the course of years naturally enabled them to not only erect factories most particularly fitted for the production of high-grade pianos, but more especially to train and surround themselves with artisans who could produce pianos worthy of bearing the name of Jesse French, a name which has for over forty years stood for the highest and best in pianodom. In short, the Jesse French and Sons pianos are the embodiment of all that progressive piano construction, ample capital and modern manufacturing methods can produce.

GRAM-RICHTSTEIG PIANO COMPANY*, Milwaukee, Wis.

Since the days of Benjamin Franklin the printing press has

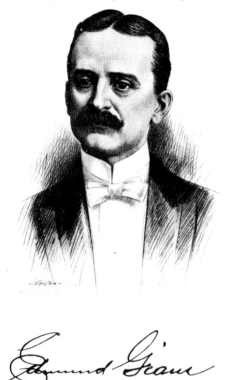

Edmund
Gram

exercised an irresistible attraction upon all wide-awake boys. They all play with it for a while. Some stay with it to try out their own staying qualities, and for a few it is the stepping stone to future success.

EDMUND GRAM, born of German parents at Buffalo, in 1863, played with a toy printing press, made some money with it and bought a larger one, and then another, until he had a fairly well equipped printing shop in the basement of his father's house, while still wearing knickerbockers. The profits from his printing presses helped to pay for music lessons. He studied piano and organ and at the age of fifteen occupied the bench as organist in one of Milwaukee's churches, a position which he held for twenty-five years.

School years over, Gram wanted to become a musician. He loved music and had demonstrated talent in that direction. His clear-headed father, however, did not approve of it. He had observed that with all his sentimental love for music, the boy had shown with his printing press that he was eminently practical, and it was decreed that he should choose a more profitable career, such as that of a lawyer or doctor. To pay for his college course and devote his whole time to study, Gram sold his printing shop at a good price and tried his best to become on

*Vol. I, p. 362.

good terms with the exact sciences as taught at college. He stood as well in his classes as any student, but the dry doctrines did not still his longing for soul-stirring music, nor satisfy his desire for exciting activity. He continued to play the organ, improved his piano playing, studied counterpoint and harmony, and not quite satisfied with all of that, took an evening course in the Spencerian Business College.

Graduating from the Milwaukee Academy at the age of seventeen, he accepted the position of bill clerk and assistant bookkeeper in a wholesale crockery house. When he advanced to the position of head bookeeper, he took a course of study in banking and law; but all of that did not quite fill up the hours of his busy days and he accepted the duties of conductor of the celebrated Lyra Male Chorus of Milwaukee.

Bookkeeping became too wearisome for active Gram and we find him, in 1883, established in the piano and music business on one of Milwaukee's business thoroughfares. A man of high principles and ideals, Gram soon made his name a synonym of integrity in the business world. He aimed to sell only the very best pianos the market offered, and became the representative for houses like Steinway and Sons, The Aeolian Company, Everett Piano Company, etc.

For years it had been his ambition to build a piano of his own. He formed a partnership with Max Richtsteig, and when he celebrated the twenty-fifth anniversary of the establishing of his own business, the first piano made in the Gram-Richtsteig piano factory had the place of prominence in the show window of the five-story business block on Grand avenue, which Gram had erected and occupied for twenty-five years. On May 1, 1912, he purchased a large property on Milwaukee street and erected thereon a palatial music store which ranks among the finest in the country.

Gram-Richtsteig Piano

As one of the most competent men in that sphere, Gram is often called upon to take part or to assume the management of

Milwaukee's music festivals and affairs. For five consecutive seasons he managed the concerts of the Theodore Thomas Orchestra in Milwaukee. He is treasurer of the Merchants' and Manufacturers' Association and a member of the Advisory Board of the National Piano Merchants' Association, acting also as State Commissioner of Wisconsin.

In the very prime of life, with a most enviable record behind him, Gram's future is full of promise. His career must serve as a stimulus to ambitious young men. Gifted with unusual talents, Gram made the best of them by steady and earnest devotion to study and work, working the harder when obstacles had to be overcome. Success has acted on him only as a call for greater exertion, to reach higher ideals. Possessing a most lovable personality, he consistently lives up to his maxim to make every day a better day for others as well as for himself.

Max Richtsteig

It is claimed that a contented man is a happy man—but it is a fact that the world is moved on its onward progress only by such men as are incapable of self-contentment. It is the restless dreamer, the enthusiast, who defies fate and destiny to accomplish his aim, without regard to his own ease or comfort. One of these ever unsatisfied men we find in MAX RICHTSTEIG. Born at Berlin, Germany, in 1869, he had the benefit of that thorough training for which the schools of Germany are renowned. After passing through the grammar and manual training schools, he continued his studies of the higher branches at the evening and Sunday school, where he acquired all the knowledge of mathematics, drafting, etc., necessary to become a competent piano constructor.

Under the personal tutelage of the well-known piano maker Eduard Werner, of Berlin, Richtsteig mastered in the course of time all the details of piano making. Competent to earn his own living, he came to America in 1888 and engaged with Bush and Gerts, of Chicago. In order to perfect himself more particularly in the art of scale drawing, he bided his time to get an

Max Richtsteig

opportunity to study under Henry Kroeger of Steinway fame. He remained at Kroeger's factory in New York for one year, when he was induced to assume the foremanship in the finishing department of his old employers, Bush and Gerts, of Chicago.

In 1898 he accepted the position as designer and constructor for the Starr Piano Company, of Richmond, Ind., where he designed scales for upright and grand pianos, including a concert grand. Eminently successful in these efforts, he became desirous of starting in business for himself. Opening business at Milwaukee, in 1905, he experienced all the trials and tribulations of the beginner, until he found in Edmund Gram a man congenial to him, filled with his own ideals, and possessed of the same ambition to build a piano of the highest order.

Gram-
Richsteig
Co.

Under the name of Gram-Richtsteig Company a partnership was formed in October, 1908. By the close of 1908 fifty pianos had been disposed of; the year 1909 closed with sales of two hundred fifty pianos, which number was doubled in 1910 and again doubled in 1911, so that larger manufacturing facilities had to be provided for.

Richtsteig did not aim for a sky-rocket success; he knew that he had to train and educate men to build the artistic piano which he had designed. Deft handling of tools is not sufficient to make artistic pianos; the men must know the why and wherefore. To train his men properly, Richtsteig started

Technical
School

the first technical school for piano makers in America, at his factory, in 1908. The proposition was accepted with enthusiasm by the young men in his employ. Only men who had practical experience in piano building were admitted. The tuition was free, Richtsteig devoting his evenings to teaching his men the fundamental laws of piano construction.

He soon had a sufficient force of thoroughly educated artisans, which enabled him to increase the output of his factory to keep pace with the ever-growing demand. The superior qualities of the Gram-Richtsteig piano were quickly recognized

by the trade and the instrument was accepted as one of the leaders.

The thorough piano maker, Richtsteig, had succeeded in constructing a piano comprising all that modern methods suggest, and had embodied in it many original ideas which enhanced the durability and reliability of the same, yet he was not contented. He knew that all piano manufacturers were

Max Richtsteig Technical School for Piano Construction.

laboring under the difficulties presented by the delicate adjustment of the action parts, which would easily get out of alignment, because of the continual change in the atmosphere from dry to wet, and vice versa. F. C. Billings, a piano tuner, had invented a metal flange in place of the commonly used wooden flange, and furthermore a metal frame with steel angle rails to prevent the usual warping and twisting of the ordinary wooden rail. Richtsteig took up these inventions and commenced to put them to most severe tests, improving the construction and application until he was satisfied that with these improvements the obnoxious warping of rails or loosening of flanges would be

Steel Angle
Rail Action
Frame

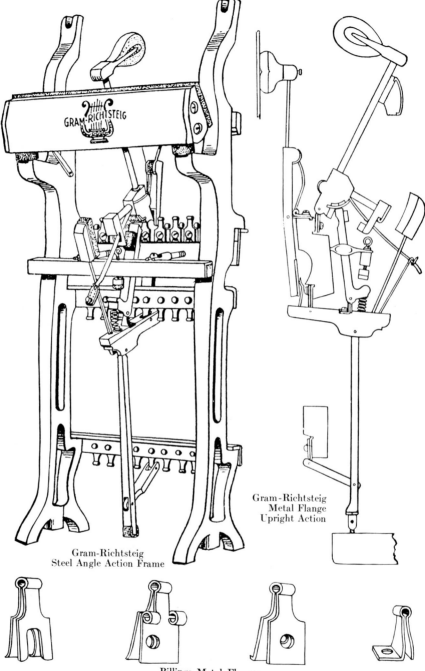

Gram-Richtsteig
Steel Angle Action Frame

Gram-Richtsteig
Metal Flange
Upright Action

Billings Metal Flanges

a fault of the past. The use of these metal frame actions with brass flanges in the Gram-Richtsteig piano was hailed with enthusiasm by piano dealers and attracted the attention of piano makers to such an extent that a corporation, with Max Richtsteig as president, has been formed to manufacture these patented metal actions for the piano trade at large, under the name of Gram-Richtsteig Metal Frame Action Company.

GRINNELL BROTHERS*, Detroit, Mich.

Just as it is almost necessary in order to become a good piano-maker to go first through the school of cabinet-making, so we find that many of the leading piano merchants who have made their mark graduated from the school of selling sewing machines or books.

IRA L. GRINNELL invested sixty dollars in six hand sewing machines in the year 1869 and sold them at retail for eighteen dollars apiece. Today he is president of a corporation doing a business of over three million dollars per annum in pianos and musical merchandise, under the name of Grinnell Brothers. Raised on a farm in New York State, Grinnell went west to grow up with the country. He did not know that he would grow faster than the country. Leaving the farm for the more remunerative field of commerce, he became a most successful dealer in sewing machines, adding bicycles during the halcyon days of that now almost discarded useful vehicle. Seeking larger fields to conquer, he began in 1882 to deal in organs, pianos, and musical merchandise. He associated with himself his brother, Clayton A. Grinnell, and the firm of Grinnell Brothers, commanding a capital of $10,000, was launched in the city of Detroit. The brothers were not satisfied to grow up with the country. With Napoleonic vision, they surveyed the field and concluded to take whatever was worth having of the piano and music business of all the country within reasonable reach of the city of Detroit. A chain of retail stores was established throughout the state of Michigan and the province of Ontario, and it is

Ira L
Grinnell

*Vol. I, pp. 362, 410.

now generally conceded that Grinnell Brothers are the largest distributors of musical instruments and merchandise in the northwestern part of the United States, acting as representatives of the most illustrious names among piano manufacturers of the east. Their laudable ambition to place a piano of their own make on the market was realized in 1903 with sufficient success as to warrant the establishing of factories at Detroit, Michigan, and Windsor, Canada. To sell at retail over three million dollars worth of pianos and musical merchandise requires an organization of the highest order.

Ira L. Grinnell is not only an indefatigable worker and exceptionally shrewd business man, but primarily a great organizer. An excellent judge of men, he has always been as willing to pay for ability in his men as to pay for quality in goods, and has consequently attached to the concern the ablest men who could be found, in whom he fostered a sense of loyalty by demonstrating his loyalty to them. To give their trusted employees an opportunity to become financially interested so as to participate in the profits realized, the firm was changed into a corporation in July, 1912. The authorized capital is $3,750,000. Several of the employees have become stockholders and three of them are officers of the corporation. Ira L. Grinnell, as president, retains the general management of the corporation, assisted by his brother, Clayton A. Grinnell, who acts as first vice-president.

C. A.
Grinnell

CLAYTON A. GRINNELL is to the outside world the best known member of the corporation. He has ever been active in promoting the interests of the fraternity of piano dealers, which has been appreciated by his being elected president of the National Association of Piano Dealers of America.

A. A. Grinnell acts as second vice-president. C. J. Nyer entered the employ of Grinnell Brothers some twenty-five years ago as a boy and by sheer industry and ability has worked

his way up so that he now is acting treasurer of the great corporation.

S. E. Clark, like Grinnell, started in the sewing machine business, drifted naturally from that into the piano business, and with considerable success represented leading houses such as Steinway and Sons, in Detroit. In 1902 he entered into a combination with Grinnell Brothers, assuming the management of their branch stores. At that time the firm of Grinnell Brothers had six branch stores, which number has now grown to twenty-four under the management of Mr. Clark.

HADDORFF PIANO COMPANY*, Rockford, Ill.

The drawing of a scale for a piano is similar to the painting of a picture. Before drawing his lines on the paper or canvas, the artist has thought out and sees before his mental eye the entire scheme, even to the delicate shades of the coloring. The creative genius sets to work first and technique follows in the carrying out of the ideas and conceptions of the genius. This is true in painting, architecture, sculpture, music and poetry.

The man who designs a scale for a piano must have the technique of piano building at his fingers' ends; he must have a well-attuned ear; but above all, he must be capable of hearing mentally that tone, that peculiar tone quality, which his artistic nature desires to produce.

Many talented artists have painted horses on canvas, but there is only one Rosa Bonheur; many have depicted battle scenes, but there is only one Meissonier. Thousands of piano scales have been drawn, and but few have survived. Genius does not accept the conventional, but creates, always original, often revolutionary and path-breaking.

Alongside of Bonheur and Meissonier, we admire Millet's autobiographies, admire them for their soothing portraiture of tranquillity and simplicity. In the world of tone we are aroused by the soul-stirring rhapsodies of Liszt, enchanted by Wagner's

*Vol. I, p. 362.

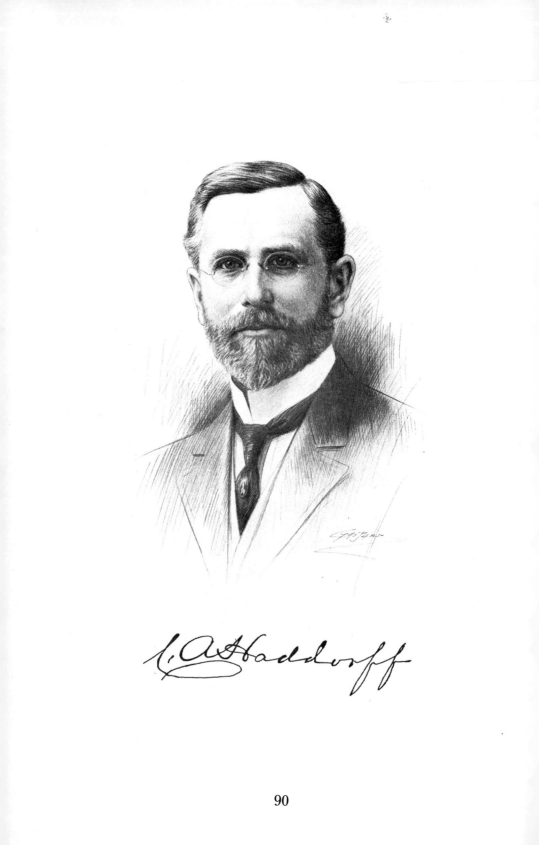

endless melodies, and we dream with Beethoven's Sonata Pathetique.

To respond to the various demands made in order to interpret the tone pictures of the composers, a piano must be designed by an artist capable of comprehending the genius of the composer. As in all branches of art, so are there among the piano designers Bonheurs, Meissoniers and Millets. Millet was a son of Normandy, where people get their sustenance from the soil and the ocean. They are poor, and those among them who are gifted with a greater intellect than the average can only dream of the greater life composed of creative activity.

CHARLES A. HADDORFF was born on a farm near Norrkoping, Sweden, on February 2, 1864. He began early to dream. Farm life was too monotonous for him. School years over, he was apprenticed to a cabinet maker, rather a prosaic employment for a young fellow, and so he continued to dream in music.

Working at the bench during the day time, Haddorff practiced piano playing and studied harmony evenings. His devotion to duty and music was so intense that he finally undermined his health and a change of climate seemed necessary. He had learnt to build pianos, and came to America in 1892, securing a position with one of the past-masters of the art, where he had a splendid opportunity to study progressive piano construction and piano making.

Six years later he was called to the superintendency of a western piano factory. The opportunity had come for Haddorff to vitalize ideas of his own. His work attracted the attention of that great organizer, P. A. Peterson, of Rockford, Ill., and on January 28, 1902, the Haddorff Piano Company began business. Backed by ample capital, Haddorff was given carte blanche to build as good a piano as he knew how. A good factory manager, his greatest strength manifested itself soon as an artist in designing and constructing.

Chas. A. Haddorff

Profiting by reading and thoroughly digesting the works of Helmholtz, Tyndall, and other scientists and theoretical acousticians, he studied Siegfried Hansing with the greatest care, especially in regard to sound board construction according to applicable scientific laws and practical observations known at this time. Extremely quiet in demeanor and modest of character, it was not in Haddorff to seek mainly for volume of tone; he cared not for noise. His aim was to produce a pure, sweet tone of sustaining quality, a soothing, restful tone similar to a Millet picture. After years and years of patient study and

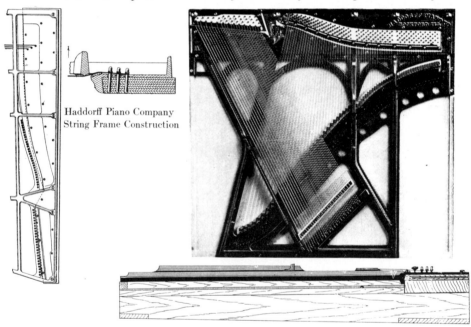

Haddorff Piano Company
String Frame Construction

Haddorff Patent Wrest Plank Shoulder

Sound
Board
Construction

work, interspersed with the usual disappointments, Haddorff succeeded admirably in his endeavors, and his latest grand and upright pianos are a revelation to connoisseurs of quality of piano tone and tone color. His scales reveal the exactness of the painstaking artist in general design, are pleasing to the eye, correctly drawn, and avoid all and any bizarre notions. It is, however, in the construction of his sound board, in the thoughtful

placing of bridges and bars in relation to their influence on the tonal quality, where we admire the earnest student Haddorff most. He had sketched his picture in drawing the scale, and now uses his palette in working out his sound board construction to bring into full light the beauty and strength of his scale conception. Very properly he has named his creation the "Homo Vibrating Sound Board." The extra heavy string plate is so constructed as to give to the sound board the utmost freedom of vibration over the greatest possible area, and his sound board does reflect the full tone of each vibrating string throughout the scale.

Aside from his efforts in scientific-artistic piano building, Haddorff has also contributed a valuable improvement to the strict constructional development of the piano, by designing a string plate, with a shoulder resting against the pin block, for which patents have been granted to him in 1903 and 1912.

The Haddorff Piano Company has been eminently successful. Employing a capital of over one million dollars and pursuing under the able management of its secretary, A. E. Johnson, a liberal and aggressive policy, moderated by strict adherence to ethical principles, the company is continually widening its sphere of activity and has of late successfully introduced the Haddorff grand pianos on the concert platform, where they are regularly used by prominent virtuosos of the day.

A. E.
Johnson

HALLET AND DAVIS COMPANY*, Boston, Mass.
Among the progressive and enterprising corporations in the piano industry of the present time the Hallet and Davis Company of Boston stands in the front rank. With a glorious record of nearly eighty years behind it, new vigor was injected into the old concern when the Conway Company took charge of it in 1905. The managing officers of this corporation are unusually well-equipped for their work.

*Vol. I, p. 286.

EDWIN NELSON KIMBALL, JR., has devoted his whole life to the manufacture of pianos. He learned the trade under his father's guidance when the latter was president of the Hallet

and Davis Company. In 1900, Kimball, Jr. succeeded his father in the presidency and has ever since had charge of the manufacturing department of the concern. Possessing a systematic, orderly mind for details in factory organization, Kimball demonstrated this ability in the designing and equipment of the new mammoth factories which were erected by the Hallet and Davis Company in Boston, in 1912.

EARLE EDWARD CONWAY, a graduate of Beloit, (Wis.) College, started out to learn the piano business with A. E. Whitney, of St. Paul, in 1893, receiving the princely salary of twenty dollars per month. It was not long before he began to sell pianos on his own account in Southern Minnesota with such success that he cleaned up a profit of six hundred dollars within two weeks. Evidently his father, E. S. Conway, the well-known vice-president of the W. W. Kimball Company, Chicago, was of the opinion that the young man was

making money too fast, and he therefore called him into the service of the **W. W. Kimball Company**, where he was charged with special work in closing up accounts and looking after the

interests of that company among the dealers during the panic years of 1893–1897. After that time he was the general traveling man for Illinois, Iowa and Nebraska. In 1902 he was elected director and secretary of the W. W. Kimball Company.

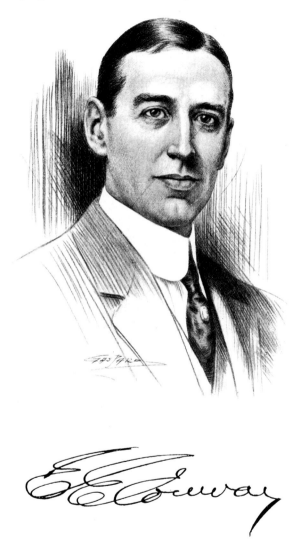

Desirous of being independent and believing that he would make more rapid progress in company with his brother, he organized in 1905 the Conway Company, of which he became president. After the Hallet and Davis Company of Boston was acquired, he accepted the office of secretary in that corporation, assuming the general management of the financial and office departments.

CARLE COTTER CONWAY graduated from Yale University at the age of twenty-two, when he was induced by his father to enter the piano business. He took a position with the W. W.

C. C. Conway

Kimball Company as retail salesman, and after a short time was charged with the responsible position of manager of the outside retail stores of the Kimball Company. The experience

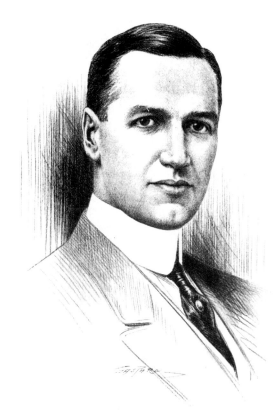

gained in that position prepared him most excellently for his larger work of managing the wholesale as well as retail departments of the Hallet and Davis Company, when he joined his brother in that enterprise. C. C. Conway, endowed with a very magnetic nature, has shown exceptional talent in producing telling advertising literature, and is like his brother, E. E. Conway, a splendid mixer, but primarily a keen and shrewd business man. The almost phenomenal growth of the Hallet and Davis Company of late years is the result of the well-considered and purposeful aggressiveness of its managers, who with youthful energy, tempered by traditional conservatism, have fully grasped the tendencies of the times and never fail to keep pace with them. The Hallet and Davis Company can point to the fact that as far back as 1867, Franz

Liszt played their concert grand pianos at the Paris exposition and enthusiastically endorsed those instruments. In 1911, His Holiness, Pope Pius X, selected a Hallet and Davis piano for the Vatican, and awarded the Hallet and Davis Company a gold medal in recognition of the beautiful qualities of the instrument. Among the many modern artists who believe in the Hallet and Davis piano may be mentioned Mary Garden, the noted opera singer, who uses a Hallet and Davis piano in studying at her home in Paris.

Alert to the demands of the times, the Hallet and Davis Company introduced, in 1911, a player piano under the name of "Virtuola". This instrument, built entirely in their own factories, has proven a great success from the start and is in great demand by dealers all over the United States, as well as in the thirty-four retail stores owned by the Hallet and Davis Company scattered throughout the country. The company also manufactures the Conway piano and controls the Simplex Player Action Company.

<small>Simplex Player</small>

The organization of the working force of the Hallet and Davis Company, the system applied in the manufacturing of the pianos and the methods used in selling the product are unique in their ways, and a most brilliant future seems to be in store for the enterprising men who are directing its destinies.

HARDMAN, PECK AND COMPANY*, New York, N Perhaps the most striking exhibit in the piano division of the Centennial Exposition at Philadelphia, in 1876, was that of the Hardman Art pianos, the most expensive of their kind in that entire exposition. The history of the house of Hardman, which was established in 1842, is one of steady and purposeful progress. When LEOPOLD PECK took an active part in the management of the concern, in 1880, he made the further development of the Hardman piano his main object, and soon succeeded in obtaining for the Hardman piano a position in the front rank of high class products.

<small>Leopold Peck</small>

*Vol. 1, p. 290.

Leopold Peck was born in Gitschin, Austria, in 1842, and died at Elberon, N. J., in June, 1904. Many years before his death he acquired the entire business of Hardman, Peck and Company. He was a man of great force, and the success of the Hardman piano must be credited to his remarkable business talents and progressiveness.

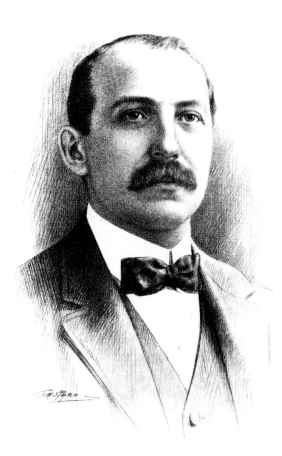

After his death the management devolved upon his son, ALFRED L. PECK, who had for many years been in the business. In February, 1905, the firm was incorporated under the laws of the state of New York, and A. L. Peck became president. Too close attention to the affairs of the business finally undermined his health and he died at Munich, Germany, on September 16, 1911, while traveling in search of health. His cousin, CARL E. PECK, succeeded him in the presidency of Hardman, Peck and Company.

Carl E. Peck

Born at Gitschin, Austria, in 1864, Carl E. Peck had the advantage of a thorough education by attending the high school and commercial academy at Prague. After graduating from the

academy, he served as a one-year volunteer and received his honorable discharge as lieutenant in the reserve of the Austrian army. Arriving at New York in January, 1890, he joined Hardman, Peck and Company, by whom he was appointed factory manager, in which capacity he was active for eighteen years. Having had splendid training in a large lumber manufacturing business located in the Black Forest of Germany, it came natural for Peck to master all the intricacies of piano building, and he has earned for himself a reputation as one of the most thorough piano manufacturers of the present day. Broadminded, just, fair and liberal, Mr. Peck enjoys the heartiest support of all his assistants, and in his modesty he is always desirous that his co-workers shall

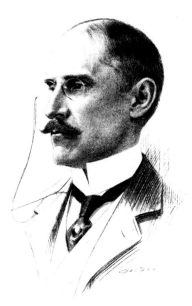

receive full credit for the great success which the house of Hardman has achieved.

The treasurer of the Company, WILLIAM DALLIBA DUTTON, a scion of one of our oldest families who can trace its genealogy back to William Brewster, chaplain of the Mayflower, joined Hardman, Peck and Company, in 1884. Born at Utica, N. Y., in 1847, he was educated at the Utica Academy, after which he spent some time traveling in Europe. Upon his return he joined his father in the piano business in Philadelphia. The original business had been established by his grandfather, George Dutton, in 1821, at Utica, N. Y. W. D. Dutton's father removed the business, in 1865, from Utica to Philadelphia. The firm

Wm. Dalliba Dutton

was changed in 1868 to Dutton and Son, when William Dalliba became a partner.

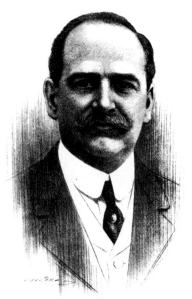

The new firm featured the Hardman piano with such success that Leopold Peck found it to his interest to induce W. D. Dutton to leave Philadelphia and take charge of the retail department of Hardman, Peck and Company, in New York, in which he was engaged for four years. Dutton's fine presence and engaging manners, backed up by a well-founded enthusiasm for the Hardman piano, and a thorough knowledge of the piano business, wholesale as well as retail, made themselves strongly felt in the general development of the business. Always ready to do his full share towards the welfare of the piano industry, Mr. Dutton was honored by successive election to every office of the National Association of Piano Manufacturers, and in 1901 he was elected president of that Association.

Fred W. Lohr

The secretary of the company, FRED W. LOHR, was born at Speyer, Germany, in 1854. He came to New York with his parents in 1855 and has resided there ever since. His connection with the musical industries dates back thirty-six years. He joined Hardman, Peck and Company, in 1883, taking charge of the wholesale department. Among the well-known travelers in the piano trade, there is perhaps none better known from one end of the United States to the other than the secretary of Hardman, Peck and Company. Thoroughly conversant with

all phases of the business end of the industry, Fred W. Lohr's sincerity and enthusiasm for his work have secured for him the respect and friendship of the large number of merchants who are distributing the products of the Hardman-Peck factories throughout the United States.

While a dignified conservatism is the keynote of the company, the aim of attaining the highest ideal in piano production is never lost sight of, as illustrated by the fact that the company controls nineteen patents for improvements to the player piano, which they market under the trade name of "Autotone", and among their patents in piano construction the patent for the metallic key-bed, issued March 25, 1886, is conceded to be of great value. The artistic superiority of the Hardman grand and upright pianos has found proper recognition in the musical world, and the Hardman piano is most especially a favorite among great singers. For many years it has been the official piano of the Metropolitan Opera Company and is used exclusively by that organization and by a majority of its artists.

To have a proper home for their artistic pianos, Hardman, Peck and Company erected a few years ago one of the handsomest buildings that can be found on Fifth avenue, New York. The architecture of that building is of so refined a character that it is often pointed out as a landmark of New York's most fashionable thoroughfare.

The Hardman piano and especially the "Autotone" is largely exported to foreign countries, and in their totality, the large establishments in which the Hardman products are manufactured are amongst the most important of the industry.

BEN H. JANSSEN, New York, N. Y.
Born at Brakin, Oldenburg, on August 31, 1862, BEN H. JANSSEN came to New York with his parents, in 1863. After going through public and high school he attempted to follow the example of his ancestors and become a sea-faring man. Six voyages across the Atlantic convinced him, however, that terra

firma was better to stand upon and progress than the smooth deck of a ship on the ocean. Following a commercial career for awhile, he entered the piano business as manager of a music store, in 1873. In 1878 he became secretary of the Mathushek and Son Piano Company, and in 1901 started in business on his own account, having received a thorough training with firms who made high grade pianos only.

A born musician, having a large number of meritorious compositions for piano to his credit, of which over two hundred and fifty have been published, Janssen is an excellent judge of tone and tone quality. He knows that quality only will win in the long run, and depending entirely upon the high character of his pianos, he has made his place in the piano world as a successful manufacturer. Gifted with poetic talent, an interesting raconteur, Janssen is one of the most popular men among his confreres, who are always anxious to honor him with offices of trust and responsibility in the various trade associations of which he is an active member.

The very prototype of honesty and integrity, broadminded, pursuing a liberal business policy, Janssen has a loyal clientele among leading piano merchants, and the satisfaction of conducting an ever increasing and growing business.

ROBERT C. KAMMERER, New York, N. Y. To be called friend by every one, to be requested to take a leading part in public affairs of moment and importance, and to have a successful business career of thirty years to point to, without ever appearing in the limelight, denotes modesty seldom found. Robert C. Kammerer was born in New York City, on September 12, 1856. His father was a very successful silk merchant, and Robert received his business training under his father's guidance. Having the opportunity of buying the controlling interest in the firm of George Steck and Company, Robert retired from the silk business in 1886 and devoted himself to pianos, a much more congenial occupation for the music-loving

man. Elected in 1905 as secretary and director of George Steck and Company (then a subsidiary of the Aeolian Company), Kammerer found a rich field to bring his talents into full play.

He is one of the most popular men in the piano trade. Always ready to help and serve, Kammerer has been elected to almost every office in the various associations, organizations and clubs in which he is an active member. As the first secretary of the National Piano Manufacturers' Association, organized in 1897, he did splendid work for several years, but his crowning effort was the management of the great convention of that Association held eleven years later at Hotel Astor, New York, when Kammerer acted as chairman of the committee on arrangements.

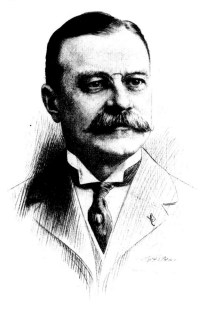

A great lover of athletic sports, he was for twelve years one of the governors of the New York Athletic Club, and served also for six years as a director in the Liederkranz Society of New York.

Fond of travel, Kammerer has visited every part of the civilized world, and acquired an urbanity and broadness of vision which makes him a most interesting conversationalist. The charm of an affable and pleasing personality, resting on unwavering integrity and honesty, is the key to his well-earned successes in business and his enviable position in society.

KELLMER PIANO COMPANY, Hazleton, Pa.
PETER KELLMER started to make pianos of his own in 1883. An artisan of the old school, he disdained commercialism and

Peter Kellmer

took pride in every instrument bearing his name. Every piano which he turned out was the best that he could make.

George W.
Kellmer

His son, GEORGE W. KELLMER, was reared in this atmosphere, being taught the art of piano making by his father. He commenced the study of music when only six years of age and later on enjoyed instruction from some of New York's greatest piano teachers. Taking charge of his father's piano factory in 1893, he has continually improved his products, grand and upright pianos, along artistic lines. He pursues the policy of selling his pianos direct to the public, finding more satisfaction in making pianos of the highest quality possible, rather than turning out large quantities of the so-called commercial kind.

CURTIS N. KIMBALL*.

C. N.
Kimball

To be born as the son of an independent farmer, who owns a valuable homestead on the fertile plains of Iowa, is a privilege hardly to be measured by ordinary standards. Such was CURTIS N. KIMBALL's good fortune and his brilliant career is a confirmation of the assertion that real leaders of men come almost invariably from the ranks of those who till the soil. Breathing the pure air of the cornfields, whose boundless area gave the young man that unhampered vision so necessary for his later achievements, work in the fields developed his muscles and bestowed upon him physical staying powers, commensurate to his natural mental abilities. Plain surroundings are most conducive to kindling enthusiasm and fostering the optimism which develop all the faculties calling for progress.

W. W.
Kimball

When at the age of seventeen, young Curtis received a call from his uncle, W. W. KIMBALL, to come to the city to learn business, he was most excellently equipped for the great future before him. A sound mind in a sound body was his capital, determination to make his mark his guide. Modest in demeanor he entered upon his new vocation with that quiet earnestness which spells ultimate success.

*Vol. I, pp. 286, 339-343.

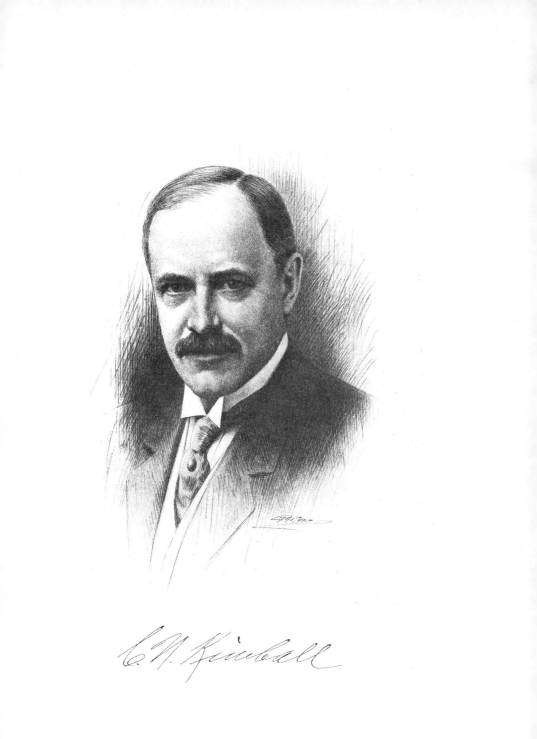

In order to learn all of the theory of commercial and industrial science, he attended an evening course at the celebrated Bryant-Stratton business college of Chicago. Not satisfied to simply write figures into the ledgers and various office books during business hours, he wanted to know the why and wherefore, and devoted his evenings to that study. He soon mastered all the intricacies of accounting, and with equal earnestness applied himself to the systematic study of the details of factory management, the distribution of the factory products, the ramifications of the agency system, and the limitless complexities of financial operations and management.

In recognition of his indomitable energy, and as a fitting reward for his valuable services, he was elected in 1898 to the office of vice-president of the W. W. Kimball Company. In 1905 he succeeded his uncle in the presidency of the great corporation.

Looking upon the destiny of the W. W. Kimball Company as his life work, Curtis N. Kimball directs its affairs in a masterly manner, ever on the alert to improve the products of the great factories. He has been highly successful in enlarging the market for and enhancing the prestige of the Kimball Piano, as demonstrated by the fact that under his regime it has more than maintained its enviable position in the concert halls of America and Europe.

Democratic, like all men who are conscious of their own strength, Curtis N. Kimball has the faculty of putting his visitors readily at ease. An attentive listener, amiably persistent, he exhibits that rapid, ready intellect, flavored by a pleasant vein of humor, which commands respect. Fair and just, of inflexible integrity, he enjoys the loyal support of his associates and employees, most of whom have worked with him for many years.

A lover of the art in all its forms, he patronizes opera and concerts, and is known as a connoisseur of rare books and paint-

ings, of which a valuable collection can be found in the palatial residence at his beautiful country estate, "Ridgewood."

Averse to public distinction, he seeks rest and recreation in his family circle, taking an intense interest in the horticultural development of his large estate, exemplifying thereby a most harmonious blending of the nature of a successful business man with the inclinations and preferences of the refined gentleman.

Among the silent workers in the piano industry of the present time perhaps none is more widely known than the secretary of the W. W. Kimball Company, EARLE BREWSTER BARTLETT. Born in 1858 on a farm in Wisconsin, Bartlett enjoyed all the opportunities for developing a strong personality which pioneer life in those early days offered to the boy of the West. At the age of nine years he earned money between sessions of school, spending twelve hours a day picking berries, or working as a lather in new buildings or helper in a shingle mill.

School years over, he took up teaching, and made use of vacation times to earn money by clerking in the stores, substituting in post offices, or doing whatever else might offer. Seeking a larger field, he went to Chicago and engaged with D. Appleton and Company as traveler, selling their American Encyclopedia. In 1872 he made the acquaintance of E. S. Conway, which led to his engagement as manager of one of the branch stores of the W. W. Kimball Company, in 1880. After a few years Bartlett was called to the main office at Chicago and appointed manager of the sales department in 1900. Five years later he was elected secretary of the company, having charge of the sales, credit and correspondence departments of the corporation.

An indefatigable worker, Bartlett is a man of fine business ability, with a charm of character that attracts every one to him, and his sincere and earnest nature strikes a responsive chord in the mind of every man who admires frank and open methods. He is surely one of the strong men in the piano industry of the nation, and is recognized as such everywhere.

E. B.
Bartlett

EDGAR C. SMITH, of German parentage, was born to his calling. Seeing the light of the world on October 24, 1860, on a Wisconsin farm, Edgar began as a youth to play the melodeon, under his mother's tutelage, followed by lessons in piano playing, in which he became so efficient that he was invited to "show off" the pianos exhibited at the county fair by a piano dealer. He did this so well that he was offered a salary of $7.00 a week to act as general utility boy, attending alternately to the duties of a porter, bookkeeper, and salesman.

Ambition directed him to Chicago. He applied for work at the Kimball Piano Store and was so fortunate as to arouse the interest of E. S. Conway, under whose tutelage and protection he gradually advanced from floor salesman to manager of the retail department of this big house, including several branch stores. A thorough musician himself, Smith naturally associated largely with disciples of St. Cecilia, and succeeded admirably in his efforts to win valuable encomiums for the Kimball piano from leading virtuosos, among whom Rudolf Ganz, Emil Liebling, Myrtle Elvyn, Robert Goldbeck and many others lead in the use of the Kimball Grand Piano on the concert platform.

Of most amiable disposition, polished and magnetic, Edgar C. Smith ranks among the most popular and respected of the piano men of today.

KINDLER AND COLLINS, New York, N. Y.
A young firm, surcharged with vitality, is that of Kindler and Collins, and its very vigor assures it success and permanence.

OSCAR L. KINDLER, born in New York in 1875, studied designing by attending the evening classes of Cooper Union. He learned the piano trade with Decker Brothers and later enhanced his knowledge and experience as a piano builder in several of New York's leading factories. During the season of 1905–6, he was secretary of the Young Men's Christian Association school for piano scale drawing.

WILLIAM P. COLLINS, born at Oswego, N. Y., in 1877, started life by working in various capacities for a newspaper in his home town. He afterward followed a commercial career and became thoroughly acquainted with the ins and outs of the piano business by traveling over all parts of the United States as representative of Kohler and Campbell, of New York. Kindler and Collins started in business in the spring of 1911. Success was theirs from the beginning. They acquired the business and trademark of the old renowned Needham Piano Company and are now manufacturing the Kindler and Collins and Needham pianos.

Wm. P. Collins

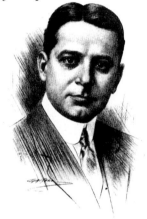

Oscar Kindler, with the training of the famed Deckers in his system cannot otherwise but produce a firstclass instrument, and William P. Collins has long ago established his reputation as a business man of sterling qualities. The future seems to have much in store for this enterprising firm.

THE KNABE BROTHERS COMPANY*, Cincinnati, O.
Tradition often controls irresistibly the destiny of man. With the glory which two generations had given to the name of Knabe in the piano world, it was foreordained that the two sons of Ernest J. Knabe, Sr., should receive particular training for their future work.

Ernest J. Knabe, Jr.

ERNEST J. KNABE, JR., born at Baltimore, July 7, 1869, attended the celebrated Scheib school and later the City College of Baltimore. He graduated in 1886 with the degree of Mechanical and Mining Engineer from the Pennsylvania Military College. He

*Vol. I, pp. 282-3-4-5-6.

then entered the factories of his father as apprentice, serving his full course from piano-case making to the drawing of scales.

WILLIAM KNABE, III, was born at Baltimore, March 23, 1871, and pursued the same educational course as his brother Ernest.

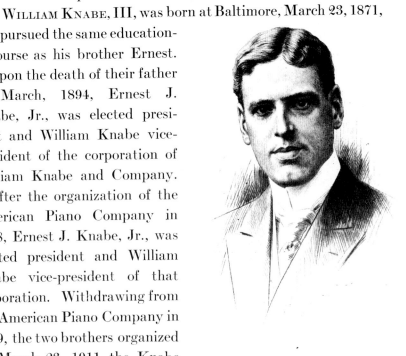

Upon the death of their father in March, 1894, Ernest J. Knabe, Jr., was elected president and William Knabe vice-president of the corporation of William Knabe and Company.

After the organization of the American Piano Company in 1908, Ernest J. Knabe, Jr., was elected president and William Knabe vice-president of that corporation. Withdrawing from the American Piano Company in 1909, the two brothers organized on March 23, 1911, the Knabe Brothers Company, a corporation of which Ernest J. Knabe is president and William Knabe vice-president. The new corporation acquired the factory buildings erected for the Smith and Nixon Piano Company at Norwood (a suburb of Cincinnati), and commenced the manufacture of the Knabe Brothers piano. After a disastrous fire, which destroyed their factories, in 1912, new buildings were erected, which were designed especially to furnish the best facilities and to obtain greatest economy in piano manufacturing.

Ernest J. Knabe designed new scales for the Knabe Brothers pianos and succeeded in producing grand and upright pianos to meet the taste and demands of modern times, retaining for his instruments, however, the "tone" characteristic of the products of the Knabe family, which has been so highly praised

by Von Bulow, D'Albert, Tschaikowsky, Gruenfeld, and other great masters of the keyboard.

Tradition lives in the new Knabe Brothers factories. Ernest J. Knabe can be found there every working day, personally superintending every phase and part of the work. He is in close touch with his workmen, whom he inspires with the maxim of the Knabe family: "The best is none too good", and the result is a product which William Knabe can readily place with the leading houses among piano merchants.

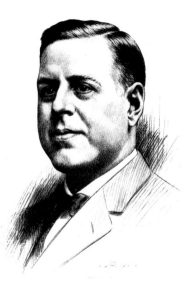

Original in conception, worked out with most painstaking care in their smallest details, the scales drawn by Ernest J. Knabe, Jr., are supplemented by acoustically correct sound board and case construction, while action and touch are capable of bringing out a tone quality which has won for the Knabe Brothers pianos the heartiest endorsement by connoisseurs.

KRAFT, BATES AND SPENCER, Boston, Mass. Born at Boston, THEODORE J. KRAFT* went to work on the bench in the old Emerson factory at the age of fifteen. It was his privilege to enjoy the tutelage of those well-known masters, Neff and Chelius, and he made the best of it, as demonstrated in the pianos which now bear his name as maker.

For over twenty years Kraft was connected with the Emerson Piano Company as piano-maker, retail and wholesale

Theodore J. Kraft

*Vol. I, p. 338.

salesman, establishing his own business in 1903. The present company was incorporated in 1911 with Theodore J. Kraft as president, Walter J. Bates, manager, and Harry L. Spencer, treasurer.

K RANICH AND BACH*, New York, N. Y.
 The propaganda for co-operative associations in industrial and commercial pursuits, starting during the troublous times of 1848-49, in Europe, was at its height during the decade of 1855 to 1865, and found sincere advocates also in America. Like so many other Utopian theories promulgated at that time, of which the gospel of free trade has proven the most pernicious and harmful to the wage-earning class, co-operative business is ideal in theory, but utterly impracticable in fact. The dictum that the stronger will always rule, indeed must rule for the benefit of the weaker, has its foundation and justification in the very fact that no two beings or things are alike.

HELMUTH KRANICH and JACQUES BACH easily proved themselves the strongest out of the seventeen men, all of them piano makers, who started in business as the New York Pianoforte Company, in April, 1864. No business can prosper, in which every one considers himself as good as the other man, and every one wants to be boss. In July, 1866, six of the members withdrew from the association under the leadership of Helmuth Kranich and Jacques Bach, establishing the firm of Kranich, Bach and Company.

Helmuth Kranich was born on August 22, 1833, in the
Helmuth
Kranich
busy little burgh of Gross-Breitenbach in Thuringia, the beautiful mountain country which has given to Germany some of its greatest poets, philosophers and musicians. Everybody in Thuringia is musical. Song aids the farmer in his task in the field and the blacksmith at his forge; the post boy (postilion) gives vent to his joy and good will toward all by blowing on his horn the wonderfully plaintive Thuringian folk-song melodies,

*Vol. I, p. 336.

while driving his horses along the mountain roads. The people of Thuringia are noted for three characteristics. They are born mechanics, natural musicians, and have a pronounced leaning towards sentimentality.

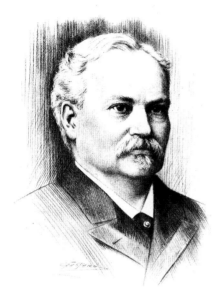

Helmuth's father was the organist of the city, a fine musician and withal very skillful in handling tools. Young Helmuth inherited these qualities, most particularly, however, mechanical skill. It was natural for him to repair or construct almost anything, from a music box to a Swiss watch while yet a school boy. His father, following the wish of the boy, apprenticed him to a piano maker, one of those old-fashioned, thoroughgoing German artisans who made every part of the piano by his own hands. The apprenticeship over, young Helmuth was restless to see the world beyond those mountains he loved so well, yet had become drearisome to him. With his younger brother Alvin, he arrived in New York in 1851, at the age of eighteen. Although without friends or acquaintances, he soon found profitable employment at the piano factory of Bacon and Raven, and a short time thereafter accepted a more profitable position with Schomacker of Philadelphia, where he remained until 1859. He then engaged with Steinway and Sons, who had taken the lead in the industry and were seeking the best talent in the land. Kranich worked in the higher branches, especially tone regulating, in the Steinway factories,

for about five years, when he joined the association above referred to.

The inhabitants of the provinces of Alsace and Lorraine come from the sturdiest Teutonic stock, but two hundred years of French regime has left its mark upon them, and the slowly pulsating blood of the German race has been mingled to some degree with the fiery temperament of the Gallic people, resulting in a combination of stability and perseverance on the one hand and alertness and determination on the other.

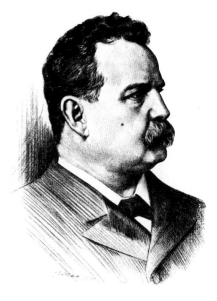

JACQUES BACH, born at Lorentzen, on June 22, 1833, was a typical Alsatian. Destined by his family to become a man of the cloth, Jacques revolted and hired out to a cabinet maker, to the dismay of his parents. After he had become an expert cabinet maker, the little villages of Alsace had no more attraction for him and at the age of twenty he went on a journey to America, experiencing a tempestuous voyage of over ten weeks on a sailing vessel. After his arrival in New York, Jacques went through the usual struggles of the young immigrant, and finally found work in the piano factory of Stodart and Morris. This was in 1853. Speaking French and German as his native languages, he soon acquired a good command of English. An excellent judge of woods, and an expert in the use of the same, he held the position of superintendent of the Stodart and Morris factory until he joined with Kranich the co-operative association.

By education, experience, knowledge and inborn force of character, Helmuth Kranich and Jacques Bach immediately proved themselves the superiors of the seventeen associates who formed the New York Pianoforte Company and consequently we find these two men in 1873 as the only survivors of that association, fighting the battle for existence and success with determination and never wavering faith. A more ideal partnership cannot be imagined. Differing in temperament, it seems as if one supplemented the other in all that may have been lacking. Sentimental Kranich was the fine strung musician, who preferred the drawing board and the tone regulator's needle to the work bench, while Bach had not the patience for that sort of thing and enjoyed the music of the circular saw and planing machine, becoming enthusiastic over a particularly fine lot of sound board lumber or richly figured rosewood, mahogany or walnut veneer. Kranich was the artist in tone creation—Bach the enthusiast in creating solid and artistic woodwork for the pianos. Kranich, sensitive and modest, shrank from too much contact with the world—Bach boldly went on the road and convinced piano merchants that the Kranich and Bach piano was the peer of any make and better than most.

Success was inevitable. Frugal, plain in their habits, the two men accumulated a fortune in excess of the demands of their ever-growing business. Careful as investors, they would help friends in an unostentatious manner, and in their business policy have exhibited such a broad-minded liberality that no other piano house can boast of more loyal representatives than Kranich and Bach.

Both men died prematurely. Jacques Bach succumbed to a disease of long standing, in 1894, and his partner followed him in 1902. The firm was changed into a corporation in May, 1890, at which time FREDERICK KRANICH and ALVIN KRANICH, sons

of Helmuth, and Louis P. Bach, son of Jacques, were elected directors and officers of the corporation.

After the death of Helmuth Kranich, his son Frederick became president, Jacques Bach Schlosser, vice-president, Helmuth Kranich, Jr., secretary and Louis P. Bach, treasurer of the corporation.

Frederick Kranich acquired a thorough knowledge of the art under the direct tutelage of his father and has evidently also inherited his father's inventive faculties, as demonstrated by his various improvements and inventions, among which are the "Isotonic" pedal, doing away with the shifting keyboard in grand pianos, and the "Violyn" plate for upright pianos, both of which inventions are covered by patents.

Albert
Krell

THE KRELL PIANO COMPANY*, Cincinnati, O.
ALBERT KRELL, born at Cincinnati, September 6, 1859, is one of the pioneers in the development of the player piano. As far back as 1899 he exhibited in New York an electric piano operated with the aid of a number of batteries by magnets placed under the piano keys. Later on Krell associated with Peter Welin and obtained several patents for player mechanism improvements, utilizing also many of Welin's inventions in the Krell player piano. The Krell Piano Company controls and has the shop-right for various piano player improvements protected by twenty-eight United States patents, some of which are considered fundamental and of great value.

Albert Krell learned violin-making from his famous father, but has devoted himself for the past twenty-five years entirely to the development of the piano and more especially the player piano. He is president of the Krell Piano Company, a corporation capitalized at $550,000, while Edwin B. Pfau is vice-president and treasurer. This corporation owns one of the largest piano factories located in the Middle West.

The Krell piano has held its place among the high grade pianos ever since it appeared on the market. The company

*Vol. I, pp. 357-8.

also does a large business with its "Royal" piano and "Royal" player piano, which well-established trade mark is owned by the Krell Piano Company.

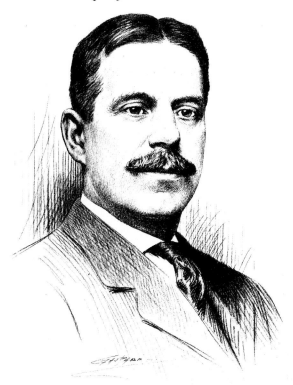

KURTZMANN AND COMPANY, *Buffalo, N. Y. Tradition is a merciless taskmaster, rewarding faithfulness and loyalty with boundless liberality, punishing disregard and neglect with disaster. In business, tradition founded on meritorious efforts of the past, is a most valuable asset, and perhaps in no industry to so large an extent as in piano manufacturing.

*Vol. I, p. 292.

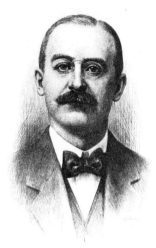

Christian Kurtzmann

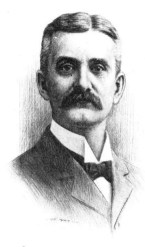

Every piano bearing the maker's name is sent out into the world to either establish or ruin the name and reputation of its maker, according to its inherent qualities.

CHRISTIAN KURTZMANN, born in Mecklenburg, Germany, on November 24, 1815, was one of those fortunate young men who found an opportunity to learn piano-making of one of Germany's great masters. In those early days many years had to be devoted to the apprenticeship, because machinery was unknown, and every part of the piano had to be formed, shaped and modeled by hand. This implied that a thorough piano maker was of necessity a craftsman well versed in the treatment of wood, as well as of metal, leather and cloth, including even the manipulation of ivory for keyboards. It was besides positively necessary that a thorough piano maker should be a fair musician.

Christian Kurtzmann became all of that in the course of time, and the writer has often enjoyed discourses with him on how tuning pins were made by hand, cut from iron wire, often very unevenly drawn, how these pins had to be filed by hand to make them all uniform, to fit the hole in the wrest-plank snugly, how the string wire was originally wound around the pins, until some bright chap conceived the idea of boring a hole through the pin to make the string hold tighter. To listen to Meister Kurtzmann's description of the many difficulties of making the individual parts of the intricate mechanism, without the aid of any special tools or machinery, his description of the anxiety of the maker as to what tones the piano might give forth when the action was inserted for the first trial, was so interesting as to tempt the writing of a romance or novel on the subject, with Kurtzmann as the hero.

He grew up in this atmosphere of laborious piano-making, when artistic achievements were priced far above monetary gain. Like all people of artistic temperament, Kurtzmann was restless to see the world, to study and to learn. He finally landed in Buffalo, N. Y., where he hung out his flag in 1848,

Christian
Kurtzmann

producing the first Kurtzmann pianos. Born artist that he was, he could produce none else but the very best, and within a short time he acquired such an enviable reputation that the demand for his pianos exceeded his ability to supply the same. Kurtzmann identified himself so thoroughly with his pianos that he would never consent to produce any more pianos than he could personally oversee in their making. While this conservative policy did not admit of accumulating money to a large degree, it did have the to him more satisfactory result of establishing the name and fame of the Kurtzmann piano as an art product beyond cavil or dispute.

For thirty-eight years Christian Kurtzmann went daily to his factory in Buffalo, with fatherly care watching the construction of pianos bearing his name, giving to each one the finishing touches, before it could leave the factory. He established the traditional Kurtzmann way of making pianos and set such a high ideal for his successors, that it required talent, effort and experience to maintain this high mark of efficiency. The perpetual growth of the business finally made the adoption of the modern corporate form advisable, opening the door for securing permanently the services of specialists.

A large force of workmen had been assiduously trained by Christian Kurtzmann, every one of them imbued with the traditional and mandatory enthusiasm to build the best piano possible, and the business had assumed proportions which dictated that expert attention should be given to the managerial and commercial branches, as well as to the manufacturing departments.

Jacob Hacken-heimer

JACOB HACKENHEIMER was born in Germany on June 26, 1871. Soon afterwards his family came to America and his father had the good sense to settle at East Aurora, a village which is in Erie County, N. Y., having been put upon the map of the United States by Fra Elbertus. It is said that since the Roycrofters made East Aurora their home, almost everything is

raised there, but they surely do raise men in that unique town, and young Hackenheimer did not lose a single opportunity. He stayed there until he had graduated from all the institutes of learning which the town possessed, and at the age of eighteen entered the employ of C. Kurtzmann and Company as office boy. He very soon outgrew the "boy", however, and learned all of the details of office work. Possessing an inquisitive and systematic mind, he then began the study of factory routine, and worked out a cost system for the ever-growing establishment. In 1894 he was appointed buyer of all supplies, and in 1895 the supervision of credits was entrusted to him, thus preparing him for the position of secretary and general manager, to which offices he was elected when the firm was incorporated in 1896.

Following the example of Hackenheimer, IRVING E. DEVEREAUX became a stockholder of the corporation in 1896. Born in the historic old town of East Nassau, N. Y., Devereaux entered the piano business just as soon as he had graduated from the Academy of Albany, N. Y. He received his training as a piano salesman in that renowned pioneer house, Cluett and Sons, of Albany and Troy, N. Y., advancing finally to the position as manager of the various branch stores of this firm. In 1892 he took charge of the wholesale business of Lyon, Potter and Company of Chicago, for the states of Iowa, Illinois, Minnesota and Michigan. I. E. Devereaux

Desirous of becoming thoroughly acquainted with piano conditions of the Middle West and East, he accepted a position with Smith and Nixon of Cincinnati, in 1894, wholesaling their products in that territory. Having thus acquired a most comprehensive knowledge of the piano business in its commercial aspect, Devereaux embraced the opportunity to acquire an interest in the C. Kurtzmann and Company corporation, in 1896, in which he has ever since served as vice-president, having charge more particularly of the distribution of the products of the factories.

Geo. H.
Moessinger

To make pianos and to sell them is not an easy task in these days of restless, oftentimes reckless competition. A well-managed office is as important to final success as are effective manufacturing and selling departments. GEORGE H. MOESSINGER was well prepared for his arduous duties when he entered the employ of C. Kurtzmann and Company as general office man and cashier, in 1893. He had gathered experience as cashier in a railroad corporation and enlarged his knowledge as office and confidential man in one of Buffalo's large manufacturing concerns. Becoming a stockholder in the Kurtzmann corporation in 1896, he was elected treasurer and has ever since served in that capacity.

The rapid increase of the business of the corporation, and the great popularity of the Kurtzmann piano, speak volumes for the fidelity with which the present managers adhere to the time-honored traditions of the house of Kurtzmann, as well as the ability with which not only the ordinary obstacles have been overcome, but through which the fame of the Kurtzmann piano has forged ahead in a manner to make it one of the best known products of the great piano manufacturing industry of America.

THE LAFFARGUE COMPANY, New York, N. Y.
Bohemia, the land of music where children play the harp, and every man or woman can play upon some musical instrument, the land which has given to the world a Joseph Haydn, Johann Dussek, Alex. Dreyschock, Moscheles, Czerny, Dvorak, and Kubelik, has long been the home of musical instrument makers. String and brass instruments were made there in the eleventh century, and towards the end of the seventeenth century, N. Christendel and others made very fine pianos at Prague.

Joseph
Oktavec

JOSEPH OKTAVEC was born at Kasojovitz, Bohemia, in 1875, and came with his parents to New York in 1887. Attending public school for two years to acquire a good knowledge of the English language, he entered upon his apprenticeship as piano maker. Just as soon as he had mastered the details of case and

sound board making, he perfected himself in the higher branches. A born musician, the world of tone was his, and a desire to build pianos according to his own conception led him to form a part-

nership with **J. George Laffargue,** in 1896, under the firm name of Laffargue and Oktavec.

Bound to produce pianos of the highest musical quality, progress was slow, and young Oktavec tasted all the disappointments and sorrows of the conscientious beginner, but success was bound to follow his earnest efforts and the demand for his pianos slowly but steadily increased. The firm was incorporated in 1904 under the name of Laffargue and Company, with Laffargue as president and business manager, and Oktavec as vice-president, in charge of the manufacturing. Success did not blind

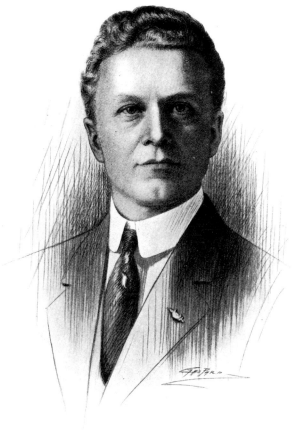

Oktavec. He is ever zealous to improve his pianos and much can be expected of his inborn talent in the future.

After Laffargue's tragic death, as the victim of an automobile accident, in 1906, LAVERNE M. IDE bought an Laverne M. Ide

interest in the corporation, assuming the offices of vice-president and treasurer.

He is a typical product of the Northwest. Born at Manchester, Michigan, in 1860, and raised on a farm, he began life as a school teacher, later becoming assistant postmaster of Tecumseh, and then trying his hand at newspaper work for about one year. Considering that he had a good foundation for a successful commercial career, he went to Detroit in 1882, eventually taking a position with the Farrand Company, where he advanced to the position of secretary of the corporation.

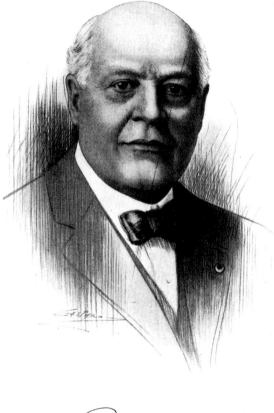

Ide may be called a determined enthusiast. He throws his whole soul into whatever he undertakes, and means to have success crown his efforts, no matter what obstacles he has to overcome. When teaching school at Tecumseh, Michigan, he was assigned to a district school which was notorious for the fact that no teacher had been able to cope with the obstreperous boys for four years past. Every one who tried to rule the boys had to give up in despair. Ide did not mean to give up. A few days after the opening of school, the scholars

started their usual revolt against the teacher. Ide coolly took the big iron poker in his hand and told the boys (some of them stronger than he was) that he would use it to hit over the head the very first boy who dared refuse to obey his orders. The boys saw that they had a real man to deal with, and did not only obey but learned to love their teacher as their best friend, and he was importuned to remain permanently.

This firmness of character is, as always, paired in Ide's make-up with a lovely, kind disposition. He makes friends of all those whom he cares to meet. Broad-minded, a man of the world, he knows how to make the products of Oktavec's genius known to the world. Ide is a lover of sport and enters upon a game of golf with the same fervor and enthusiasm which he displays in his business activity. His confreres have honored him with the office of secretary of the New York Piano Manufacturing Association and elected him president of the New York Piano Club.

LAWSON PIANO COMPANY*, New York, N. Y.

CHARLES B. LAWSON was born in Brooklyn, New York, on February 6, 1855, was educated in the public schools, and entered the piano industry in 1875 in the employ of Billings and Wheelock, then doing business at 14 East Fourteenth street, New York. In 1877 the firm of Billings and Wheelock dissolved partnership, and Lawson cast his lot with William E. Wheelock, manufacturing the Wheelock piano. Becoming a partner in the firm of William E. Wheelock and Company, in 1880, he continued with that concern until it was merged with the Weber Piano Company in 1896. He became vice-president of the Weber Piano Company, with full charge of all their factories, until the business was again merged with the Aeolian combination in 1903. With this combination he became a director of the Aeolian interests until 1906 when he organized the co-partnership of Lawson and Company with his two sons, William W.

Chas B. Lawson

*Vol. I, p. 326

Lawson and Arthur W. Lawson, and George A. Griffin, manufacturing the Lawson piano.

HENRY AND S. G. LINDEMAN*, New York, N. Y.

Knowing that modern business demands more than the usual public school education, and later on the mere practical

S. G.
Lindeman

ability to handle tools, Henry Lindeman induced his son SAMUEL G. LINDEMAN to take a complete scientific course at the New York University, whence the latter graduated in 1888 as a member of the Zeta Psi fraternity.

Leaving the University, young Lindeman acquainted himself with banking methods by serving for one year in one of the largest banking institutions of New York and then entered his father's business, where he devoted three years to studying the art of piano building, practically and theoretically, under the guidance of his father.

Born in New York, on March 24, 1869, Samuel G. represents the third generation of Lindemans in the piano industry. Assisting his father in the business management, he believes in perpetual progress. Alert and enterprising, he secured for his firm the exclusive use of the Melodigrand principle of sound board construction, under the patents granted to Frank B. Long. Its adoption for the Lindeman grand, upright and player pianos must redound to increasing fame of the Lindeman pianos.

GILLIS R. LINDEMAN, the son of Samuel G., is learning scale drawing, etc., under the direct tutelage of Henry Lindeman,

*Vol. I, 279, 280.

preparing himself for his career as a piano constructor, for which calling he seems to possess particular talent.

FRANK B. LONG, Los Angeles, Cal.

A career typical of the characteristic restlessness of a new and growing country we find exemplified in that of FRANK B. LONG. Born at Waterloo, Ind., in 1863, he left school at the age of fourteen and two years later studied piano construction in the shop of Story and Clark, under the tuition of Peterson. After devoting the better part of two years to the study of violin and piano playing under Master Wirschel at Peoria, Long turned to selling pianos and organs, traveling for many leading firms over the greater part of the United States. In 1885, the great land boom of Southern California attracted him to San Diego, where he engaged in business of his own and became one of the

Frank B. Long

victims when the "boom" exploded. Nothing daunted, Long went back to tuning and selling pianos, making his headquarters at Santa Barbara, Cal. After he had earned sufficient to pay all of his San Diego debts, he filled various important positions at San Francisco, Los Angeles, Chicago, Cincinnati, and elsewhere, returning again to Los Angeles in 1900 to establish his own business there, selling pianos at wholesale and retail.

Of a restless disposition, but a keen observer, Long's intimate knowledge of piano construction led him quite natur-

ally to efforts of improving some of the many shortcomings of the piano, which no one deplores more than does the piano salesman.

He invented, and has been granted patents for adjustable agraffes, a touch regulator, and various improvements in upright piano actions, but his crowning effort seems to be a novel construction of the piano sound board, to which he has given the name of "Melodigrand", and for which patents were issued to him by the United States government and also by foreign countries.

Long aims to prevent the usual flattening out of the sound board by glueing the board on to a continuous oval shaped laminated rim. This rim is built up of nine-ply ma-

Frank B. Long Sound Board Construction.

ple veneers to assure strength and a certain pliability at the same time. As the illustrations show, Long applies so-called sound posts placed diagonally opposite each other, pressing at the point of contact against the rim and sound board. He claims that by the aid of this diagonal pressure exerted by the sound post, the crown or arching of the sound board can be permanently maintained.

The Melodigrand sound board construc-ruction has been adopted by the renowned firm of Henry and S. G. Lindeman, of New York, who are embodying the same in all of their pianos, with great success.

To prevent the rattling in upright actions, Frank B. Long has a piece of cork inserted in the hammer flange rail, projecting about one-eighth of an inch, and acting

Frank B. Long's Patented Upright Action
with Cork Cushions

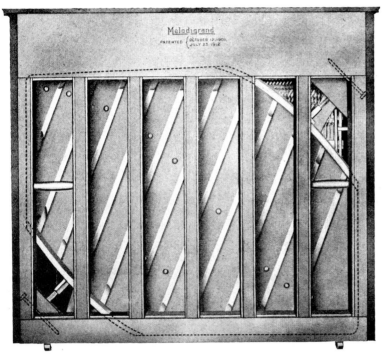

Frank B. Long Sound Board Construction

as a cushion against which the flange is tightly screwed, thus absolutely preventing any loosening or rattling.

A similar insertion of a strip of cork in the hammer rail and underneath the key bolster prevents any reverberation

when the hammer and key fall back in their natural position. Although this invention is not revolutionary nor a departure from conventional action construction, it is accepted as an important improvement and letters patent have been granted for the same.

L OUISMANN-CAPEN COMPANY, Brockport, N. Y.

The Brockport Piano Manufacturing Company began business in 1893, manufacturing the "Capen" and other pianos, which always found a ready market. In 1912 Louis S. Kurtzmann and his son, Christian Kurtzmann, Jr., acquired a controlling interest in the company and reorganized the same, changing its title to Louismann-Capen Company, with Louis S. Kurtzmann as president, Christian Kurtzmann, Jr., vice-president and secretary, and George C. Gordon, treasurer. The company manufactures the "Louismann" and "Capen" pianos, both high grade instruments,

designed by Louis S. Kurtzmann, a piano maker of the old school who is well versed in all branches of the art, from scale drawing to tone regulating.

Born at Buffalo, N. Y., in 1860, he graduated from the St. Joseph's College, in 1878, and entered upon an apprenticeship as piano maker under the tutelage of his father. He continued in the business, forming a partnership with his brother, Fred C. Kurtzmann, until 1901, when the firm was incorporated. Acting as president until 1910, he sold his interest in this corporation.

His latest creation, the "Louismann" piano, has a distinctive individuality, possessing a melodious liquid quality of tone of great carrying power and clarity.

His son, Christian Kurtz- mann, Jr., was born in Buffalo, in 1886. Enjoying the benefits of a higher education, he is well read and a good musician. After studying modern industrial methods and the application of scientific discoveries at the Massachusetts Institute of Technology in Boston for three years, he entered the piano factory in 1908, well prepared to learn piano making under his father's guidance.

The reorganization and equipment of the extensive factories of the Louismann-Capen Company have been carried out by Christian Kurtzmann, Jr., with the one object in view of producing an artistic piano, under most favorable conditions and at a minimum cost.

LUDWIG AND COMPANY, New York, N. Y.
The sudden rise of the firm of Ludwig and Company during the latter part of the nineteenth century invited the attention of the entire piano trade at the time. Two men, who had both for many years studied piano-making, practically and theoretically, formed a partnership, built very good pianos and sold them to the trade at a moderate price. Quality and economy were their watchwords.

John Ludwig

Chas A. Ericsson

JOHN LUDWIG, born in New York, in 1858, learned his trade from his father, who had built pianos in Hamburg, Germany. After serving his apprenticeship, he found employment in several of the leading New York firms until he associated himself with Charles A. Ericsson, starting under the firm name of Ludwig and Company, in **1889**.

CHARLES A. ERICSSON, born at Gothenburg, Sweden, in 1859, came with his parents to New York in 1866. Graduating from the College of the City of New York at the age of sixteen, Ericsson took up the profession of his father, who for many years had been foreman in the factory of Hazelton Brothers. Young Ericsson remained with this firm for eleven years, acquiring a most thorough knowledge of piano construction and piano making. As a member of the firm of Ludwig and Company, Ericsson assumed the management of the factory. The rapid growth of the business made the formation of an incorporated company advisable, and in 1902 the firm was changed to a corporation under the old title of Ludwig and Company.

LYCUS D. PERRY became a stockholder in the corporation in 1902. Like his associates, Perry is a practical piano maker. Born at Port Clinton, Pa., in 1863, where his father had established himself as organ builder and piano maker, young Perry joined his father, making pianos under the name of Perry and Sons until 1898, when the firm was changed to Perry Brothers, upon the retirement of the father. Merging his business with that of Ludwig and Company, Perry transferred his activity from Wilkesbarre to New York, taking an active part in the management, and being elected treasurer of the company in 1904.

J. J. RYAN, under whose management the branch store at Philadelphia had developed a large business, also joined the corporation as stockholder, and is serving as vice-president and secretary. The chain of retail stores established by the company is under the direct management of J. J. Ryan. Charles A. Ericsson was elected president in 1905, since when the financial and commercial interests came also under his care.

In 1907 the company erected its mammoth factories on Willow Avenue, and in spite of the prevailing panic, was able to finance the enterprise without resorting to mortgage loans. Considering that the firm had started only 18 years before, with a very limited capital, the savings from wages earned by the two partners, the accumulation of nearly one million dollars of values is really remarkable, and speaks volumes for the ability,

self-sacrifice, integrity, and business acumen of the founders. John Ludwig retired in 1911, enjoying a well-earned rest as the owner of a large fruit ranch in West Virginia. Selling a large proportion of the product through its many retail stores, the company enjoys the loyal patronage of a number of leading piano merchants in the United States.

M ASON AND HAMLIN COMPANY*, Boston, Mass. It is said that artists are born. This may be true, but surely the environment in which a child or young person grows up at the time when the mind is most receptive for lasting impressions has as much to do with the development of talent and genius as the later necessary devotion to the predestined profession, a devotion which must jealously bar everything else out of one's life that might possibly interfere with the fullest development of the God-given gifts.

Richard W. Gertz

RICHARD WILHELM GERTZ, born at Hannover, Germany, on April 21, 1865, is one of the few blest people who not only inherited a love for music and great musical talent from his grandfather and father, both great musicians, but who also was favored by coming during the days of his youth into close contact with the great minds of the historic classical period of the nineteenth century. His father, Concertmaster of the Orchestra, often played at the same desk with the great Joachim. Richard Wagner, Liszt, Bulow, Brahms, and Spohr were his intimate friends and frequently visited the Gertz home at Hannover. They took a friendly interest in the bright boy Richard, who would even in those early days discuss with these masters the various tone qualities and tone effects.

His father had started in the piano business in 1873. Discriminating artist that he was, he would naturally deal only in the very best pianos built at that time. He introduced Steinway and Sons pianos in Germany, having also the agency for the Bechstein and Bluthner pianos. Later on he added thereto the Mason and Hamlin organs. It followed as a matter

*Vol. I, pp. 76, 110, 181, 315, 316.

of course that the Gertz piano warerooms became the meeting place of all the leading musicians who either lived at Hannover or visited that city, and Gertz supplied them with pianos for their studios and concerts. The first two Steinway pianos imported from New York were a large and a small upright. The small one was sent to Franz Liszt, who used it to play the piano part of the Cecilia Oratorio at the great Wartburg festival, while the larger upright was used by Liszt in his studio at Weimar. The latter instrument is still in the possession of the Gertz family.

While attending the Kaiser Wilhelm Gymnasium at Hannover (one of Germany's celebrated high schools) Richard made use of every opportunity to work in his father's repair shop, a most interesting occupation, because it gave him the opportunity to study the difference in construction of nearly all the leading makes of pianos of the early schools as well as the most modern. His father would oftentimes take old grand pianos as part payment in exchange for new pianos. Many of the former were from twelve to sixteen feet in length. Young Richard would cut them down to the more conventional length of seven feet, design a new scale, and then make merchantable instruments of them, which he sold at good prices. Many pianos worth preserving, because of either their historical value or for their highly artistic cases, but without satisfactory tone, were sent to the Gertz repair shop for the purpose of reconstruction in a manner which would make them musically satisfactory. This meant oftentimes not only the designing of a new scale but also the making of new action and keyboard, all of which had to be done by hand because of the awkward construction of the piano case, and in trying to do such work to the utmost perfection according to modern notions, young Richard was compelled to invent special tools and small machines, such as boring and turning lathes, in which efforts the technical instruction which he had received in school stood him in good stead. He discovered that he possessed inventive ingenuity and his first invention in

Rich. W. Gertz, Oct. 2, 1900

Rich. W. Gertz, Oct. 2, 1900

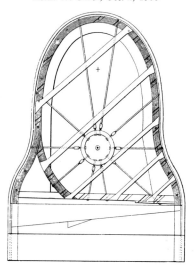

Resonator

Resonator

Rich. W. Gertz. Feb. 20, 1905

Rich. W. Gertz, Feb. 28, 1905

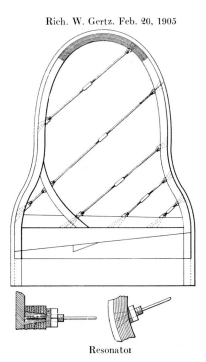

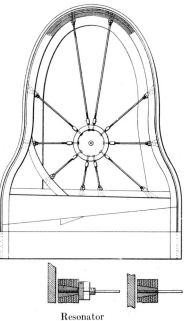

Resonator

Resonator

piano construction was a transposing keyboard, which latter Richard had made entirely by his own hands.

During a visit of William Steinway at his father's home, in 1880, the former encouraged young Richard to come to New York to work at the Steinway factory. After graduating from the Kaiser Wilhelm school, Richard answered that call and landed in New York in the fall of 1881. Having the freedom of the Steinway workshop by reason of his father's connection with the house, Gertz worked in the different branches of the Steinway factory for two years. Desirous of seeing more of the United States, he engaged in 1883 with Bollman Brothers, St. Louis, to take charge of their repair shop. It is well-known that the repair shop of a large piano establishment has always an irresistible attraction for the real student of piano construction, for the reason that he gets an opportunity to compare the different constructions of the leading makers, and to draw valuable conclusions therefrom. Gertz started in even as a boy to keep a diary in which he noted all salient points, such as length of strings, stroke of hammer, depth of touch, size and thickness of sound boards, etc., of each of the various makes of pianos which his father sold, or which came under his own observation. This diary became in the course of time of the greatest value to Gertz when he commenced his first experiments in constructing pianos of his own.

It was his father's desire that Richard should also become thoroughly familiar with the construction of the American cabinet organ, and after remaining approximately two years with Bollmann and traveling about in the Southern States, Richard engaged with the Mason and Hamlin Company, in whose factories he worked until 1886, when he returned to Hannover.

The following two years he attended technical schools, broadening his education and giving special attention to the study of acoustics. He also paid lengthy visits to some of the

leading piano factories of Germany. During this time he became intimately acquainted with Hans von Bulow, then the Hofcapell-meister at Hannover, Johannes Brahms, and other musical celebrities, with whom he often discussed the good or weak points of various pianos. In 1888 he made his first start in manufacturing pianos at Hannover, for which he drew the scales and made the patterns.

Assuming the management of the business after his father's death, in 1892, Gertz found that the renting of expensive grand pianos to professionals was not a paying proposition for the reason that those pianos would usually lose the lustre of their tone quality because of the flattening out of the sound board caused by the perpetual pressure of the strings upon the sound board, under varying climatic conditions. He began experimenting on some of these used pianos by putting iron rods across the outer frame or case, forcing the contraction of the rim of the case and causing a consequent arching of the sound board. Having received satisfactory results therewith and having made the important discovery of benefitting to a surprising extent especially the four upper octaves in such pianos, he conceived the idea of applying this principle to new pianos and began to experiment in that direction.

In the spring of 1895 he visited the United States again, upon the instigation of the Mason and Hamlin Company, to design new scales for their pianos. His work proved so successful that the company invited him to become a stockholder and take full charge of their manufacturing department. Perceiving greater opportunities and freedom for his genius in the larger field thus offered him, he accepted the proposition. Leaving the business at Hannover in charge of his brother, he returned to Boston in 1895 and immediately commenced to reorganize the piano department of the Mason and Hamlin Company.

Painstaking to a degree, imbued with a thoroughness characteristic of the German artisans, capable of showing his

workmen at the proper moments that he could himself do in a masterly manner any kind of work which he demanded of them, he not only acquired their respect, but succeeded in transferring to them his enthusiasm, a quality necessary for the creation of any art product. Indeed, Gertz's idiosyncrasy of studying out the possible good or bad effect of even the smallest, most insignificant, part of a piano upon its tone quality borders almost upon the eccentric.

Aided by his inborn faculty to distinguish the really artistic in everything, he has made good use of his

Tension Resonator

exhaustive studies in the art of piano building. Utilizing all the good ideas which have stood the test of time, and disregarding everything of questionable value, he worked out his own ideas as exemplified in the present day Mason and Hamlin grand and upright pianos.

Tension
Resonator

With more leisure and most ample facilities at his command, Gertz began to develop the idea of the tension resonator to a practicable possibility, and after testing its usefulness thoroughly, he applied for patents, the first of which was granted to him in 1900, supplemented by another patent for further improvement of the tension resonator in 1905.

Like all great piano constructors, Richard W. Gertz is ever striving to impart to the piano that soulful tone quality which is so far only to be found in the violin, and in working out his invention of a tone resonator, Gertz did not only aim to prevent the flattening of the sounding board after several

years' use, but mainly to give to his pianos that sonorous musical quality, which according to his theory can only be acquired when the sound board as well as the strings are brought to a considerable tension.

Among the many other improvements in piano construction devised by Gertz may be mentioned his tone-sustaining pedal and damper frame. As an expert in pneumatics he has naturally

Rich. W. Gertz, Feb'y 9th, 1904
Tone Sustaining Damper Lifting Device

given much thought to the player piano mechanism, and a patent was granted to him on April 15, 1913, for a most ingenious controlling device for automatic musical instruments.

In recognition of his great services, Gertz was elected secretary of the Mason and Hamlin Company, in 1903, and president in the year 1906.

It is not often that an intense love for and devotion to art are found in a man who also possesses all the attributes of a keen, successful business man. Of course, the latter ability can in such a make-up be best demonstrated in a business which is closely allied to art or is in itself of an artistic nature. Dating his ancestry back to Peregrine White, who was one of the passengers on the Mayflower, ADIN MARSHALL WRIGHT was born at Grafton, Vt., on October 3, 1859. Graduating from the high school, he attended for three years the celebrated institution

A. M. Wright

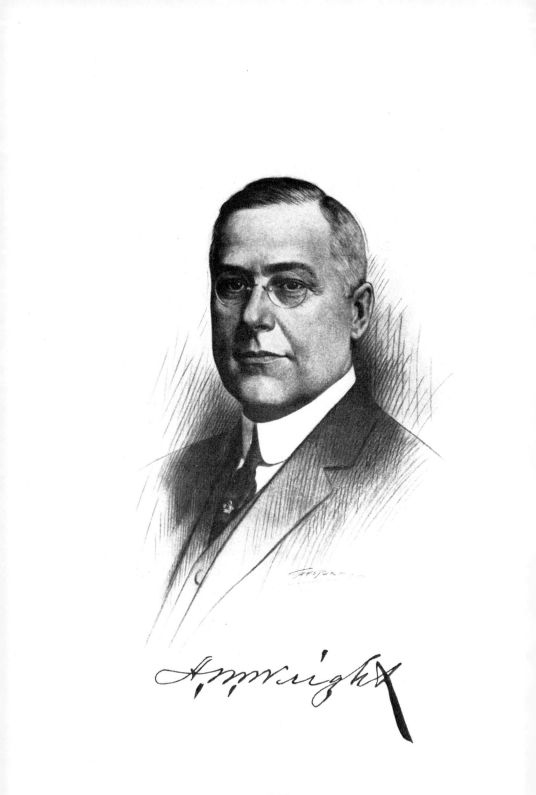

142

known as "Ward's" School, at Bellows Falls, after which he devoted two years to the study of music, violin and harmony, becoming quite a scholarly performer on the violin.

The dual nature in Wright came to the fore when at the age of twenty he engaged for one year with the Esteys, of Brattleboro, as a tuner of organs, and more so when in order to satisfy his desire to become thoroughly familiar with the mysteries of piano building he engaged for four years with the Emerson Piano Company and Vose and Sons, of Boston. Knowing the piano and being deeply interested in the tonal development of the instrument, Wright looked about for an opportunity to utilize this knowledge in the most effectual manner. He was evidently not conscious of the fact that his commercial and executive talents were even greater than his artistic predilections. He reveled in art, music in particular, but his mind relentlessly directed him to the pursuit of business for which he had developed a desire kindred to enthusiasm.

Success in business was for Wright, however, only thinkable when business was somehow connected with higher art, and we find him in 1887 as president of the Manufacturers' Piano Company of Chicago, representing the Weber piano. In 1894 he accepted the position as manager of the Everett piano warerooms in New York. The opportunity had now come to utilize his artistic instinct, technical knowledge of piano building, and business abilities with telling effect. Securing the services of the best known piano scale designer of that time for the construction of a thoroughly artistic concert grand piano, he laid his plans to enlist Ossip Gabrilowitsch to play this new concert grand on a tour through the United States. It became necessary for Wright to make a trip to the home of Gabrilowitsch, in St. Petersburg, to make arrangements for this extensive tournee, which proved as great a success for the piano as for the virtuoso.

Ossip Gabrilowitsch

But still Wright was not satisfied. He was looking for greater honors. He felt that a better grand piano could be built than that upon which Gabrilowitsch had played. He engaged John Anderson as factory superintendent, began to talk piano tone and tone quality to him, and told him what he wanted. Anderson went to work and built a grand piano which Alfred Reisenauer pronounced "tadellos" when he made his sensational tour through the United States. Reisenauer, enjoying a great reputation as virtuoso throughout all Europe, and having a good berth as professor of the Conservatory of Music in Leipsic, was averse to coming to America. Wright went to Leipsic, and knowing the attraction of Auerbach's Keller from his studies of Goethe's Faust, selected that romantic place for his dinners with Reisenauer. While the inspiring atmosphere of the Keller was helpful, it still required all of Wright's personal magnetism, persuasive power and urbanity to overcome Reisenauer's reluctance to leave Europe, but his enthusiasm, his own unshakable faith in the success of the enterprise carried the day, and Reisenauer signed the contract.

A great lover of music, paintings, books, etc., Wright has traveled in nearly all parts of the civilized world, and there is perhaps no art gallery of any renown, here or in Europe, which he has not visited repeatedly and with great profit to himself. Ever since boyhood, he has never lost an opportunity to attend the opera and concerts, listening to the interpretation of classic compositions by the greatest artists and virtuosos. To engage with Wright in a discussion of music and its exponents brings forth his almost amazing knowledge of everything great in the world of tone, a knowledge which can only be acquired by a lifetime's earnest study and loving devotion. Among his intimate personal friends, he can count many of the names prominent during the past thirty years on the concert stage.

But with all this, he never lost sight of business, and when in the spring of 1906 the general management of the Mason and

Hamlin Company was offered to him, Wright accepted the position and began immediately a most remarkable campaign for placing the Mason and Hamlin pianos in that prominent position to which they are entitled by force of their intrinsic and artistic value.

Favored with an exceptionally strong constitution, carefully preserved by a rational mode of living, Wright applies himself with all his enthusiasm and intense nature to the propaganda for the Mason and Hamlin piano. His amiable disposition, business perspicacity, indomitable energy and determination to accomplish his objects, have enabled him to increase the prestige of and market for the Mason and Hamlin piano in America as well as in Europe in a remarkable manner, and have also largely aided in gaining enthusiastic admirers for the same in the musical world at large.

A. M. Wright is a member of the Boston Chamber of Commerce, Boston Art Club, Boston Athletic Association, and the Oakley Country Club. He was elected vice-president and general manager of the Mason and Hamlin Company in 1906.

"The father of music in America" is the title given to LOWELL MASON, because he insisted that music should be a part of the curriculum of our public schools. He agitated and fought for it until he had overcome all opposition and could rest on his hard-earned laurels. But he is even better known to fame as the composer of "Nearer, my God, to Thee", "My faith looks up to Thee", "From Greenland's Icy Mountains", and many other well-known hymn-tunes. He has furthermore become known as the founder of the Mason family. His sons, Henry Mason and Dr. William Mason, both owe their brilliant careers mainly to their father, who inspired them with the ambition to aim for the highest in whatever they might undertake.

Henry Mason studied music, art and philosophy in Germany. When he returned to America he saw the possibilities of Emmons Hamlin's invention, and started the house of Mason

and Hamlin, whose product, the American cabinet organ, conquered the world.

Henry Lowell Mason

His son, HENRY LOWELL MASON, received a most careful training for his future vocation. Passing the entire course of studies at Phillips Exeter Academy, he entered Harvard University, where he devoted three years to the study of history, the fine arts, philosophy and finance.

In his early days he had learned to play the violin, and he now studied the theory of music under John K. Paine, at Harvard, and perfected his piano and organ playing under that celebrated teacher, H. B. Chelius, enjoying at the same time, of course, the benefits of close intercourse with his famous uncle, Dr. William Mason.

Named after his grandfather, Henry Lowell Mason inherited all the former's love for the beautiful and is a musician of no mean order. As far back as 1890 he was honored by an invitation to play the organ in a matinee concert where Arthur Nikisch presided at the piano. Entering upon his business career under the guidance of his father, he realized the influence which musicians have in formulating public opinion regarding musical instruments, and therefore centered his energies mainly upon a publicity propaganda among and through musicians. Taking charge of the artist department of the Mason and

Harold Bauer

Hamlin Company he introduced Harold Bauer to the American public in 1890. Martinus Sieveking toured the United States under his direction, in 1892, followed by that remarkable tournee of Ossip Gabrilowitsch in the winter of 1905–6. Katherine Goodson, the favorite pupil of Leschetitzky, continued to make propaganda for the Mason and Hamlin piano on her tour through the States under Mason's management, in 1907. Of late years, the Mason and Hamlin piano is continually represented on the concert platform as the favorite instrument of many of the foremost virtuosos.

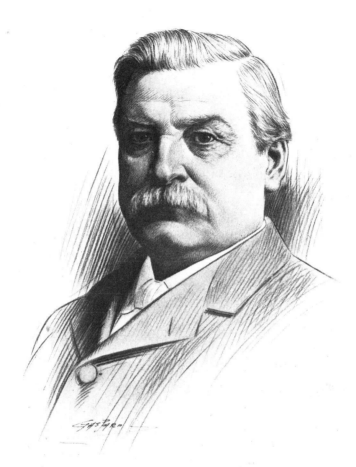

Paul G. Mehlin

A student of literature, Henry L. Mason has established for himself a name as a writer, and his essay on "The Modern Artistic Pianoforte, and its Construction," written in 1900, is often quoted. He also wrote in 1901 a history of the development of the American cabinet organ, besides contributing quite freely to the literature of today on music and pianos, in leading magazines. Henry L. Mason is also often invited to spread the gospel of good music from the lecture platform. His frequent visits to the musical centers of Europe have brought him in contact with the leaders in music and literature, leaving that touch of cosmopolitan tolerance and liberality which is so necessary in his particular sphere of activity.

An active member of the Papyrus, the St. Botolph, and the Harvard Musical Association, he has been elected an honorary member of the Handel and Haydn Society.

PAUL G. MEHLIN AND SONS*, New York.
It has been said that the boy is the grandfather of the man. This pert saying seems to indicate that traces of the later on developed characteristics of a man can be found in the boy. Perhaps this is true. But with rare exceptions, the child of much promise, the prodigy, hardly ever fulfills the fond expectations of its admirers. On the contrary, real strength of character usually develops very slowly, and many of the world's benefactors did not appear in the limelight until they had passed middle age.

Paul G.
Mehlin

PAUL G. MEHLIN, born at Stuttgart, Germany, in 1837, attended school until his twelfth year. Considering that the rigid school laws of Germany demand attendance until the end of the fourteenth year, this fact indicates that Mehlin had either made exceptionally rapid progress in his studies or that his teachers considered further efforts with him useless. At all events, we find him at the age of twelve working in a cabinet shop and two years later as apprentice of that great piano maker, Friedrich Doerner of Stuttgart.

*Vol. I, pp. 336, 410.

With the daring of youth, Mehlin started for the new world just as soon as his apprenticeship was over. Evidently being one of fortune's pets, he found at Liverpool one of those fast

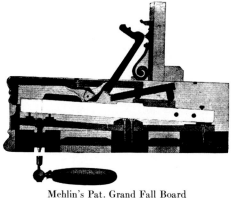

Mehlin's Pat. Grand Fall Board
and Touch Regulator

sailing clipper ships which could make the run to New York in the then remarkably short time of twenty-eight days. This was in 1853. There were but a few piano shops (the term "factory" could not be applied) in New York, but with his proverbial good luck

Mehlin found employment in one of the very best, that of Raven and Bacon, where Jacob Decker was then foreman. Mehlin soon became acclimated in every sense of the word, picking up American ideas, manners and ways with avidity, and earned good wages.

To widen his knowledge, he engaged with Light and Bradbury, but when Lincoln issued his first call for 75,000 men to defend the Union, Mehlin dropped his tools and joined what is known to history as the New York Turner Regiment, or 20th N. Y. Volunteers, as bugler. This regiment was ever at the front of activities, and Mehlin thus became one of the heroes of Antietam, Gettysburg, and other battlefields.

In 1863 he received his honorable discharge as first lieutenant and returned to his old job at the Bradbury factory. Mehlin next joined the forces of Ernest Gabler, where he remained for sixteen years as chief tone regulator.

Having passed the proverbial "Schwabenalter", he resolved to start out on his own account and formed a partnership with Behr Brothers in 1884, which was dissolved by mutual agreement in 1889, when Mehlin founded, in conjunction with his eldest

son the firm of Paul G. Mehlin and Son. It is only from this time on that Mehlin developed his long-slumbering talents as a constructor and inventor. Having observed during his career of nearly forty years of piano-making that most scale designers worked in a haphazard way, mainly copying from one another, Mehlin was anxious to find law and reason, cause and effect,

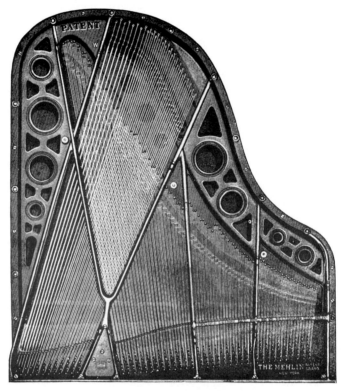

Mehlin Concert Grand

in piano construction and he invented an apparatus for measuring the tension and resultant vibration of strings, in order that he might be able to design scales with equalized tension throughout He also constructed a machine for measuring to a certainty the pressure of the strings on the bridge, by aid of which he secures an equalized pressure throughout the piano. The beneficial results of such scientific research are shown most effectively

in Mehlin's concert grand and so-called "inverted grand pianos," whose noble quality and great volume of tone have forever established Mehlin's fame as a designer of piano scales.

Endowed with an eminently practical turn of mind, Mehlin has invented a number of practical and valuable devices in piano construction, among which may be mentioned his patented cylinder top for upright pianos, a metallic action frame, a fallboard which permits the player the full scope of the keys, and a touch-regulating device, as shown in the illustration.

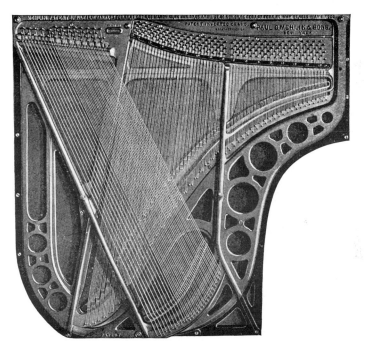

Mehlin Inverted Grand

At the age of seventy-six, Paul G. Mehlin is one of the few fortunate beings who can look back upon a life spent in useful occupation, having accomplished more than he ever hoped for, and knowing the future of his business safeguarded in the hands of his three sons, every one of whom has been well trained for his particular work according to his talents and

ability. Unassuming and modest, he has ever enjoyed the respect of all and sincere admiration and friendship of those who know him well.

H. PAUL MEHLIN, born in New York in 1864, entered upon a commercial career after absolving public school, and the College of the City of New York. In 1889 he joined his father and has ever since directed the financial and commercial departments of the firm with notable success. That he is a born merchant is best illustrated by an episode which happened while he was still in his teens. Employed as bookkeeper in one of New York's largest wholesale dry-goods houses, he was called upon to take immediately the place of one of the firm's best salesmen, who had suddenly died at San Francisco. He had only a few hours to get ready for his trip across the continent, and arriving at San Francisco, the importance of his mission and the conditions beyond his control which faced him, temporarily unnerved him. Gathering courage, however, he started out, and had the satisfaction of reporting to his firm the booking of profitable orders amounting to $67,000 for his first day's work. Not bad for a youngster nineteen years of age!

A hard worker, and a good mixer of most genial disposition, he is often called upon to give his services for the common good. President of the Board of Education in his home town of Maywood, N. J., H. Paul Mehlin has acted as treasurer, vice-president and president of the National Association of Piano Manufacturers (of which association he is a charter member) during the years 1903-4-5, and served also as president of the Piano Manufacturers' Association of New York for two years.

Paul G.
Mehlin, II.

His eldest son, PAUL G. MEHLIN II, born July 27, 1894, is preparing himself now to become a practical piano maker, representing then the third generation of this family devoted to the art.

Charles
Mehlin

CHARLES MEHLIN, born in New York on October 23, 1873, has evidently inherited his father's talents. At the age of

fifteen he went to Stuttgart, Germany, to learn piano-making of that renowned master, Carl J. Pfeffer. He remained there for three and one-half years—long enough to imbibe sufficient of that artistic atmosphere of musical Stuttgart and to be strongly enough impressed with the proverbial painstaking thoroughness of the German artisan, to make of him a piano maker who loves his art for art's sake and is thus bound to in time contribute his share to the world's progress.

Charles Mehlin has already the record of four patents for improvements in pianos to his credit, two of which have been granted for an ingenious fall board for grand pianos and one for an improved form of pedals. An innovation of considerable importance is protected by the patent for designing a string frame minus the conventional bass bar. Like all leading present day constructors, Charles Mehlin is seeking to obtain for his piano a more liquid and luscious tone, to accomplish which efforts are made to overcome or do away with the rigidness of the piano structure.

String Frame

Thoroughly grounded in whatever scientific research so far offers the piano constructor, Mehlin has tested out his innovations in all possible directions, to his own satisfaction, and feels assured of its complete success. For years he has also given careful thought to the great problem of preventing the sagging of the sound board, caused by the perpetual pressure of the strings, and his efforts in that direction are promising of results for the future.

Touched with just sufficient "Bohemianism", Charles Mehlin enjoys the intercourse with members of the musical fraternity. His home, located on the historic grounds of old Fort Lee at the edge of the cliff three hundred and sixty-five feet above the Hudson, from where Washington watched the Battle of Harlem Heights, is the rendezvous of artistically inclined people. A miniature stage built into this house serves often for musical or theatrical performances. The great Caruso amused

himself there by drawing caricatures of Paul G. Mehlin, Sr., and Charles for his sketch book.

Otto F.
Mehlin

Since 1896, OTTO FREDERICK MEHLIN has been working faithfully with his two elder brothers to assist the father in his ambitious plans. Possessing an exceptionally orderly mind, with special control of details, energetic and didactic, it may be said that Otto F. Mehlin was born for the exacting calling of a piano factory superintendent. Born in New York in 1880 he attended the public and high schools and spent three years at the technical College of Mobile, Ala., after which he served the regulation apprenticeship under his father. In 1901 he was appointed superintendent of the Mehlin factories.

He is one of those silent workers for whom the limelight does not shine, but who are fully as important and necessary factors to accomplish lasting success as those perhaps more brilliant men whose deeds can be observed by everybody. It is not easy to design and construct a modern piano in accordance with the demands made, but the building of such a piano, providing fitting materials, watching its progress while passing through the hands of hundreds of workingmen, and attaining a perfection almost alike in every piano, requires a genius in his sphere equal to that of the designer and constructor.

Many of the greatest inventors in the piano industry never reached their aims for lack of a factory organization which could successfully carry out their ideas. The secret of the Mehlin success is the splendid organization of the firm—next to the piano, which is in a class of its own, because the founder of the house never did believe it proper for an artist to merely copy where he should create.

NATIONAL PIANO COMPANY*, Boston, Mass.
Among the rising men of the present generation in the piano trade, A. L. JEWETT has made a record of perpetual success which seems full of promise for the future.

A. L.
Jewett

Born at North Dixmont, Me., in 1872, Jewett attended the public and high schools and came to Boston in 1891 to take a full course in the Boston Business College. Following a commercial career for six years, he joined the Briggs Piano Company in 1897, as a traveling salesman, gradually working into an executive capacity, so that he was elected treasurer in 1906, assuming at the same time the general management of the business.

Seeking for a larger field for his activity, Jewett organized, in July, 1910, the National Piano Company, by merging under that name the interests of the Briggs Piano Company with those of the Merrill Piano Company, to which later on was added the Norris and Hyde Piano Company, a combination of three of the best known piano concerns of Boston.

In 1911 he commenced to manufacture a novel player piano action which has a seamless metal shell for each individual valve, an innovation looked upon as a progressive step in the manufacture of player pianos.

This brief history shows that there are just as good opportunities in the piano industry today for the talented and active young man as there ever have been. It is safe to assume that the National Piano Company under Jewett's energetic management will more and more be considered as a factor in the piano trade, as time goes on.

THE PACKARD COMPANY*, Fort Wayne, Ind.
"What's in a name?" The Packard Piano is made by Albert Sweetser Bond. Isaac T. Packard, the organ-maker, never knew how to build a piano. He did build some very fine cabinet organs, and then he died.

ALBERT SWEETSER BOND is a born artist, and when he resolved to make pianos, they had to be artistic. Hence the Packard piano has acquired the reputation which really belongs to Bond.

A. S. Bond

Quietly Albert S. Bond educated others to assist him, and now he tries to make the world believe that the others did it all.

*Vol. I, pp. 372-3-4.

True, Bond does not any longer handle the chisel or plane, nor the draftsman's tools, neither does he make entries in the cash book, although a past-master in all of it. But he directs, and what is more, inspires those who assist him to do their very best, each in his sphere, and the result is the faultless Packard piano.

It is not a contradiction to state that the artist, A. S. Bond, is also a good business man. His contemporaries are sure of it, and elected him president of the National Association of Piano Manufacturers.

His two brothers, H. W. and S. C. Bond, look after the manufacturing details. That excellent piano constructor, R. W. S. Sperry, continually thinks out improvements for the Packard piano. C. J. Scheiman, as treasurer, and I. M. Kuhns, as secretary, look after the commercial and financial end of the business, and every one claims that Albert S. Bond deserves the credit for the great success of the Packard Company, while Bond tries his best to make his associates responsible for it.

Under such pleasantries, however, the Packard piano made by Bond has advanced and taken its place with the leaders of the Western contingent of the piano industry.

THE POOLE PIANO COMPANY, Cambridge, Mass.
WILLIAM H. POOLE was born at Weymouth, Mass., on

Wm. H.
Poole

December 21, 1864. Graduating from the public schools and business college in 1884, he worked in his father's country store as clerk. In 1887 he took a position as bookkeeper with Sylvester Tower, the piano action maker. He then became a traveling salesman for C. C. Briggs and Company until 1893, when he started in business on his own account to make the Poole piano.

Manufacturing reliable instruments, grands, uprights, and player pianos, Poole succeeded in building up a very successful business. Always interested in public life, he served as a member of the town committee of Belmont, where he lives, and in 1912 was elected to the Legislature of Massachusetts as a Protectionist

Republican, serving on the Mercantile and Labor Committees of the Legislature. Of a quiet disposition, Poole is a great student of economics.

RICCA AND SON, New York.
Italy claims the undisputed title as "cradle of the piano", and it has remained a cradle for nearly two hundred years, to

quote one of Hans von Bulow's witty epigrams. Whatever glory Italy can claim in pianodom for the past sixty years is to be traced to the city of Naples, where the genial Sievers and the father of J. and C. Fischer, of New York fame, builded very good pianos.

LUIGI RICCA was born at Naples on June 21, 1853. He studied music and became a music teacher. Coming to New York in 1886, he joined the faculty of the German Conservatory of Music, teaching guitar and mandolin playing principally. Not satisfied with the quality of the instruments then obtainable, Ricca commenced in 1890 to manufacture guitars and mandolins according to a peculiar construction of his own. Meeting with unex_

Luigi
Ricca

pected success, he felt encouraged to embark upon the manufacture of pianos in 1898.

His thorough knowledge of tone enabled him to produce a piano which found a ready market from the start, so that he found himself compelled to erect in 1903 large factories to meet the demand. Making use of the best in modern factory construction and equipment, Ricca is able to produce a good

piano at a moderate price, thereby continually extending his market to an extent far beyond his fondest dreams when he changed from teaching to manufacturing musical instruments.

The manufacture of electric and player pianos has become an important feature of the business, which has finally been incorporated under the name of Ricca and Son, with Luigi Ricca as president, H. F. Ricca as treasurer, and E. I. Ricca as secretary.

F. G. Jones

SCHILLER PIANO COMPANY*, Oregon, Ill.
One of those restless characters to whom life seems altogether too short to accomplish all that is worth striving for and to be as useful to society as they desire, we find in the late FREDERICK GEORGE JONES. Born at Coburg, Canada, on March 19, 1847, Jones enjoyed but scant school education. At the age of twelve he began to earn his living as errand boy in a book store. In 1865 he came to Oregon, Ill., where he started a general merchandise store, in 1868. Energetic, but conservative, Jones made such progress as the limited sphere would permit of. This very limitation prompted him to take an active part, if not the lead, in all movements tending to aid in the growth of the city of Oregon.

When the Schiller Piano Company was organized in 1891, Jones was one of the first to subscribe largely to the capital stock of $25,000. The concern did not prosper, and the stockholders became uneasy. Although neither legally nor morally obliged to do so, Jones bought up the stock of the dissatisfied, and assumed the management of the concern with so remarkable a success that the yearly output of pianos increased from three hundred in 1892 to nearly six thousand in 1912, and the capital increased by accumulation from $25,000 to nearly $400,000, besides paying regular dividends without interruption. If a country merchant, reared in a small community, and never having tried his strength in any of the great marts of the country at large, accomplishes such remarkable results, exceptional

*Vol. I, p. 362.

ability has been aroused, sterling integrity, tireless devotion, and broad vision have been brought into play.

It is not to be wondered at that Jones' services were in demand for political and civic purposes. He confined himself, however, to serving on the School Board and as Alderman of his home city.

In business, on the contrary, he was ever ready to assume greater responsibilities. After the Schiller Piano Company had been placed on a solid foundation and his three sons could relieve

Geo. F. Jones' Reinforced Back for Upright Pianos

him of all detail work, Jones started an iron foundry, developed water power to furnish electric light and power to the city of Oregon, and its industries, and finally became connected with a large financial institution in Chicago. Favored with a rugged constitution, carefully preserved by a sane method of living, Jones never knew when he overworked himself, but nature enforced its demands and ended his career on March 13, 1913.

Geo H. Jones

The big institution which he has built up is now in charge of his three sons. The eldest, GEORGE H. JONES, born at Oregon in 1875, is a thorough piano-maker, who has several important improvements in piano construction to his credit, among which his patented rectnagular back brace for upright pianos shows originality.

Acting president since his father's death, George H. Jones devotes most of his time to the management of the factories.

Edgar B. Jones

EDGAR B. JONES, born at Oregon in 1880, showed musical talent at an early age and was sent to the conservatory of music at Leipzig, Germany, in 1899, but was called back to Oregon a year later to assist in the management of the fast-growing business. Elected treasurer of the company, he took charge of the office and sales department, and now has also assumed the office of secretary.

Cyrus F. Jones

The youngest son, CYRUS F. JONES, graduated from school at the age of seventeen, and immediately went to work in the player piano department of the company. Possessing inventive talent, he developed several useful improvements in player piano mechanism, for which patents were granted. His latest invention, an automatic tracker device for electric player pianos, has proven a great success.

SCHUMANN PIANO COMPANY*, Rockford, Ill.

W. N. Van Matre

WILLARD NAREMORE VAN MATRE dates his ancestry back to the Van Meterens who lived during the sixteenth century at Antwerp, and whose ancestry has been traced back to Hrolf the Viking, Duke of the Normans.

Jans Gysbestin Van Meteren and his son Jansen landed at New Amsterdam in 1663, and settled in New Utrecht on Long Island, N. Y. Among their descendants was Col. Garrett Van Matre, the intimate friend of George Washington.

Willard N. Van Matre was born on a farm in northern Illinois in 1851. Graduating from the Munroe, Wis., high school in 1869, he began his career by selling fruit trees, changing to sewing machines, and finally organs made by the Chicago Cottage Organ Company. In 1885 he became a stockholder in

*Vol. I, p. 362.

that company, taking charge of the selling department. In 1895 he became interested in the Smith and Barnes Piano Company, where he had charge of the correspondence and

selling as secretary of the company.

An expert salesman, Van Matre became desirous of building a piano in which he could embody his own ideas of construction and tone quality, and therefore bought in 1900 the controlling interest in the Schumann Piano Company. He started out to produce in the Schumann piano an instrument as good as many years of experience and ample capital would make. Accepting the best of modern construction, regardless of cost, Van Matre and his experts developed many novel ideas in the construction of the Schumann piano, to make it worthy of the name of the great composer.

The Schumann player piano is in every detail and in its entirety a product of the Schumann factory, built with that loving care which Van Matre knows so well to awake in his men. An idealist and enthusiast, Van Matre could never be tempted by prospects of larger gain to build anything else but the very best pianos, and has been rewarded with adequate success in his efforts.

Schumann Piano Co. String Plate

Schumann Piano Co. Laminated Sound Board Frame

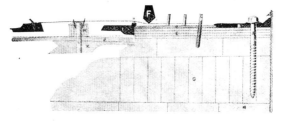

Schumann Piano Co. Sound Board and Wrest Plank
Construction

His son, WILLARD N. VAN MATRE, JR., born in Chicago in 1890, entered his father's factory at the age of eighteen, perfecting himself in the art by practical experience at the work bench and drawing board.

J. P. SEEBURG PIANO COMPANY, Chicago, Ill.
JUSTUS PERCIVAL SJOBERG was born at Gothenberg, Sweden, on April 20, 1871. Going through the public schools, he took a course of studies in Chalmers Technical School, graduating in 1887.

Following the example of many of his countrymen, he emigrated to America at the age of sixteen and commenced immediately after his arrival at Chicago an apprenticeship in the Smith and Barnes piano factory. After four years' service he took a position with Bush and Gerts, whence he was called to take charge of the manufacturing of the Kingsbury piano in the factories of the Cable Company, which position he occupied for eight years. Of an economical disposition he had accumulated a small capital, which he invested with a partner in a piano action manufacturing business. For the sake of convenience he changed his name from Sjoberg to Seeburg.

His inborn love for music lured him back to the piano business and in 1907 he retired from the action business and established the J. P. Seeburg Piano Company. With keen foresight, he specialized on building coin controlled player pianos. The vast experience which he had gathered as piano maker and action maker stood him in good stead in his new enterprise, and success followed his very first efforts. Original in his ideas, he constructed not only a good piano, but designed a player mechanism which is as effective in bringing out the fine tonal qualities of his piano as it has proven of exceptional durability.

In the further development of his business, Seeburg added the building of orchestrions, in the designing and construction

of which he again demonstrated his ability to utilize with great effect his original ideas. A large number of patents for various improvements have been granted to him and he has found it expedient to also protect his artistic case designs by patents.

Always on the alert, anxious to inform himself on the progress made by others, Seeburg travels periodically through Europe, and to find larger markets for his products he also visits the South American countries, studying trade conditions and opportunities. An artist by instinct and devotion, Seeburg aims primarily to produce instruments of real musical qualities. Liberal, broadminded, with keen discernment, and business acumen, he is of very interesting personality,

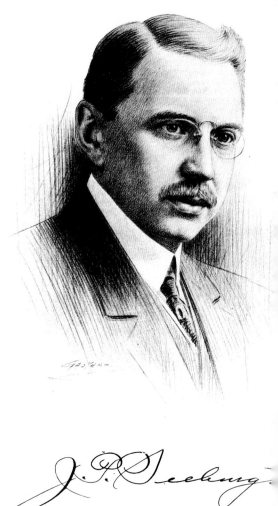

well read, and an ardent patron of opera and concert halls.

M. STEINERT AND SONS COMPANY, Boston, Mass. It was in 1865 that Morris Steinert* opened his music store on Grand avenue, New Haven. His stock consisted of two second hand pianos and some small musical instruments, but

*Vol. I, pp. 188, 426-27, 29, 38.

such was his remarkable business ability that he made a profit of $3,000 during the first four months of his business career.

Alexander Steinert

Alexander
Steinert

ALEXANDER STEINERT, the second out of seven sons, was then about four years of age. Only thirteen years later we find him as manager of the Steinert music store at Providence, R. I., an institution even then of sufficient importance to pay an annual rental of $3,000 for its quarters. Morris Steinert was a great musician—indeed music was his life. As a matter of

course, all of his children had to study music, or rather they grew up in surroundings where music was discussed and performed on all kinds of instruments from early morning until late at night.

Alexander became a fine performer on the piano, thoroughly at home in its extended literature, and he brought his talent into play with great effect as a piano salesman. The results achieved by the young man at Providence were such that he began to look for larger fields to conquer, and he induced his father to open a store in Boston. Considering the traditional predilection of the New Englanders for Boston-made pianos, this was rather a bold move, but Alexander was equal to it. With the Steinway piano as leader, he opened up a large establishment in Boston at the corner of Tremont and Boylston streets. Fortune was kind to him. A few years later he disposed of his lease on this property with a net profit of $200,000. In 1895 he erected that imposing structure known as "Steinert Hall," on Boylston street.

While getting a firm foothold in Boston, Alexander began to show his commercial genius and talent as an organizer by establishing a perfect chain of stores throughout New England. With keen foresight be believed in the great future of the player piano and secured the general agency for the Aeolian Company player products, for the territories controlled by his many stores, and furthermore strengthened his position by acquiring control of the old renowned Jewett Piano Company, which, under his management, has grown to be one of the factors in New England's piano industries.

A far-seeing, shrewd merchant, Alexander Steinert knows how to pick the right men for assistants. A. H. Hume entered the employ of Alexander Steinert in 1888. Starting as bookkeeper, he was soon charged with the supervision of the various branch stores and upon the acquisition of the Jewett Piano Company was elected treasurer of that concern and manager

A. H.
Hume

of the piano factories. In 1903 the Hume piano was produced
under Hume's personal supervision. Its superior qualities have
secured for the Hume piano a place among the leaders of the
present day.

Steinert Hall may properly be called headquarters for the
musical and artistic world of cultured Boston. Lhevinne, Josef
Hofmann, Harold Bauer, Fritz Kreisler and many others have
made their bows from its platform.

A member of the Art Commission of the city of Boston,
the Fidelio Singing Society, the Boston Art Club, and honorary
member of the Harvard Music Club, Alexander Steinert exerts
a most beneficial influence in the propaganda for broadening
the fields of artistic endeavor.

S TEINWAY AND SONS*, New York, N. Y.
Just as a most masterful copy of a Raphael or Correggio
will ever be only a copy and far from the original, so it has
proved impossible to produce a piano equal to the Steinway
piano, even though the Steinway were copied to the minutest
detail. No art product can be duplicated by copying. It is
an individual creation and it takes more than wood, metal and
superior handicraft to produce an art creation such as the
Steinway piano. No other piano has been admittedly so often
copied by makers in all parts of the world as the Steinway,
and no other piano has almost from its very first appearance
enjoyed the endorsement of its competitors to the extent that
the expression "as good as a Steinway" has become proverbial
in the piano trade. Back of the Steinway piano is the Steinway
tradition, Steinway atmosphere, and Steinway organization.
Steinway tradition means that no effort must be spared, no
expense considered, in order to produce the best possible in the
art of piano building.

Fortunes are invested in lumber to permit of thorough
air-seasoning for years. Every part of the piano is made in the
Steinway shops under the direct supervision of a Steinway,

*Vol. I, pp. 299-312.

and according to the Steinway standard of excellence. In the finishing factories at Steinway, Long Island, can be found as many as six hundred grand pianos in the bellying room; each one exposed to the seasoning by the steady temperature of the room for months after the sound-board is inserted. Starting with careful selection of material, each kind by experts in their particular line, such material has to undergo scientific tests before it is utilized and put into the hands of experienced workmen.

Steinway organization means analytic and synthetic manner of investigation applied to the manufacturing as well as the selling departments. Empiricism is debarred. Any suggestion worth considering is minutely investigated and scrutinized, and action taken only when positive improvement or utility has been demonstrated beyond a doubt.

It is but natural that the artistic atmosphere permeating the entire establishment should have its telling influence in the production of pianos of special design and embellished with paintings, carvings and inlaid work. Admitting that the piano is a musical instrument and at the same time a piece of decorative furniture, it is imperative that it should match its surroundings, to provide a harmonious effect on eyes and feeling. Hence Steinway and Sons established many years ago an art department, from which the most costly products in the piano industry have emanated.

Art Pianos

The inspiring influence of an atmosphere created by tradition can be found in the Steinway organization to an extraordinary degree. It is a common occurrence to see in the Steinway factories a father, son and grandson working in the same department, which means that down to the very workman the art of building the Steinway piano is transmitted from father to son and to grandson.

Loyalty, a virtue which is becoming rarer and more rare in the specializing thrift of industrial development, and which

cannot be bought with money, is one of the strongest traits of nearly all those who have ever entered the employ of Steinway and Sons. The reason for this striking fact is that from the very founders of the house of Steinway through the four generations, the primary aim of the leaders has ever been the effort to produce the most artistic instrument and never lose sight of the proper consideration for the welfare of their co-workers to an extent which assures enthusiasm born of self-interest.

Broad-minded, well-directed liberality and brilliant intellect has ever characterized the business management of Steinway and Sons, and this policy, coupled with a remarkable efficiency in continually improving the highest product in the art, has given the House of Steinway the undisputed rank of leader in the industry.

CHARLES H. STEINWAY saw the light of the world on June 3, 1857, in a room directly over the first warerooms of Steinway and Sons, in Walker street, New York, and lying in the cradle, he could hear the best musicians of those days play on the pianos built by his father and grandfather. When he had learned to walk he would spend most of his time in the workshop watching with curious eyes the creation of pianos out of boards and planks, and soon learned to play upon them. His mother took him to Germany at the age of ten, to finish his school education at Berlin. In 1871 he returned to the United States and attended the military college of the State of New York for one year. After a course in commercial science at Packard's Business College, he entered the employ of Steinway and Sons on January 2, 1874, as an apprentice in the piano factory, devoting four years to the practical study of piano-making. His predilections and destiny, however, were for the commercial and financial end of the business, and when he was elected a director and vice-president of Steinway and Sons in 1878, he transferred his activities from the factory to the counting-room at Steinway Hall.

Chas H. Steinway

From the very beginning, Charles showed remarkable talent for unraveling and solving financial problems, so that his Uncle William charged him with the supervision of the making of inventories and balance sheets, dissecting the same, and working out the problems which presented themselves.

The first mission in which he had to exercise his own initiative and diplomacy was when in 1883 he had to reorganize the business of Mathias Gray and Company, the then Steinway representatives at San Francisco, which difficult mission he accomplished not only to the satisfaction of his own house, but also pleasing to the other creditors and every one concerned. A year later he was sent to London with instructions to in some way buy the half interest of the resident partner in the London branch of the Steinway House. To delegate a young man of twenty-seven years of age to antagonize an unwilling partner many years his senior and who possessed the additional advantage of being thoroughly familiar with business conditions in London, appeared to be a rather risky undertaking. Subsequent events, however, proved that Charles H. Steinway was the man for the place. He succeeded in a very admirable manner in bringing about the desired dissolution without any unpleasant after-effects.

Henceforth Charles was entrusted with the entire supervision of the European business of the house, and from 1890 on he visited the European branches regularly once or twice a year.

Paderewski While in London in May, 1891, Charles heard Ignace Paderewski play Beethoven's Emperor Concerto No. 5, in Queen's Hall, and was so impressed with the performance that he cabled to New York, advising the engagement of Paderewski for an American tour, adding that in his opinion, Paderewski would make as great a success as Rubinstein, Adelina Patti, or Jennie Lind. This cablegram was discounted to some extent at Steinway Hall as being prompted by youthful enthusiasm,

although Charles's judgment on matters musical, and especially piano playing, was highly respected (as it deserved to be). Consequently the authorization was cabled to him to make proper arrangements with Paderewski. To encourage Paderewski, Charles immediately opened at the London house a credit account of 25,000 francs for Paderewski to draw against at his pleasure, so that he might devote his entire time to preparations for the American tour, to commence in October. Steinway furthermore guaranteed Paderewski a net income of 150,000 francs from this tournee, an amount which at that time was considered rather extravagant. Before Paderewski left the shores of America, however, after his first concert tour under the management of the Steinway House, he was presented with an additional check for 150,000 francs, because his box-office earnings amounted to double the guarantee, so that his total earnings aggregated 300,000 francs, a result unprecedented at that time. It is rather interesting to note, however, that on one of his later tours, the gross receipts of Paderewski's concerts amounted to 1,250,000 francs.

Charles H. Steinway discovered Paderewski. Paderewski's own genius and the assistance rendered him by the well-directed and lavish expenditure for propaganda on the part of the Steinway house, are to be credited for the astonishing financial success of the Paderewski tours in America.

After the death of William Steinway on November 30, 1896, Charles H. Steinway was elected president of Steinway and Sons on December 4, of the same year. While he had demonstrated his ability to bring to a successful conclusion difficult missions as laid out for him by his superiors, and had demonstrated his tact and diplomacy in critical situations, it remained for the days of his being clothed with the entire responsibility as president of the great corporation to show his real mettle. At the time when the management of the big concern fell into his hands, one of the most severe panics that

the American business world has ever experienced had almost paralyzed commerce and industry, and it required great foresight, firmness of purpose, and decisive action, to steer such a big ship safely through the many breakers which at that time threatened all industries. With strength and determination Charles H. Steinway inaugurated a policy of well-considered economy, displaying great prudence and practical wisdom. He introduced the cash basis for the entire business and eliminated the former contingent liabilities of the company. Ordinarily, radical changes of that order re-act on the sales account of a firm, but in this case the remarkable fact must be recorded that under Charles H. Steinway's regime the output of Steinway and Sons has increased fully one hundred per cent.

Charles H. Steinway is one of the few modern leaders in industry who have successfully studied the trend of the times and who had the courage to adjust their affairs in accordance therewith. Not losing sight for a moment of the traditional and fundamental policy of the house to produce the very best piano possible, Charles had observed that the changed conditions in commerce required a change in the policy of marketing the product, and he consequently introduced the methods of modern advertising and recognized particularly the prime necessity of giving the greatest possible value to the purchaser.

Of a most amiable disposition, broad culture, and decided musical talent, he is often approached to accept positions of honor and distinction. However, he invariably declines, confining his activities in that respect to his duties as director of the Pacific Bank and the Citizen's Savings Bank of New York, which institutions he has served since 1884, acting as vice-president of the Citizen's Savings Bank for a number of years.

It was but natural that he should, as the representative head of the house of Steinway, receive decorations from European potentates, be elected a member of the Legion of Honor of France, and have the Order of the Red Eagle conferred upon

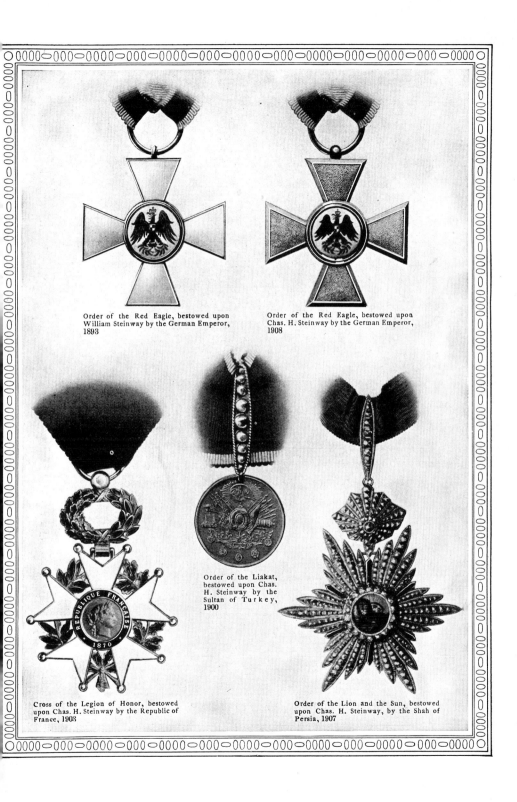

Order of the Red Eagle, bestowed upon William Steinway by the German Emperor, 1893

Order of the Red Eagle, bestowed upon Chas. H. Steinway by the German Emperor, 1908

Order of the Liakat, bestowed upon Chas. H. Steinway by the Sultan of Turkey, 1900

Cross of the Legion of Honor, bestowed upon Chas. H. Steinway by the Republic of France, 1903

Order of the Lion and the Sun, bestowed upon Chas. H. Steinway, by the Shah of Persia, 1907

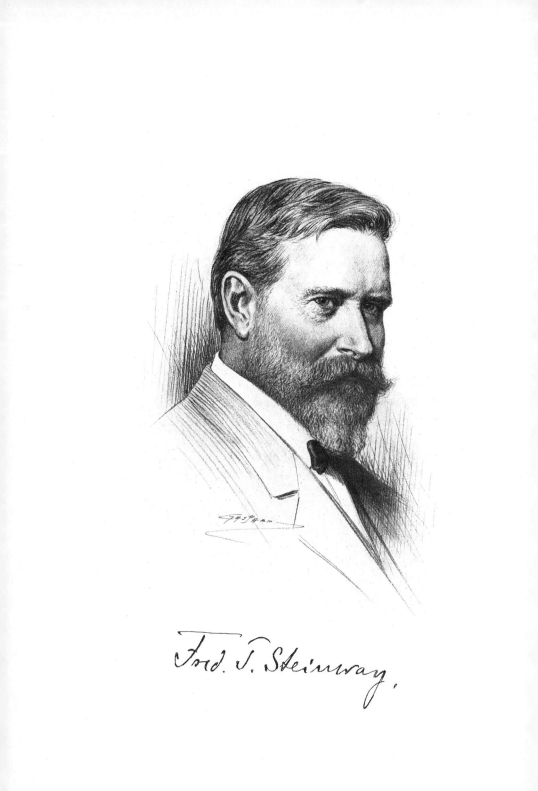

Fred. T. Steinway.

him by the Emperor of Germany, who granted him furthermore the exceptional honor of an audience at the Imperial Palace in Berlin.

While Charles H. Steinway is a member of many of the leading clubs of New York, of the Chamber of Commerce, Philharmonic Society, and other organizations, he is primarily a family man, and fond of devoting his leisure hours to his love of music. He is an accomplished pianist and composer, and more than forty of his compositions have been published, among which "Album Blaetter" and "Marche Triumphal" have been especially well received by the musical world.

In every great institution, as well as in epoch-making move-ments, will be found one or more men who are properly called the "silent workers." Never appearing in the limelight, such men, however, perform duties and accomplish deeds which are essential to the success of the entire.

Fred. T.
Steinway

FREDERICK T. STEINWAY, brother of Charles H. Steinway, was born in New York on February 9, 1860, and after receiving his elementary school education at Berlin, Germany, he entered the School of Mines at Columbia College, New York, taking a course in chemistry and metallurgy. Leaning very strongly towards the pursuit of a scientific career, he became deeply interested in mineralogy and chemistry and would no doubt have made a name for himself in those sciences, if his name had not been Steinway. He was urged to join the Steinway family in their great enterprise, and entered the employ of Steinway and Sons as apprentice in their factories.

It was just about at that time when Theodore Steinway made his experiments for the purpose of finding the proper alloy of ore for the modern piano plate, in which efforts Frederick was of great assistance, because of his expert knowledge acquired at the School of Mines. Under the guidance of his uncle, Albert Steinway, he was trained in the management of the big factories, becoming in time an acknowledged expert in all kinds of piano

materials, especially lumber, veneers, etc., and also in the proper equipment and most effectual organization of factories. The imposing new factories erected by Steinway and Sons at Steinway, Long Island, in 1903, were planned and designed by Frederick T. Steinway, and will stand as his monument, being admittedly models of modern piano factory construction.

Imbued with a sincerity of purpose and of an intense nature, Frederick T. Steinway exerts the very influence required for an institution like the Steinway factories, where the enthusiasm of the employees and the love for their work are such important factors. Just and fair in all his dealings, he is beloved among all the employees, because of his kind disposition and amiability. Democratic in his tastes, he is a lover of fine horses, but at the same time a great student and a very good amateur musician, leaning especially toward the classics in music. Naturally averse to any public activity, he nevertheless accepted the honorable position of trustee in the time-honored German Savings Bank of New York city, as successor to his illustrious uncle, William Steinway, in that institution.

Henry
Ziegler

There is perhaps no severer test for the ability and ingenuity of a man than to be placed in the position of successor in the field of labor in which an extraordinary genius has earned a world-wide and lasting reputation.

HENRY ZIEGLER, son of Doretta Steinway Ziegler, was born in New York and learned the trade of cabinet-making in his father's shops, which were renowned for the highly artistic furniture created there. His uncle, Theodore Steinway, discovered that Henry showed decided genius as an independent thinker and creator, and induced him to leave the cabinet works and become his pupil in piano construction, and from 1875 up to the time of Theodore's death in 1889, Ziegler enjoyed the daily intercourse and instruction of that great master, who unhesitatingly declared that he considered Ziegler his worthy successor in every respect. Building upon Theodore's

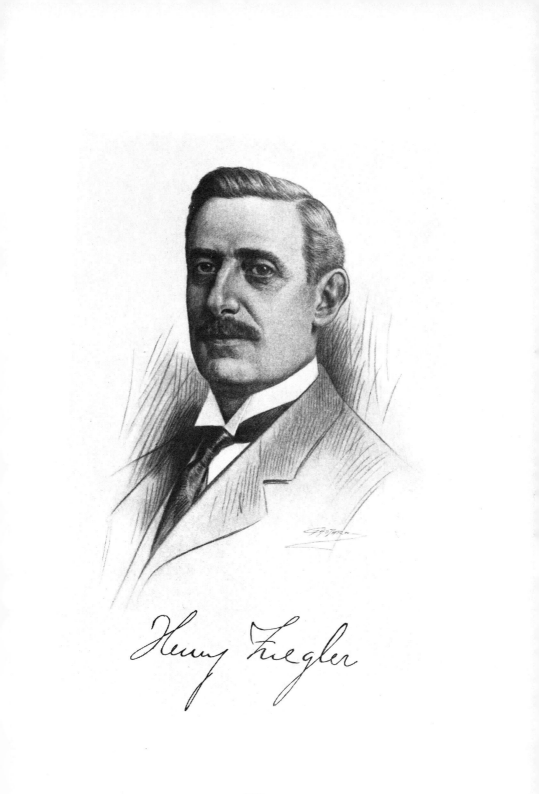

Henry Ziegler

Henry Ziegler, Oct. 11, 1898

Henry Ziegler, Jan. 8, 1895

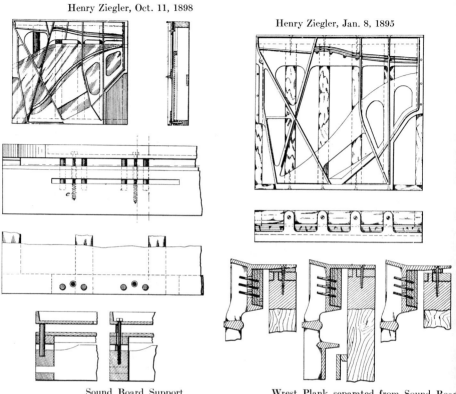

Sound Board Support

Wrest Plank separated from Sound Boar

Henry Ziegler Upright, Pat. Feb. 1, 1903

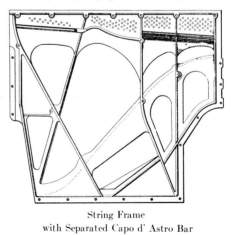

String Frame
with Separated Capo d' Astro Bar

Henry Ziegler, Oct. 3, 1899

Henry Ziegler, Nov. 2, 1897

Sound Board Support

Connection of Wooden Frame with
Metal String Frame

Henry Ziegler, Pat. Feb. 3, 1903

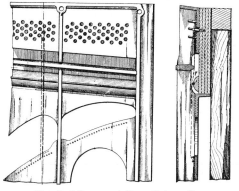

Detail of Separated Capo d' Astro Bar

fundamental innovations, Ziegler has ever aimed to refine the tone quality and hence he primarily sought for improvements in the resonance qualities of the sound board, as illustrated by the various patents granted to him.

His further efforts in that direction were crowned with success in the most ingenious construction of the string frame, ordinarily called the iron plate, constructed by him in such a manner that a wrest plank can be inserted into the string frame entirely independent and free from the main body of the piano
case, which method permits the sound board to vibrate more freely. The original design of his patented string frame enabled him also to make a very important improvement in the Capo-d'Astro bar for upright pianos, through which the singing quality of the upper octaves has been so materially enhanced as to produce that wonderful balance of tonal harmony characteristic of the Verte Grand piano.

In the course of time Ziegler remodelled all the scales of the Steinway grand and upright pianos, and made very important improvements in the construction of the grand pianos, as illustrated by the patent granted him October, 1899. His latest product is the Miniature Grand, in the designing of which Ziegler succeeded in retaining the requisite qualities of the grand piano tone in an instrument which is only five feet six inches long.

Henry Ziegler is so thoroughly in love with his work that he knows of no greater pleasure than to be left alone in his studio. He is, of course, a great student of scientific literature, especially such as refers to acoustics and production of tone. His achievements assure him a niche in the gallery of scientifically thinking piano constructors, to whom the industry at large is indebted.

WILLIAM R. STEINWAY, born in New York on December 20, 1881, attended St. Paul's school at Garden City, New York, graduating in the class of 1899, whereupon he entered his apprenticeship as a piano maker in the Steinway factories.

Having acquired a proficiency in the art of building pianos, he followed his inclination and desire for commercial activity and for that purpose entered the counting-room at Steinway Hall, in 1902, where he was active until 1908, when he was delegated to open up and manage the retail warehouse of Steinway and Sons in Hamburg, Germany. In 1909 he established the Steinway warerooms at Berlin, where he now makes his headquarters, as the representative head of all the European branches of Steinway and Sons in Berlin, Hamburg and London, dividing his time between those three cities, with occasional visits to New York.

William R. Steinway is endowed with a great deal of personal magnetism and personal charm. As a matter of course he is a good performer at the piano, well read and thoroughly conversant in modern languages, but he is primarily an all-around business man of the highest order, having a cosmopolitan comprehension of the commercial and financial conditions obtaining in the various countries in which he directs the interests of the parent house. A splendid mixer, of jovial nature, and endowed with oratorical talent, he is often called upon to preside at banquets and other occasions.

THEODORE E. STEINWAY, born October 16, 1883, in New York, attended St. Paul's school at Garden City, and graduated there in 1900.

Theodore
E. Steinway

Choosing the career of a piano constructor, Theodore E. Steinway spent five years at the bench in the Steinway piano factories, in order to become thoroughly versed in the art, and afterwards became assistant to Henry Ziegler, preparing himself to eventually follow in the footsteps of his illustrious uncle, Theodore Steinway, and of his cousin, Henry Ziegler. A man of the world, of a fiery and impulsive temperament, Theodore is a great reader of fiction, as well as of serious literature. Being an accomplished linguist, it is natural for him to be also a bibliophile. In short, he combines to a remarkable degree all

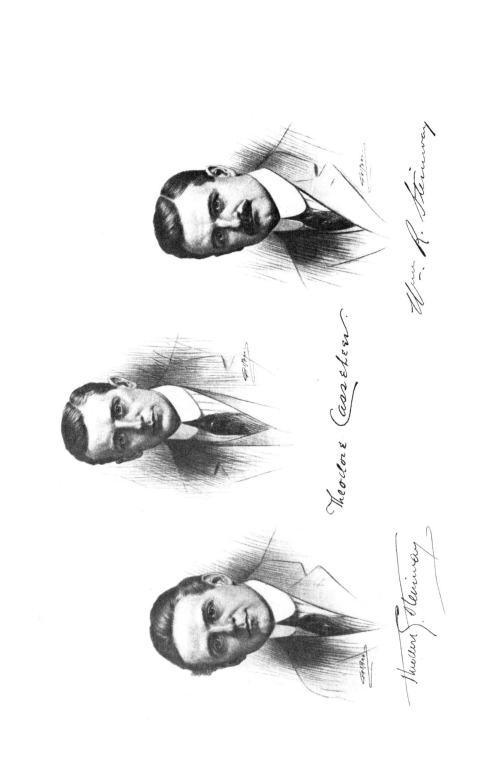

the characteristics which we find in men who have attained fame in the world of creative art, of which sentiment is one of the leading traits. The latter is illustrated by the fact that Theodore E. Steinway, upon entering married life, chose his home in the beautiful apartments which have been erected on the site of the old Steinway factories on Park avenue and Fifty-third street, New York, where more than 150,000 Steinway pianos have been built.

It has ever been the wise policy of the Steinway organization to provide for every important position an understudy, a competent person, who, if necessity requires, can step into the place of one of the leaders. True to the Steinway tradition, such understudies have always been selected among members of the family.

THEODORE CASSEBEER, the grandson of Doretta Steinway, was born in New York on September 9, 1879. He attended schools in New York and at Stuttgart, Germany, until his fifteenth year, when he took up mechanical drawing preparatory to entering a four-year apprenticeship as piano maker at the Steinway factories. He then studied for one year with Henry Ziegler to become versed in the theory of piano building, and after that devoted two years to a so-called apprenticeship under the lumber inspector of the firm, traveling with the same all over the United States in the search of lumber for the Steinway pianos. In 1907, he was appointed assistant manager of the factories under Frederick T. Steinway.

In meeting Theodore Cassebeer, one is immediately impressed with his positive sincerity and earnestness. Cassebeer is a great student, specializing on forestry and forestry products. In the years of his traveling, he has accumulated a collection of all sorts of woods used in the piano, which collection comprises the seed, leaves, and bark from every kind of tree, and wood in its various shapes and forms from the raw to the polished state. A great lover of nature, he enjoys his camping out in mountain

Theodore Cassebeer

districts in search of lumber, and being an active member of the New York Athletic Club, he rather enjoys his visits to the wild and untraveled sections of the forests.

Desirous of marching at the head of the procession, Cassebeer spends as much of his time as he can in visiting model factories in America, as well as in Europe, studying their equipment and methods, and exchanging with their managers ideas and experiences.

F. Reidemeister

One of the silent workers in the house of Steinway we find in FREDERICK REIDEMEISTER, who was born in Brunswick, the old home of the Steinways, on November 30, 1865. He attended the classical schools of that old German town, and graduated at the age of eighteen, when he entered upon his commercial career. In 1888 he came to New York, taking a responsible position with a large manufacturing company until he joined Steinway and Sons in 1891, where he was appointed as assistant cashier. In 1896 he was promoted to the position of cashier. Later on he became a stockholder, and was elected director and treasurer of the organization.

Reidemeister is one of those deep-thinking, sensitive men, whose sense of duty is pre-eminent in their character, managing the finances of the great house of Steinway with as much painstaking care as admirable ability. He is a most valuable assistant to his brother-in-law, Charles H. Steinway.

N. Stetson

Strong magnets attract strong bodies, and it is but natural that the house of Steinway should attract to itself the best brains and talent which were to be found in that particular field. NAHUM STETSON, who dates his ancestry back to Robert (Cornet) Stetson, immigrant from Kent, England, in 1634, and one of the settlers of Plymouth Colony, was born at Bridgewater, Mass., on December 5, 1856. After attending high school and business college, he prepared for a university course, but failing health compelled him to abandon that project and he became assistant cashier of the Bridgewater Iron Company, which was

founded by his grandfather, who is credited with having made the first railroad rails in America.

In the fall of 1875, Stetson was appointed confidential clerk to John S. Albert, chief engineer of the United States Navy, who was then in charge of the Bureau of Machinery of the Centennial Exposition at Philadelphia. Prior to the opening of the exposi- *Centennial Exposition* tion, Stetson was appointed secretary to this Bureau and had full charge of that great department during the exposition. Steinway and Sons had a special exhibit in the machinery department, showing their metal productions, and Stetson consequently came quite often in personal touch with the late Albert Steinway. The acquaintance finally culminated in the engagement of Stetson as retail salesman for the Steinway house. He entered upon his labors there in November, 1876.

Before taking up his business career, Stetson had studied piano playing and harmony for a number of years under B. J. Lang of Boston and William Mason of New York. When he had become proficient enough in piano playing to appreciate a good instrument, his father took him about the different warerooms to select a piano, and while both father and son, as New Englanders, had a predilection for Boston-made pianos, Nahum preferred the Steinway. But he refused at first to take it, because in his opinion, he was not treated properly by the salesman at Steinway Hall. His father quickly settled the matter by telling Nahum that he was not buying a Steinway salesman but a Steinway piano. The boy little thought at that time that eight years later he would be on the floor of Steinway Hall as the head-salesman, but has ever remembered his own experience, and aside from his inborn amiability, has carefully nursed and developed that urbanity which is so distinctive among men of culture.

Stetson is one of the charter members and was the first secretary of the New York Piano Manufacturers' Association. In that capacity he was entrusted with the arrangements of the

great banquet of the association in which William Steinway presided, and the then President Grover Cleveland was the guest, and addressed the assemblage.

In recognition of his valuable services, he became a stockholder of Steinway and Sons, and was elected to the office of director and secretary of the corporation. He also served as a director in the various branch establishments of the Steinway house in San Francisco, St. Louis, Chicago, and Philadelphia.

Nahum Stetson is a born musician of unusual ability. He has engraved his name as a composer in the granite of time, and his compositions have been played, among others, by Theodore Thomas, P. S. Gilmore, and Clarence Eddy, and many of them have been transcribed for the player piano. His first composition was published by Ditson and Company in 1876.

Ernest Urchs

Solicitous parents oftentimes attempt to plan the future of their children, a custom prevailing especially among German people. Filial obedience alone is often responsible for a young man's following the calling selected for him by his father.

When ERNEST URCHS had gone through the schools in his home city, New York, his father desired that he should take up a commercial career and he began his apprenticeship in one of New York's great wholesale dry-goods houses, as bookkeeper. However, the desire to "sell something," the disposition to debate the subject, a predilection for literature and music, combined to persuade Urchs to forsake calicos and dress goods for music in its commercial sense. A very clever performer on the piano, he naturally sought the acquaintance and society of the shining lights in that profession. It was through Frank Van der Stucken, who at that time conducted a series of symphony concerts in the old Chickering Hall at Fifth avenue and Eighteenth street, New York, that he obtained a position as retail salesman with Chickering and Sons, in which capacity he enjoyed the guidance as well as the friendship of the late P. J. Gildemeester.

In 1891 he engaged with Steinway and Sons as floor sales-man. His initiation two years later into the wholesale depart-ment culminated in his appointment to the "ambassadorship," which, as the term implies, requires not only a circumspect view of trade conditions but tact and discretion in the handling of numerous diplomatic missions for Steinway and Sons through-out the United States.

During the earlier years in the history of the house, the concert and artist department rose to formidable heights in its strength and ramifications under the able and unique manage-ment of the late C. F. Tretbar. After Mr. Tretbar's retirement, Mr. Urchs was appointed manager of that department in 1906. His first success was the bringing out of Josef Lhevinne in 1906. Urchs secured ninety-three concerts that season for Lhevinne, an unprecedented number for a new artist, excepting perhaps Paderewski in the early nineties. Besides many others, he managed the tours of Mme. Bloomfield Zeisler, Richard Buhlig, Ernest Hutcheson, and Ernest Schelling.

Josef
Lhevinne

A man of the world, well read, surcharged with optimism and enthusiasm, Ernest Urchs is a brilliant entertainer, perfectly at home in Bohemia as well as in the gilded halls of the Waldorf-Astoria. But his real pleasure and enjoyment he finds in his home life, pondering over his books, exchanging letters with the brilliant men and women of the day, and most especially playing on a Steinway grand piano his favorite classic composers.

He has been a shareholder in Steinway and Sons since 1900.

STRICH AND ZEIDLER*, New York, N. Y.
In this age of materialism, where success is generally measured in accordance to the accumulation of dollars, firmness and almost blind devotion to art are required to stay away from the mad rush for gain and adhere to principle and conviction. WILLIAM STRICH was born in New York in 1863. His father was one of New York's best known music teachers and the boy had to practice on the piano in his teens whether he liked it or not.

Wm.
Strich

*Vol. I, p. 336.

But William enjoyed it, and became interested in his instrument, so that he desired to become a piano builder.

Passing through Columbia grammar school and a course in the School of Mines, he entered the employ of Steinway and Sons in 1881. Advancing from one department to another until he had mastered it all in the course of eight years, he formed a partnership with his colleague, PAUL M. ZEIDLER, to make the Strich and Zeidler piano.

Paul M.
Zeidler

Paul M. Zeidler's father and grandfather had been piano makers in that classic old town of Braunschweig, where Theodore Steinway had built pianos and in later years worked out his great inventions. Paul saw the light there in 1862, but came to New York in 1869 with his father. After attending the public schools, he completed an evening course in engineering at Cooper Institute and entered the Steinway factories in 1876 to learn piano making. Studying in that celebrated high school of the art for eleven years he spent several years in western piano factories and returned to New York in 1889 to join his friend Strich. The career of both men dictated their future. Both artists by inheritance, instinct and education, nothing short of the best in piano building would satisfy them. The result is the Strich and Zeidler piano, which enjoys a reputation in all parts of the United States as one of the most conscientious products of advanced art in piano building.

Many patents have been issued to the members of the firm, especially for improvements of sound board construction. As designers and builders of elaborate art cases for grand and upright pianos, Strich and Zeidler have acquired an enviable reputation.

Pursuing the even tenor of their ways, both members of the firm find greater satisfaction in producing pianos of the highest possible character than in swelling their bank account by turning out a merely commercial product.

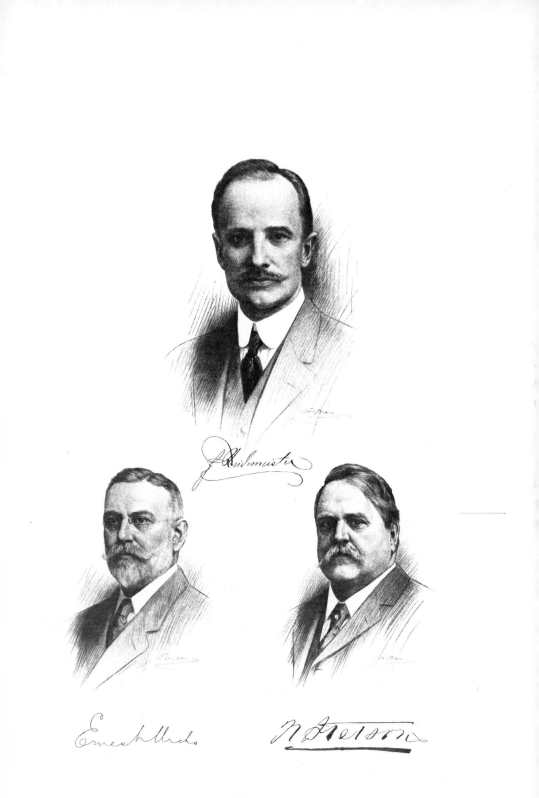

189

HORACE WATERS AND COMPANY, New York, N. Y
Lemuel Gilbert of Boston was one of those versatile inventors who would never be satisfied with building a plain piano.
He experimented extensively with upright pianos having all sorts of attachments. Among his many creations, a piano with an Aeolian Attachment made quite a sensation for a while.

Horace Waters

HORACE WATERS, a music teacher, deeply religious, yet filled with Yankee business instinct, undertook the sale of these instruments, hoping thereby to increase the sales of hymns published by him. With considerable courage Waters entered one of those instruments at the great fair held at Castle Garden, New York, in 1845. His competitors, who had only regular square pianos to show at this fair, became so jealous of Waters' success in attracting visitors by playing the Aeolian piano and singing his hymns, that they attempted to drown his music by playing upon all their pianos simultaneously as soon as Waters commenced. Nothing daunted, Waters stopped, addressed the audience and appealed especially to the sense of fairness of the ladies present, which clever move silenced the other pianos immediately. After the fair was over, the New York piano men told Waters he had better pack up his "old traps" and return to Boston.

Tremaine Brothers

Waters stayed in New York, rented a store on Broadway and engaged the Tremaine Brothers who were not only good singers, but also very clever salesmen, to go about churches and Sunday

schools with the Aeolian piano and sing Waters' hymns. They met with considerable success. No doubt William Tremaine remembered that period when he started his great Aeolian Company.

Horace Waters was a character in many ways. A sincere and almost fanatic prohibitionist, he would in his zeal often forget that he was trying to sell a piano and talk temperance gospel to his prospective customers. Yet he was so good a business man that he easily took the lead among the piano merchants of his day. It is said that he was the first to introduce the system of selling pianos on installments. Horace Waters died in 1893.

Samuel T. White

It was in February, 1869, when SAMUEL T. WHITE, then fifteen years of age, entered the employ of Horace Waters as errand boy. He rose to clerkship in the course of time and was admitted to partnership in 1880. The firm was incorporated in 1886 with Horace Waters as president, his son T. Leeds Waters, vice-president, William H. Alfring, treasurer, and Samuel T. White, secretary.

White had broadened out in various ways; a man of high ideals, he became desirous of obtaining for his company a higher standing, and urged his partners to go into piano manufacturing. He finally succeeded in persuading them, and they started a factory, making from the very start a high class piano.

The management of the concern had rested for many years with White, and after the death of T. L. Waters in 1908, he was

elected president of the corporation. An indefatigable worker, quiet and conservative, White never allowed ambition to control better judgment, and has ever been satisfied to manufacture a limited number of pianos, every one of which he could conscientiously guarantee as good value for the money received. The firm does mainly a retail business through its two stores on lower Fifth avenue and West Forty-second street, New York, having in its career of sixty-eight years established an enviable reputation.

Merrill K. Waters.

Merrill
K. Waters

MERRILL K. WATERS, as secretary, represents the third generation of the Waters family in the corporation.

WESER BROTHERS, New York, N. Y.
 Men born and raised on a farm are usually slow of development, but as compensation possess so much reserve power that

they easily outrun and outlast the city-bred man in the race of life.

JOHN A. WESER was born on a farm in Ulster County, N. Y., in 1853. His parents had immigrated from Germany as young people. Frugal and industrious, they were prosperous, and able to provide for their eight children a proper education, including the study of music. John, the oldest son, possessed considerable mechanical inclination. When he was twelve years of age, his father surprised the family one day by announcing his intention of going to New York with the view of buying a piano. John, who had never seen nor heard a piano, begged his father to buy a sewing machine, rather than a piano, as he preferred something which was set in motion by having "wheels go 'round." But father knew better. He bought a real piano and a toy sewing-machine, the former for John to learn to play upon, the latter to play with.

John, in his eagerness to get at the real "inwardness" of the piano and sewing machine soon managed to put them both out of commission. Evidently the sewing machine eventually lost its attraction for the boy, but the piano remained to him the wonder of wonders. Whenever the piano tuner came to the house, John would watch his every move with an eagle eye. He saw how the man tightened up the strings by turning the tuning pins, and when his piano teacher declared that the piano was out of tune again, John went to his father's workshop, where he found a king bolt with a wrench attachment. He filed a slot into the head of the bolt and thus improvised a tuning hammer. With this tool he set to work to "pull up the strings" as he had seen the tuner do. But to his horror many of them broke and the piano was utterly useless after he had finished his job.

In repairing the damage done the professional tuner had to take the piano apart, and John now saw the complicated mechanism, and received his lessons as to the difficulty of tuning. He learned quite a little about hammers and dampers, and their functions, and from then on farming lost all its charms for John. He thought, talked and dreamt of pianos. Although his father offered to buy him a nice farm, John was determined to become a piano-maker, to which his father finally yielded. He took the boy to New York and placed him as apprentice in a piano factory. This was in 1872. Seven years later, during which time he had acquired a thorough knowledge of piano making, John started in business on his own account under the firm name of Weser Brothers. He had meanwhile called one after the other of his five brothers to New York and made piano makers of them. His output was two pianos per week. Now he is the owner of one of the largest piano factories in New York, turning out 5,000 pianos per year on an average. It was a hard struggle for the country boy in the beginning, but he had staying qualities. He did not know that he had inventive faculties.

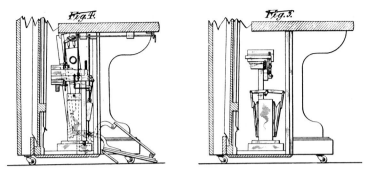

John A. Weser Feeder Bellows for Player Piano

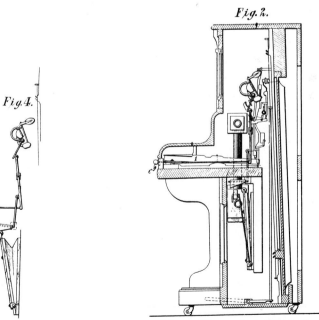

John. A. Weser patented Expression
Device for Player Piano

With keen foresight he was one of the first who saw the potentialities of the player piano. He also saw its original crudeness.

Weser Brothers turned out their first upright player piano in 1897, and since then John A. Weser has obtained thirty-four patents for inventions and improvements in player mechanism. Among them several are basic, as for instance the patent granted on May 28, 1907, for a supplemental expression device, whereby a movable hammer rest rail moves in correspondence with the variations of air pressure in the feeder bellows, moving away from the hammer when the pressure tends to give the greatest force to the blow, and moving towards the hammer when the pressure is such as to reduce the force of the blows. The patent granted June 1, 1907, is also for an invention to better control the expression in electric pianos by combining the motor operated bellows and the foot power bellows. Weser was among the first to put upon the market a piano which could be played either manually or by electric motor or foot power, as the performer might choose.

Starting in business at the age of twenty-six, and satisfied to build up slowly and carefully, he discovered at middle age his ability to manage a large business and also the possession of mechanical constructive ability of a high order. Two of his brothers, Winfield S. Weser and George W. Weser assist him in the management of the great industry, the former having charge of the offices and the latter acting as factory superintendent.

WILCOX AND WHITE COMPANY*, Meriden, Conn. To be granted a patent for an improvement of a mechanical device which for more than twenty years has engaged the experts of the United States Patent Office with applications almost numberless and offered so rapidly as to compel a continual increase in the number of examiners, is in itself a great compliment and a certificate of inventive ability. But when such patents stand the test of time and the attacks of

*Vol. I, pp. 367-8-9-370.

competitors, thus proving their utility, indisputable proof is given that they emanated from a fertile mind, particularly gifted and trained in that direction.

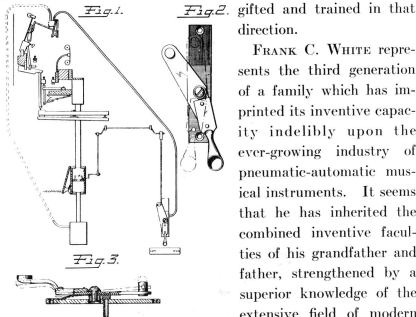

FRANK C. WHITE represents the third generation of a family which has imprinted its inventive capacity indelibly upon the ever-growing industry of pneumatic-automatic musical instruments. It seems that he has inherited the combined inventive faculties of his grandfather and father, strengthened by a superior knowledge of the extensive field of modern technical developments

Frank C. White

Frank C. White Controlling Device for Player Piano
Pat. April 23, 1912

which were not at the command of his forbears, who have done such important pioneer work.

The Angelus player mechanism was an accomplished fact when Frank C. White took charge of the Wilcox and White factories. It had created a sensation and occupied the place of honor in the front ranks. It was for White, however, to maintain that position for the Angelus, by keeping pace with the procession of many

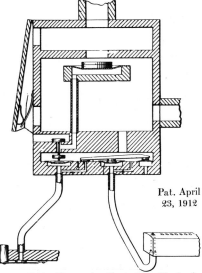

Pat. April
23, 1912

Frank C. White Expression Controlling Mechanism

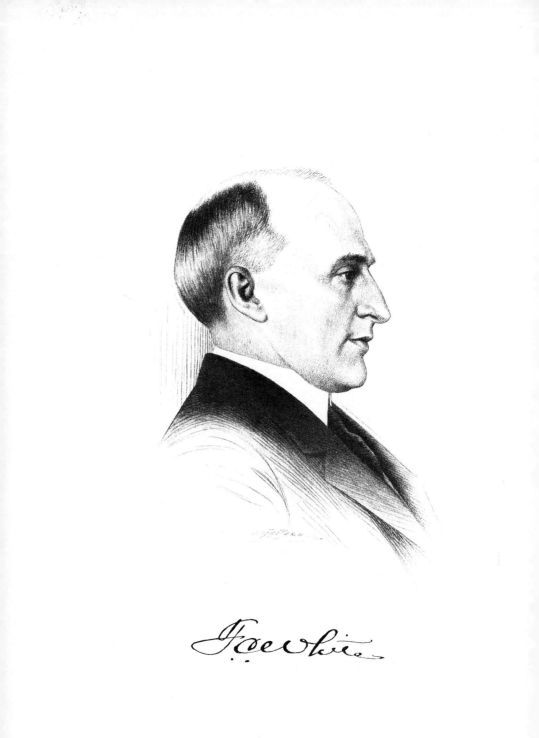

198

talented inventors who devoted their genius to the improvement of the player mechanism. The point sought for by all of them was to make the player mechanism act as nearly human as possible, so as to enable the performer to interpret the compositions of the great masters correctly and eliminate all the shortcomings of the machine-like actions of the player mechanism. Perhaps none of the inventors have contributed more in this respect to the improvement of the player piano mechanism than Frank C. White has in his controlling and expression devices, patented April 23, 1912. Broadly speaking, these patents cover means for controlling the solo, the accompaniment, and the soft pedal, all of which can be operated independently or simultaneously by a single controlling lever. *Expression Controlling Device*

So far twenty United States patents have been granted to White for improvements in piano player mechanism, among which his improvements on the tracker board, music sheets, means for producing perforated note sheets, together with the valuable patent on the adjustable finger manual for Cabinet piano-players, and the self-opening and closing pedal arrangements are most noteworthy, and point to further developments to be expected from this talented scion of a remarkable family of inventors.

WINTER AND COMPANY*, New York, N. Y.
A career full of romance and adventure, showing also unusual versatility and enterprising courage is that of JULIUS WINTER. Born in Hungary in 1856, Winter enjoyed a thorough school education, entering the Hungarian government service at the age of seventeen. He remained in the service as official of the railroad department for seven years, when the desire to see the world took him to New Zealand. During his three years' sojourn there, he tried his hand at farming for about two years, and undertook two inland exploring expeditions. Cruising about the South Sea islands, Winter made a landing at Finsch *Julius Winter*

*Vol. I, p. 336.

Hafen, the seat of the German government in New Guinea, Kaiser Wilhelm's Land.

At the suggestion of the then governor, he entered the government service as assistant secretary, being soon advanced to the office of manager of the government stores, then as assistant, and finally chief of the head settlement. He acted as member of the Supreme Court, Chief Judge of the native courts, Naval Judge, and treasurer of the colony. Born with the mind of the investigator, he made up a number of exploring expeditions into the interior of New Guinea.

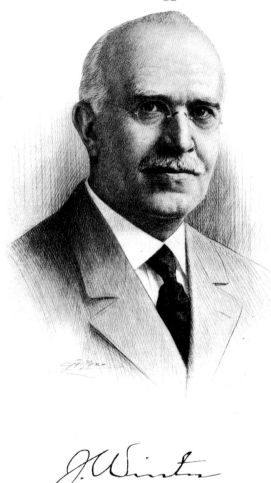

After serving the government for about five years in those various capacities, he took again to traveling, and visited Java, India, China, and Japan, landing finally in San Francisco in 1892, whence he went direct to New Orleans. Accepting the position as manager of the Junius Hart piano house, he stayed at New Orleans until the spring of 1897, when he followed the invitation of Ludwig and Company of New York, to become their general traveler, which position he occupied until June, 1901. He then bought the piano manufacturing business of Heller and Company, changed the firm

name to Winter and Company and commenced the manufacture of the Winter piano.

Success crowned his efforts to the extent that he found himself compelled to more than double his manufacturing facilities, erecting in 1903 the large and modernly equipped factory on Southern boulevard. The old factory is utilized for the manufacture of the Rudolf piano owned by the corporation of Winter and Company. In 1904 Winter and Company commenced the manufacture of a player piano mechanism known as the "Master Player." This mechanism, which has many superior points, protected by patents, is used exclusively in the Winter piano.

Broadminded and public-spirited, Winter is an experienced financier, business organizer and manager. Of artistic temperament, with the proper leaning towards sociability, he was very active in the formation of the New York Piano Club (the only institution of its kind) and was honored by his confreres with the election as first president of the club.

GOTTLIEB HELLER is a piano maker who received his training in the conventional manner. Born at Stuttgart, Germany, in 1868, he learned the trade of cabinet-making and came to America in 1887. After working in two of the most prominent piano factories for several years, he studied for another two years under John Ludwig. Starting in business in 1900 under

Gottlieb
Heller

the firm name of Heller and Company, he became a partner in the firm of Winter and Company when the latter took over his business.

Heller is an expert scale draftsman, and has devoted his life to the study of piano construction. Well read in the literature on musical instruments and acoustics, Heller has demonstrated his unusual ability in the designing and construction of the Winter piano, the making of which is under his direct supervision, as superintendent of the factories.

OTTO WISSNER*, Brooklyn, N. Y.

Otto
Wissner

OTTO WISSNER was so fortunate as to be born the seventh child out of twelve whom his parents reared. His father occupied the high position of State Engineer in Germany, earning a salary which enabled him to give all of his children a most thorough education. That, however, was all he could give. They then had to fight the battle of life as best they could, unaided.

Otto Wissner was born in 1853 near Giessen, an old and renowned college town of Germany. He attended the schools, studied music and other branches, until he had passed his sixteenth year of age, when he was told to make his own living. He came to New York, intending to become a piano maker. Starting as case-maker, he went from branch to branch until he was efficient enough to find an engagement with George Steck, that pastmaster of piano building of his day. After gathering the desired experience in the construction of upright pianos at Steck's factory, Wissner engaged with Fred Mathushek of New Haven, rounding out his studies in scale drawing and tone regulating. Gifted with a very finely developed sense of hearing, tuning came almost naturally to Wissner.

In 1878 he established himself in Brooklyn, N. Y., as piano dealer, tuner, and repairer. A thorough expert, Wissner prospered from the start. The great variety of pianos which passed through his hands tempted him to spend a good deal of his time in comparative experiments and finally led him to resolve to

*Vol. I, p. 336.

make the Wissner piano a piano different from others. He began the manufacture of this piano in 1890. In the winter of 1895 he had the satisfaction of hearing Anton Seidel play his grand

piano as accompanist to Madame Materna and Emil Fischer in a concert at the Brooklyn Academy. Julie Rive King used the Wissner grand piano for four consecutive years in her concert tours through the United States, and Rudolf Friml, Emil Paur, Arthur Hochman, and other celebrities of the keyboard also showed their appreciation of Wissner's art in piano making.

The business grew by leaps and bounds, assuming proportions which induced Wissner to open a large number of retail stores. More interested in producing artistic pianos which should speak for themselves than to expect other recognition for his work, Wissner has not attempted to protect his many useful innovations by patents, excepting a capo d'astro for upright pianos, for which he received a United States patent in 1897.

Solidity of construction and minute attention to all details characterize Wissner's pianos. Aiming first of all to obtain tone, Wissner insists that every part of his pianos must be finished in the highest artistic manner, irrespective of cost.

It is but natural that a man of Wissner's temperament should take active interest in matters musical. He is an active member of several singing and choral societies, always ready to assist, as illustrated by his donation of a concert grand and a

parlor grand as well as an upright piano for the benefit of the great festival of the United Singers of Brooklyn in 1900.

As one of the delegates of the festival committee appointed to transmit the thanks of the Brooklyn Singers to Emperor Wilhelm of Germany for the prize pokal which the Emperor had donated, Wissner was granted an audience at the Imperial Palace in Berlin.

In spite of the close attention Wissner gives to his business, especially the factory, he still finds time to act as director and trustee of several of the largest financial institutions of Brooklyn.

<div style="float:left">Wm. Otto
Wissner</div>

His eldest son, WILLIAM OTTO WISSNER, born in New York in 1882, began his career as piano maker quite early, and developed so well that he became a valuable assistant to his father at the age of twenty, and has been in full charge of the factories until 1909, when he turned his attention to the management of the sales department.

<div style="float:left">Otto R.
Wissner</div>

The younger son, OTTO R. WISSNER, born in New York in 1885, went to work at the bench at the age of seventeen, and has assumed the management of the factories since 1910.

The business has lately been incorporated with a capital of $1,000,000. The officers are: Otto Wissner, president; Otto R. Wissner, vice-president; William O. Wissner, treasurer.

JAMES B. WOODFORD*, Philadelphia, Pa.
Among those whose activity has been of far-reaching influence in merchandizing pianos, JAMES B. WOODFORD stands foremost. On February 10, 1873, Woodford entered the piano trade as accountant and general assistant for Whitney and Courier, of Toledo, Ohio. Three years later he bought for this firm the Loring and Blake organ business of Worcester, Mass., securing an interest therein and assuming the general management.

The advent of the upright piano hastened the decline of the cabinet organ business and in 1888 Woodford sold out the organ business to join the Hallet and Davis Company. Having made his mark as a factor in the piano and organ business, he was called

*Vol. I, p. 282.

upon by Steinway and Sons, in 1893, to open up a branch store in Philadelphia, which he managed until 1899.

During his career as a distributor of pianos, Woodford came to the conclusion that pianos ought to be merchandized like any other commodity, on the one price system under proper standardization. The modern bazaar, better known under the misnomer of "Department Store" had become a fixed institution in the commercial life of America, with John Wanamaker as the leader. Woodford studied the possibilities of establishing piano departments in these great marts, visited by thousands of people daily, as against the very few people who could be induced to visit an ordinary piano store. As an accountant, he had prepared convincing statistics and tables to show the soundness of his proposition, and when he found that John Wanamaker contemplated the organization of a piano business, negotiations were opened, and the result was the establishment of the unrivalled piano and organ departments of the Wanamaker stores in Philadelphia and New York under the management of J. B. Woodford, on April 15, 1899.

Success came immediately, and the Philadelphia store has the proud record of selling 294 pianos, players and organs at retail in one day, and the New York store of selling nearly 1200 in a single month. Almost daily concerts are given by artists of renown in Egyptian Hall, Philadelphia, and at the Auditorium, New York, the concert halls at the Wanamaker stores. Each of these halls has a seating capacity of about 1400 people. The Grand Court at the Philadelphia store has the largest pipe organ in the world. It was built by W. B. Fleming for the 1904 World's Fair in St. Louis, at a cost of over $100,000. Guillaume played upon it through the greater part of the fair, after which it was bought by Mr. Woodford for the Wanamaker store.

With the Wanamaker prestige, capital, and selling organization behind him, Woodford achieved success so far unparalleled in piano merchandizing. The one-price system appealed strongly

to the public and the sales increased steadily in a manner which made it advisable that the Wanamaker house should begin to manufacture pianos. The property of the old renowned Schomacker Piano Company* was acquired, later on a con-

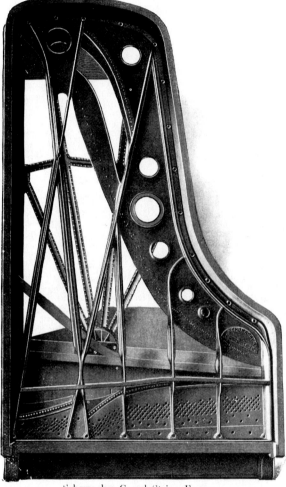

Schomacker Grand String Frame

trolling interest in the Emerson Company of Boston** was secured, and finally the Lindeman and Sons Piano Company of New York was absorbed, all of these purchases having been negotiated by Mr. Woodford.

*Vol. I, pp. 214, 280-2, 336. **Vol. I, pp. 292-93.

As president of the Schomacker Piano Company, Woodford secured the services of W. C. Schwamb, a most eminent piano maker, scale designer, and constructor, who succeeded in remodeling the Schomacker piano in a manner which assured the same a place in the front rank of the best pianos of the day. Whatever genius, money, experience, and modern facilities can accomplish in constructing and building an artistic piano of the highest order, is found in the Schomacker piano of the present day.

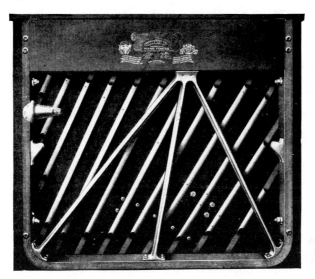

Schomacker Upright Piano Construction

Woodford revolutionized piano merchandizing. Many of the great department stores of America have followed the example of Wanamaker, most of them with considerable success. The tendency to standardize pianos, and price and sell them in their class is steadily growing, thanks to the initiative and tireless activity of James B. Woodford.

THE RUDOLPH WURLITZER COMPANY*, Cincinnati, O. Some men take particular pride in being their own ancestors, but the world at large believes in Darwin's theory of evolution, and many prominent men point modestly to a long line of

*Vol. I, 354-355.

ancestors, from whom they claim to have inherited their peculiar talents, exalted by continual evolution from one ancestor to the other. Whatever truth there may be in this theory, HANS

ADAM WURLITZER was famous as a violin maker at Markneu-kirchen from 1732 to 1795, and is now even more so, having become the great-great-grandfather of the present heads of the house of Wurlitzer.

Since Hans Adam, every Wurlitzer has been a maker of musical instruments, as the Wurlitzers before him have been, but all of them modelled their instruments by hand and never dreamt of the possibility of a great Wurlitzer plant near Niagara Falls, where about 1400 people produce all kinds of musical instruments by aid of the most wonderful machinery, driven by electric power generated at Niagara Falls. Although it would be next to impossible to make such instruments as are now built at the Wurlitzer factories, without the aid of powerful machinery, yet if the attempt were made it would require a force of nearly 10,000 people to produce the same quantity which the 1400 now turn out.

Such is modern progress, nowhere more vividly exemplified than in the Wurlitzer works, which were started in 1908 at Sawyer's Creek (now called Wurlitzer), Niagara County, New York, and were doubled in size in 1909, doubled again in 1911, and large additions added in 1913, covering now altogether about sixty acres of ground.

Starting in with making so-called automatic musical instruments, such as barrel organs, orchestrions, etc., the manufacture of the Wurlitzer player piano was taken up, and after the organization of the Rudolph Wurlitzer Manufacturing Company, with a capital of $1,000,000, the Wurlitzer-Hope-Jones Unit Orchestra was developed. This Unit Orchestra is the most complete musical device now in use. It is an electrical instrument in which the component parts of an orchestra of forty musicians are brought under the control of a single man

who plays the keys on a three manual console. The action being electric pneumatic, has a much more rapid repetition than can be found in a piano action. The instruments represented are violins, violoncellos, violas, clarinets, flutes, piccolos, oboes, saxophones, trumpets, French horns, tubas, Italian harp, church organ, cathedral chimes, sleigh bells, xylophone, bass and snare drums, kettle drum, and triangle.

The Wurlitzer automatic orchestras, which can also be played by means of a music roll, are built in sizes varying in cost from $1,000 to $60,000. The Unit Orchestra installed at Hotel Statler, Buffalo, N. Y., cost $30,000. Being in effect a combination of percussion, wind and string instruments, the Unit Orchestras will be the home orchestra of the future.

Aside from the various mechanical instruments, including coin-operated player pianos, etc., the Wurlitzer Company has of late devoted much attention to the development of the Wurlitzer piano along artistic lines and with commendable results. With all the solicitous care given to the manufacture of the Unit Orchestra and the artistic piano, and the justified pride taken in these products of their factories, the Wurlitzers have in addition developed a harp, which is generally conceded to be without a rival in tonal qualities and construction.

The innovation of using a sound board made of two thicknesses of spruce, glued together so that the grain or fibers of the board cross each other, gives to the sound board not only much greater strength, to prevent cracking, but what is more, it tends to insure a rich mellow timbre, so much sought for in harp tones.

The Rudolph Wurlitzer Company is capitalized at $4,000,-000 and controls also the Rudolph Wurlitzer Manufacturing Company, capitalized at $1,000,000.

HOWARD E. WURLITZER, president of the corporation, is one of those brilliant men who are so far-seeing as to be ahead of the times in their plans, and consequently easily assume leadership when the time of realization arrives. Born at

Howard E. Wurlitzer

Cincinnati on September 5, 1871, he immediately went to work in his father's business, after graduating from school at the age of seventeen. In 1890 he made an extended trip through Europe, visiting all leading manufacturers of musical instruments, in order to become thoroughly informed on the state of the musical instrument industry at large. Observing the tendency towards development of automatically playing instruments, Howard began to pay special attention to that branch of the business and has visited Europe annually since 1902.

Feeling that it would be necessary to manufacture his own instruments, he induced his younger brothers to acquire thorough theoretical and practical knowledge and experience in instru-

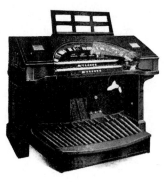

ment making in Europe, meantime starting his factories at Sawyer's Creek, N. Y. Unostentatious, almost quiet in his demeanor, Howard E. Wurlitzer has demonstrated his great ability as an organizer and financier. Gifted with a remarkable memory, he quickly grasps big projects and propositions. Daring, but careful, he has made a special study of economics and systems applicable to business, and consequently handles his manifold duties with apparent ease.

As a member of the Civic Center Commission of the city of Cincinnati, he has proposed almost revolutionary, but carefully thought out plans for permanent relief of the congested business district and furthermore made valuable suggestions for beautifying the city in accordance with modern ideas. A keen observer, he has profited even in this respect by his travels, and practical results can be expected from his activity in that sphere.

Rudolph H.
Wurlitzer

In RUDOLPH H. WURLITZER we meet the artistic genius of this remarkable family. Born at Cincinnati, December 30,

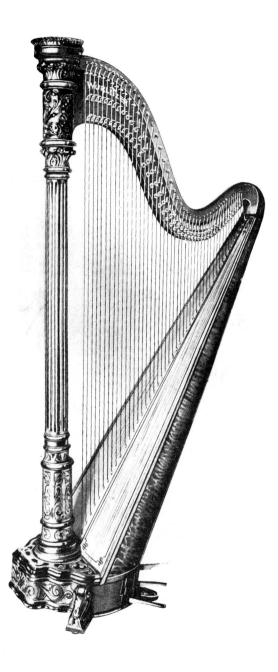

1873, he attended school until 1891, when he went to Berlin, Germany, to go through three semesters at the university. He studied acoustics with Helmholtz, experimental physics with Professor Kundt, the history of music with Spitta, and musical instruments with Prof. Fleischer. Studying violin playing under Wirth of the Joachim Quartette, and working also with that great violin expert, Riechers, the intimate friend of Joachim, Rudolph Wurlitzer enjoyed brilliant opportunities to acquire an exceptional knowledge of violins. Returning to Cincinnati, he was elected a director in the Rudolph Wurlitzer Company in 1894, and in 1912 vice-president and treasurer.

An accomplished musician, Rudolph H. Wurlitzer is an authority on violins, the study of which he has made a specialty. His judgment on instruments made by the old masters is generally accepted as final. His deep researches into the mysteries of tone production are of immeasurable aid in the construction of the various Wurlitzer instruments, most especially the Wurlitzer piano, which possesses a rich, liquid, yet luscious and powerful tone quality seldom found.

A member of the University Clubs of Cincinnati and Chicago, and other organizations, he is largely interested in musical affairs. Liberal minded, tolerant and genial, his valuable services are properly appreciated by the great Wurlitzer institution.

Farny R. Wurlitzer

The youngest brother, FARNY R. WURLITZER, is a born manufacturer. Graduating in 1901 from the Technical Institute of Cincinnati, he went immediately to Switzerland to work for Paillard, the celebrated maker of music boxes. He then spent six months in the factory of Phillips at Frankfort on the Main, studying auto player pianos and the manufacture of orchestrions, and finally took a thorough course at Pellisson's brass instrument factory at Lyons, France. Thus equipped, he returned to Cincinnati in 1903, and took charge of the automatic instrument department. In 1908 he was elected president of the

Rudolph Wurlitzer Manufacturing Company, assuming the management of the factories at Wurlitzer, N. Y.

Aside from his valuable technical and practical knowledge of the manufacturing business, Farny Wurlitzer knows how to treat and control men. Severe, but just, his workmen believe in him and are willing to give him their best. Edward H. Uhl

EDWARD H. UHL, manager of the great Chicago branch of the house of Wurlitzer, joined in 1894 as traveling man. He developed into an executive of great strength, and takes an active part in the management of the Rudolph Wurlitzer Manufacturing Company, as director and secretary.

Such is the organization of the great house of Wurlitzer, which supplies the United States army bands with their instruments, sells a Jew's harp for ten cents or a Unit Orchestra for $60,000, makes its presence felt in all parts of the United States as manufacturer of high class pianos and player pianos, sells violins to connoisseurs in all parts of the world, and has produced a harp which is hailed by virtuosos as the acme of perfection.

Hans Adam Wurlitzer may certainly be proud of being the ancestor of such "fiddle makers." He must have been a great genius!

PIANO ACTION MAKERS

THE COMSTOCK-CHENEY COMPANY, Ivoryton, Conn. Nestled among the hills of the beautiful Connecticut River valley lies the factory town of Ivoryton, the spot where as far back as 1834 SAMUEL MERRITT COMSTOCK erected a small shop in which he manufactured ivory tooth-picks and ivory combs. Dating his ancestry back nearly 400 years to the Van Comstock family of Germany, Samuel Merritt was born as the ninth child of Samuel Comstock, the elder, who was captain of a vessel engaged in the West Indies trade, but was one of the settlers of Middle Essex county, Connecticut.

S. M.
Comstock

Samuel Merritt possessed the inventive faculties peculiar to the Connecticut Yankee. Inventing all kinds of labor-saving machinery and devices for working ivory, his business increased by leaps and bounds, and he had to look about for assistants to manage his various factories. In July, 1860, he associated himself with George A. Cheney, Charles H. Rose, and William C. Comstock, under the firm name of Comstock-Cheney and Company. The manufacture of piano ivory was then commenced. In 1872 the partnership was changed to a corporation under the name of The Comstock, Cheney and Company, and the year following the company began the manufacture of piano and organ keys as a distinctive branch of their business. In 1885 the manufacture of piano actions and hammers was added.

Samuel Merritt Comstock died on January 18, 1878, and was succeeded as president of the Company by George L. Cheney, who served until his demise in 1901. Of Samuel Merritt Comstock's eleven children, his sons ROBERT HENRY COMSTOCK and ARCHIBALD W. COMSTOCK are now active in the company as president and treasurer, respectively, while C. G. CHENEY, son of George L. Cheney, is vice-president.

R. H.
Comstock
A. W.
Comstock
C. G.
Cheney

The extent of the company's business is best illustrated by the fact that they cut up every month from eight to ten thousand pounds of African ivory, which they import direct, having

caravans of their own to collect the ivory tusks in Africa. In their various establishments at Ivoryton, they employ up to eight hundred persons. Around the factories a model town has sprung up, in the building of which the company has shown the greatest liberality, donating sites and buildings for churches, libraries, amusement places, etc.

Two young men of the third generation of the Comstock and Cheney families are managing the affairs of the Piano and Organ Supply Company of Chicago, where piano actions and keys are also extensively manufactured, especially for the Western trade.

STAIB-ABENDSCHEIN COMPANY, New York, N. Y.
Ever since upright pianos were made, inventors have been busy designing an action which has a prompt and unfailing repetition. From Wornum to Erard and Pape, the experiments have been without number and the patent records of Washington abound in references to upright piano actions. The main reason that so many attempts remained fruitless is to be found in the fact that nearly all these efforts were strictly empiric, without the foundation of scientific principles. Mechanical construction has, during the last decades, been more and more reduced to scientific principles. The science of mathematics has forced the employment of the matrix, and the hit or miss methods of "inventing" have been relegated to the scrap heap.

Albert Staib

ALBERT STAIB, president of the Staib-Abendschein Company, has for over thirty-five years been active in the piano action business. His father was foreman of Decker Brothers action department and taught his son the art, when the latter entered upon his apprenticeship in 1879. Albert resigned his position as foreman with Decker Brothers in 1890 to assume the factory management of the Staib-Abendschein Company.

Geo. F. Abendschein

GEORGE F. ABENDSCHEIN graduated from the New York City college at the age of seventeen and followed a commercial career for a number of years. His inclinations tended, however,

so strongly towards a creative occupation that he utilized his evenings to study mechanical engineering and architecture in one of New York's institutions, and it was a happy day for him when in 1890 he could join Staib in the new enterprise of making piano actions for the trade. Attending mainly to the commercial and financial end of the business, Abendschein found time to interest himself in the factory and in conjunction with Staib improved and devised many labor-saving machines and appliances.

Students of all that had been accomplished in piano action development, Staib and Abendschein became deeply interested in the experiments of Hastings, Becker, Ammon, Hutchinson, and others to improve the "repetition" in upright actions so desirable especially since the advent of the player piano. For two years the company had the inventor Snyder working on the problem, in their shops, and while this ingenious man made considerable headway, he finally gave up in despair of ever accomplishing the sought-for positive and never-failing repetition.

Satisfied that Snyder had come very near the goal, Staib and Abendschein began to apply their practical and scientific knowledge and experience and finally succeeded, mainly because of following mathematical-scientific principles, in producing an action which seems to answer all requirements. Simplified in its structure, the action is capable of 1400 successive strokes in one minute, a repetition more than sufficient for any purpose. The invention is protected so far by 143 United States patents, nine of which are considered basic. The title "Mastertouch" seems to be well chosen for this action, as one of its best points is the lightness and elasticity of touch.

In FRED H. ABENDSCHEIN, who joined in 1905, the company acquired the assistance of an expert engineer of the modern school, who has demonstrated his inventive and constructive

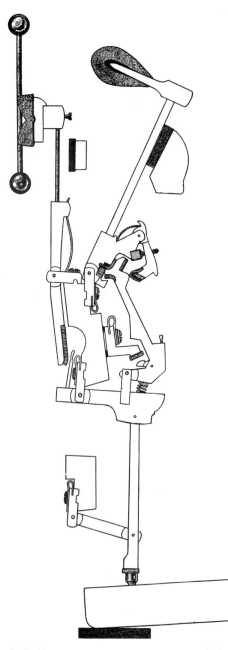

Staib-Abendschein Mastertouch Repeating Action

ability as illustrated by obtaining a patent for a non-frictional spring for grand and upright actions. He has acted as secretary of the company since 1908.

DAVID H. SCHMIDT COMPANY*, Poughkeepsie, N. Y. To get the proper training for his future position as head of the business founded by his father, DAVID H. SCHMIDT was

David H. Schmidt

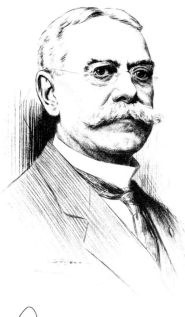

apparenticed to a cabinet maker in New York for three years and after that to the well-known piano maker, William Manner, for two years, to learn the higher branches of piano making. At the age of nineteen he went to Germany gathering experience in the larger establishments there for two years, and joined his father by request in 1878. Ten years later he was admitted to partnership, and upon the retirement of his father he assumed control and took full charge of the business.

As a competent piano maker, he has all the practical knowledge required to manufacture a good piano hammer, and he succeeded admirably in enhancing the good reputation which his father had established for the "Schmidt" piano hammer. Under his management the business grew to proportions which made it advisable to adopt the corporate form in 1908 under the name of David H. Schmidt Company. The officers of the corporation are David H. Schmidt, president and treasurer, Christian W. Schmidt, vice-president, and A. F. Stern, secretary.

*Vol. I, p. 381.

STRAUCH BROTHERS, New York, N. Y.

Peter D.
Strauch

PETER D. STRAUCH, the founder of this firm, was born at Frankfort on the Main, Germany, in 1835. He was one of a family comprising six brothers and three sisters. His father, having the remarkable stature of six feet nine inches, was Sergeant of the Guards of the Grand Duke of Hesse-Darmstadt. A civil engineer by profession he occupied for many years the high position of Governor of the state prison of the Grand Duchy of Hesse-Darmstadt.

As is usual with military men, the father trained all of his boys after military fashion, which filled the youngsters with such disgust against militarism that the idea of immigrating to America took hold of them, to such an extent as to induce their mother and sisters to leave their home for the New World, in 1851. Intending to become pioneer farmers, they bought through tickets in London for the far West. After the hardships of a three-months' passage on a sailing vessel, they arrived in New York, only to find that their tickets to the West were of no value. The money which they had left was just enough to enable the family to reach Albany, N. Y., by boat, and they located there.

The boys all found employment in various lines of business, and Peter D., then fifteen years of age, was apprenticed for five years to F. W. Frickinger, the pioneer piano action maker of Albany. After completing the apprenticeship, he worked for about three years as journeyman for Frickinger, who finally took him into partnership.

About 1861, Strauch went to New York City, working in various piano factories as action finisher. In 1867 he started with his brother William an action factory under the name of Strauch Brothers. Among the first who took up the manufacture of upright actions, Strauch Brothers were very successful, and Peter D. became interested in financial institutions.

A charter member of the Gansevoort Bank, he served as vice-president for five years. He retired from business in 1907, enjoying his well-earned rest at his beautiful country home.

His two sons, ALBERT T. and WILLIAM E. STRAUCH, received under their father's guidance a most thorough training in the piano action business. Albert T. Strauch, born in New York in 1866, attended the public schools and military school at Stamford, Conn. Joining the General Society of Mechanics and Tradesmen, of New York, he served for a number of years as member of the library committee, as secretary and chairman, and finally as a member of the executive committee. An expert on piano action construction, he obtained patents for improvements in grand and upright actions.

WILLIAM E. STRAUCH, born in New York in 1867, took a course in Packard's business college, and studied action regulating and scale drawing with James and Holmstrom for two years. In 1887 he entered the business of his father, spending four years in perfecting himself for practical action work, after which he took charge of the factories as superintendent. Like his brother Albert, he is an active member of the General Society of Mechanics and Tradesmen of New York, of which he was elected president. The records show that he is the youngest president which this old renowned society has had for one hundred and twenty-five years past.

WESSELL, NICKEL AND GROSS*, New York, N. Y.
To inherit a business with a world-wide reputation is good luck. To be brought up by a father who has gone through hardships to achieve success is to be fortunate. ARTHUR WESSELL, oldest son of Otto Wessell, was born in New York on January 7, 1875. After leaving Columbia grammar school, he studied law at Columbia University and was admitted to the bar in April, 1899. During his college years he was quite prominent as an all-around athlete, serving as pitcher of the University baseball team.

*Vol. I, 379-380.

After the death of his father, Arthur Wessell was compelled to quit the profession of law, in order to assist in the management of the business. He was elected director and secretary of Wessell, Nickel and Gross, and in 1912 became vice-president. Being trained as a law student to look upon matters in the abstract and concrete, dispelling the irrelevant and irrelative in forming conclusions, Arthur Wessell is splendidly equipped to fill his position, in which he has to dissect and diagnose matters of finance and commercial importance in connection with the daily business of the great corporation. A man of the world, amiable, well-read, fond of sports, he is one of the most popular men in the trade.

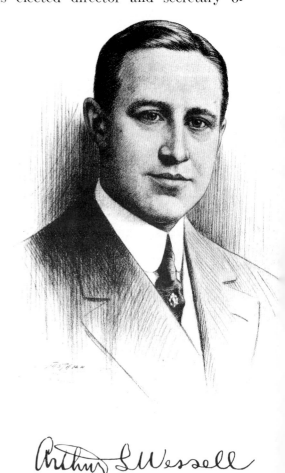

Fernando A.
Wessell

His brother, FERNANDO A. WESSELL, was born in New York on the 5th of January, 1877. Because of an early interest in mechanics, his father directed the boy's training towards preparation as a piano action maker for the future.

In 1893 Fernando Wessell graduated from high school with a special diploma for efficiency, especially in craftsmanship.

At the age of sixteen, he entered upon his apprenticeship in the shops of Wessell, Nickel and Gross, becoming proficient in all branches of the art. In 1898 he was appointed assistant super-

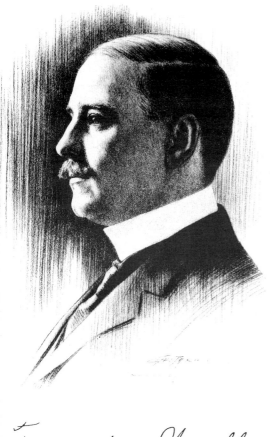

intendent and elected director of the corpor- ation. Since 1899 he has also acted as treas- urer, and in 1912 was elected president.

Fernando A. Wes- sell represents the young school in the industrial world. His training permits him to make extended use of the application of math- ematical scientific prin- ciples in designing or providing new devices for the greatest possible exactness in the manu- facture of the Wessell actions, and a large part of his time is de- voted to directing the construction of auto- matic machinery in their own machine shop. Through his efforts to keep always in the lead in factory equipment, fully aware of the importance of continual progressive activity, he maintains the high reputation for positive reliability which has placed the Wessell action in the lead for the past forty years. Thoroughly alive to the constant efforts to improve the construction of piano actions, Wessell is not given to experimenting for the sake of making a record at

the patent office, and will only accept improvements after they have stood the test of time by actual usage. Not novelty, but positive reliability is his aim in directing the manifold departments of the Wessell, Nickel and Gross factories.

Henry
Nickel

HENRY NICKEL, son of Adam Nickel, one of the founders of the firm, was born in New York in 1879. After going through Columbia Institute, he turned to action making under his

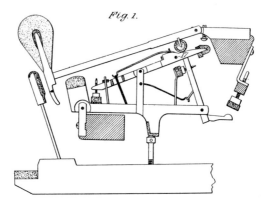

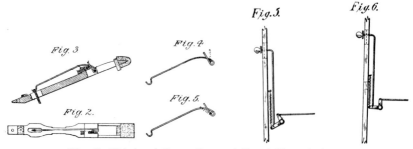

Wessell, Nickel and Gross, Patented Grand Piano Action

father's guidance. In 1899 he was elected a director and vice-president of the corporation, and in 1912 to the office of treasurer. Following with studious care the policy inaugurated by their fathers, of manufacturing the best possible piano action which experience, large capital and modern equipment can produce, the present members of the corporation have not only maintained

the proud position as leaders in the industry, but are continually extending their activities with gratifying results. Among their progressive moves is an improvement in grand piano action, patented November 9, 1909, which enables a proper regulation of the tension of the double springs as applied in the Wessell, Nickel and Gross Grand Action, under their patent No. 366,360.

WOOD AND BROOKS COMPANY, Buffalo, N. Y. Sending caravans of their own to the interior of Africa, to collect elephant tusks, in order to cut them up and use the ivory for 100,000 piano keys every year, is only a part of the business of the Wood and Brooks Company. They also supply the piano trade with about 100,000 piano actions every year, or about one-third of all the keys and actions used. All of this has been accomplished within the short space of twelve years.

CHARLES RAYMOND WOOD entered the employ of Pratt, Reed and Company at Deep River, Conn., in 1888, at the age of twenty. Four years later he was appointed superintendent of the factories. In 1901 he organized the Wood and Brooks Company, a corporation of which he is treasurer and general manager.

Chas R. Wood

One of nature's noblemen, Wood is strong both mentally and physically. Large and broad in conception and execution, yet weighing carefully the pro and con, he has a keen eye for the practical and economical, and is as great a manufacturer as he is a shrewd, daring and aggressive business man. Kind and considerate, he is at the same time firm and unrelentless, capable of pursuing a foe to the last ditch. Perhaps his strongest trait is his unerring judgment in selecting the right men to carry out his plans. His exceptional talent as an organizer is demonstrated in the factories of the company. Even to the well_ informed factory expert, the Wood and Brooks factories are a revelation. Solicitous for the comfort and safety of the employees, the large buildings have been carefully designed to achieve the best results with the least effort. "Lost motions" are not known in these establishments—every movement counts.

Believing that he succeeds best in business who can give the greatest value for the money, Wood organized his factories regardless of cost, primarily to produce positively reliable goods, and his next aim is to produce them for less money than his competitors. An economist of the modern school, he applies the principle that high-priced labor is the most economical in the end. He pays the highest wages of all industries in Buffalo and consequently obtains the highest efficiency.

Original in all that he undertakes, Wood has designed most of his labor-saving machines, which are all built in his own machine shop. A veritable marvel among the hundreds of automatic machines is the huge device for putting the cloth bushing in keys or actions into the entire set of eighty-eight parts at one stroke.

A princely entertainer and interesting conversationalist, Wood prefers his family circle for rest and recreation to the club rooms, but does not neglect to freshen up every once in a while by making a trip to Europe, besides his periodical travels to call on customers.

In 1905, the Wood and Brooks Company acquired the business of the old-established Seaverns Action Company and in 1910 purchased the Kurtz Action Company of Rockford, Ill.

N. R. Luther assists Wood largely in the general management, as secretary of the Company. Warren B. Thayer has charge of the Kurtz Company establishment, while Hubert O. Fox takes care of the selling department.

All of the members of the executive force are in the prime of life, destined to play their roles as dominant factors in the trade for many years to come.

N. R. Luther

Warren B. Thayer

Hubert O. Fox.

NAME	BIRTHPLACE	DATE OF BIRTH
Abendschein, G. F	New York, N. Y	Sept. 6, 1868
Abendschein, Fred H	New York, N. Y	Mar. 20, 1883
Anderson, John	Westergothland, Sweden	Apr. 16, 1859
Bach, Jacques	Lorentzen, Alsace	June 22, 1833
Baldwin, Dwight H	North East, Pa	1822
Bartlett, Earle Brewster	Frankfort, Wis	June 3, 1858
Bauer, Wm. Max	Chicago, Ill	Feb. 11, 1870
Beach, Wm. H	Mt. Morris, N. Y	Apr. 4, 1851
Behning, Gustav	New York, N. Y	Dec. 26, 1868
Behning, Henry	Bridgeport, Conn	Nov. 26, 1859
Behr, Henry	Hamburg, Germany	Sept. 22, 1848
Behr, William J	Brooklyn, N. Y	Jan. 5, 1872
Bent, George H	Chicago, Ill	Oct. 11, 1878
Bent, George P	Dundee, Ill	June 16, 1854
Bond, Albert S	Ft. Wayne, Ind	Oct. 16, 1863
Bond, Herbert W	Ft. Wayne, Ind	Oct. 6, 1870
Bush, William L	Chicago, Ill	Mar. 3, 1861
Butler, James H	Frankfort, Ky	July 22, 1867
Cable, Fayette S	Cannonsville, N. Y	Mar. 18, 1855
Cable, Hobart M	Walton, N. Y	Mar. 3, 1842
Cable, Hobart M., Jr	Boston, Mass	Dec. 15, 1881
Cassebeer, Theodore	New York, N. Y	Sept. 8, 1879
Cheney, C. G		
Cheney, George L		
Chickering, Clifford C	Cincinnati, O	Aug. 19, 1864
Chickering, Fred W	Cincinnati, O	Mar. 1, 1865
Chickering, Wallace W	Cincinnati, O	Jan. 20, 1874
Clark, Melville	Oneida County, N. Y	
Collins, Wm. P	Oswego, N. Y	July 10, 1877
Comstock, Archibald W	Ivoryton, Conn	1860
Comstock, Robert H	Ivoryton, Conn	

NAME	BIRTHPLACE	DATE OF BIRTH
Comstock, Samuel M	Essex, England	
Connor, Francis	Ardee, Ireland	June 19, 1843
Conover, J. Frank	Mt. Morris, N. Y	1843
Conway, Carle C	Oak Park, Ill	Dec. 19, 1877
Conway, Earle Edward	Sparta, Wis	April 15, 1874
Decker, Frank C	Albany, N. Y	July 5, 1857
Decker, Frank C., Jr	Sparkill, N. Y	July 7, 1889
Devereaux, Irving E	East Nassau, N. Y	July 18, 1861
Doll, Chas	New York, N. Y	1888
Doll, Frederick	New York, N. Y	1883
Doll, George	New York, N. Y	1880
Doll, Jacob	Rohrbach, Baden, Germany	Nov. 14, 1849
Doll, Jacob, Jr	New York, N. Y	Nov. 7, 1881
Doll, Otto	New York, N. Y	1878
Doud, L. L	Greenwich, O	May 20, 1838
Dowling, Geo. J	Cambridge, Mass	1864
Dutton, Wm. Dalliba	Utica, N. Y	Dec. 1, 1847
Engelhardt, Alfred D	Dolgeville, N. Y	Dec. 14, 1881
Engelhardt, Walter L	New York, N. Y	Apr. 3, 1884
Ericsson, Chas. A	Gothenburg, Sweden	June 11, 1859
Fox, H. O.	Chicago, Ill	Aug. 29, 1871
French, H. Edgar	Nashville, Tenn	Apr. 3, 1877
French, Jesse	Southampton, Eng	July 23, 1846
French, Jesse, Jr	Nashville, Tenn	Dec. 29, 1879
Gerts, John	Westphalen, Germany	Sept. 4, 1845
Gertz, Richard W	Hannover, Germany	Apr. 21, 1865
Gram, Edmund	Buffalo, N. Y	Aug. 23, 1863
Grinnell, Clayton A	New York, N. Y	Dec. 2, 1859
Grinnell, Ira L	New York, N. Y	1848
Hackenheimer, Jacob	Germany	June 26, 1871
Haddorff, Charles A	Norrkoping, Sweden	Feb. 2, 1864
Heller, Gottlieb	Holzgerlingen, Wurttemberg, Germany	Apr. 25, 1868

NAME	BIRTHPLACE	DATE OF BIRTH
Ide, Laverne M	Manchester, Mich	Mar. 26, 1860
Janssen, Ben H	Brakin, Oldenburg	Aug. 31, 1862
Jewett, A. L	North Dixmont, Me	Feb. 15, 1872
Jones, Cyrus F	Oregon, Ill	Apr. 26, 1887
Jones, Edgar B	Oregon, Ill	May 20, 1880
Jones, Fred George	Coburg, Canada	Mar. 19, 1847
Jones, George H	Oregon, Ill	Oct. 29, 1876
Kammerer, Robert C	New York, N. Y	Sept. 12, 1856
Kellmer, Geo. W	Hazleton, Pa	June 21, 1868
Kimball, Curtis N	Mitchell Co., Ia	Jan., 1862
Kimball, Edwin N., Jr	Atlanta, Ga	Mar. 9, 1868
Kindler, Oscar L	New York, N. Y	Nov. 14, 1875
Klugh, Paul B	Detroit, Mich	Nov. 25, 1878
Knabe, Ernest J., Jr	Baltimore, Md	July 7, 1869
Knabe, William, III	Baltimore, Md	Mar. 23, 1871
Kraft, Theodore J	Boston, Mass	
Kranich, Helmuth	Gross Breitenbach, Thuringia, Germany	Aug. 22, 1833
Krell, Albert	Cincinnati, O	Sept. 6, 1859
Kurtzmann, Christian, Sr	Mecklenburg, Germany	Nov. 24, 1815
Kurtzmann, Christian, Jr	Buffalo, N. Y	Nov. 25, 1886
Kurtzmann, Louis S	Buffalo, N. Y	Feb. 2, 1860
Lane, Walter	Berkshire, Eng	Aug. 2, 1868
Lawson, Charles B	Brooklyn, N. Y	Feb. 6, 1855
Lindeman, S. G	New York, N. Y	Mar. 24, 1869
Lohr, Fred W	Speyer, Germany	June 14, 1854
Long, Frank B	Waterloo, Ind	June 12, 1863
Ludwig, John	New York, N. Y	Oct. 1858
Luther, N. R	Providence, R. I	1873
Mason, Henry Lowell	Boston, Mass	Aug. 14, 1864
Mehlin, Charles	New York, N. Y	Oct. 23, 1873
Mehlin, H. Paul	New York, N. Y	June 6, 1864
Mehlin, Paul G	Stuttgart, Germany	Feb. 28, 1837

NAME	BIRTHPLACE	DATE OF BIRTH
Mehlin, Paul G., II	Maywood, N. J	July 27, 1894
Mehlin, Otto F	New York City	Nov. 30, 1880
Meikle, Ernest G	Pecatonica, Ill	Nov. 25, 1865
Moessinger, Geo. M	Buffalo, N. Y	Feb. 8, 1856
Morenus, Howard B	Walton, N. Y	May 31, 1869
Nickel, Henry	New York, N. Y	June 21, 1879
Oktavec, Joseph	Kasojovitz, Bohemia	Mar. 12, 1875
Peck, Alfred L	Dresden, Saxony	Oct. 21, 1871
Peck, Carl E	Gitschin, Austria	Aug. 30, 1864
Peck, Leopold	Gitschin, Austria	Apr. 15, 1842
Perkins, E. R		1869
Poole, Wm. H	Weymouth, Mass	Dec. 21, 1864
Reidemeister, Frederick	Brunswick, Germany	Nov. 30, 1865
Ricca, Luigi	Naples, Italy	June 21, 1853
Richtsteig, Max	Berlin, Germany	Feb. 22, 1869
Schmidt, David H	New York, N. Y	Aug. 17, 1857
Schurz, Edwin W	Three Rivers, Mich	Aug. 8, 1875
Seeburg, J. P	Gothenberg, Sweden	Apr. 20, 1871
Smith, Edgar C	Winnebago Co., Ill	Oct. 24, 1860
Staib, Albert	New York, N. Y	May 1, 1863
Steinert, Alexander	Athens, Ga	Mar. 14, 1861
Steinway, Charles H	New. York, N. Y	June 3, 1857
Steinway, Frederick T	New York, N. Y	Feb. 9, 1860
Steinway, Theodore E	New York, N. Y	Oct. 16, 1883
Steinway, William R	New York, N. Y	Dec. 20, 1881
Stetson, Nahum	Bridgewater, Mass	Dec. 5, 1856
Strauch, Albert T	New York, N. Y	Apr. 2, 1866
Strauch, Peter D	Krunstadt, Germany	Feb. 12, 1835
Strauch, William E	New York, N. Y	Sept. 18, 1867
Strich, William	New York, N. Y	June 28, 1863
Thayer, Warren B	Boston, Mass	1870
Treacy, Daniel F	New Brunswick, N. S	Mar. 27, 1846
Uhl, Edward H	Indianapolis, Ind	Dec. 18, 1870

NAME	BIRTHPLACE	DATE OF BIRTH
Urchs, Ernest	New York, N. Y	Aug. 10, 1864
Van Matre, Willard N	Stephenson Co., Ill	June 29, 1851
Van Matre, Willard N., Jr.	Chicago, Ill	Aug. 19, 1890
Votey, Edwin S		
Waters, Horace	Jefferson, Me	Nov. 1, 1812
Waters, Merrill K	Sudbury, Vt	Aug. 19, 1884
Weser, John A	Ulster Heights, N. Y	Mar. 23, 1853
Wessell, Arthur	New York, N. Y	Jan. 7, 1875
Wessell, Fernando A	New York, N. Y	Jan. 5, 1877
White, Frank C	Brattleboro, Vt	Oct. 28, 1870
White, Samuel T	Brooklyn, N. Y	Mar. 12, 1854
Winter, Julius	Hungary	Aug. 14, 1856
Wissner, Otto	Giessen, Germany	Mar. 2, 1853
Wissner, Otto R	New York, N. Y	Feb. 6, 1885
Wissner, William Otto	New York, N. Y	Mar. 2, 1882
Wood, Chas. Raymond	Providence, R. I	1868
Woodford, James B	Hector, N. Y	Apr. 2, 1849
Wright, Adin M	Grafton, Vt	Oct. 3, 1859
Wurlitzer, Farny R	Cincinnati, O	Dec. 7, 1883
Wurlitzer, Howard E	Cincinnati, O	Sept. 5, 1871
Wurlitzer, Rudolph H	Cincinnati, O	Dec. 30, 1873
Young, Francis		
Zeidler, Paul M	Braunschweig	Nov. 7, 1862
Ziegler, Henry	New York, N. Y	Oct. 30, 1857

PAGE

ABENDSCHEIN, FRED H. 217, 219
ABENDSCHEIN, GEORGE F. 216, 217
ACTION, MASTERTOUCH 218
ACOUSTIGRANDE 54
AEOLIAN COMPANY 6-9, 44, 81, 103, 125
AEOLIAN HALL ... 9
AMERICAN PIANO COMPANY 110
ANDERSON, JOHN 68-73, 144
APOLLO PLAYER PIANO 59
ARTISTANO .. 49
AUTOTONE ... 101
AUTOMATIC SOLO DEVICE, KLUGH 45
BACH, JACQUES 114-115
BACH, LOUIS P. 116
BACON & RAVEN 113, 149
BALDWIN COMPANY 4, 9-12
BALDWIN, DWIGHT H. 9
BAUER, HAROLD 167
BAUER, JULIUS & CO. 12-15
BAUER, WILLIAM MAX 12-15
BARTLETT, EARLE B. 107
BATES, WALTER J. 112
BEACH, WM. H. 28, 30, 32, 33
BEHNING, GUSTAV 15
BEHNING, HENRY 15
BEHNING PIANO CO. 15, 16
BEHR BROS. & CO. 16-19, 149
BEHR, HENRY 16, 18
BEHR, WM. J. .. 19

PAGE

BENT, GEO. H.................................... 23
BENT, GEO. P.................................... 21-23
BENT, GEO. P. COMPANY.......................... 21-23
BLOOMFIELD-ZEISLER.............................. 187
BILLINGS, F. C.................................. 85
BILLINGS & WHEELOCK............................. 125
BOND, ALBERT SWEETSER.......................... 155, 156
BOND, H. W...................................... 156
BOND, S. C...................................... 156
BRAHMS, JOHANNES................................ 139
BRADBURY PIANO.................................. 77
BRIGGS PIANO COMPANY........................... 155, 156
BROCKPORT PIANO COMPANY........................ 130
BULOW, HANS VON................................. 157
BUTLER BROS. PIANO MFG. CO...................... 33-36
BUTLER, JAMES H................................. 33-36
BUTLER, R. H.................................... 36
BUSH, WM. L..................................... 23-26
BUSH & GERTS.................................... 23-28, 82, 84, 163
BUSH & LANE..................................... 28-33
CABLE COMPANY................................... 36-46, 163
CABLE, HERMAN D................................. 41, 46, 47
CABLE, HOBART M. COMPANY........................ 46
CABLE, HOBART M. JR............................. 46
CABLE, FAYETTE S................................ 47
CABLETON.. 49
CABLE NELSON COMPANY........................... 47, 49
CAMPBELL, HON. PHIL. P.......................... 25
CAROLA INNER PLAYER............................. 44, 45
CARTER PIANO COMPANY............................ 62
CARRENO, TERESA................................. 73
CARUSO.. 153
CASSEBEER, THEODORE............................. 183, 184

PAGE

CHASE, A. B. COMPANY.......................... 28, 49, 50
CHELIUS, H. B.................................. 146
CHICAGO COTTAGE ORGAN CO..................... 46, 47, 160
CHICKERING BROS............................... 1, 50-55
CHICKERING, CLIFFORD C........................ 50-54
CHICKERING, C. FRANK.......................... 52, 53
CHICKERING, FRED W............................ 50, 54, 55
CHICKERING, GEORGE............................ 52
CHICKERING, JOSIAH B.......................... 50, 52
CHICKERING, WALLACE W......................... 50, 55
CHICKERING & SONS............................. 53, 55
CHRISTOFORI xix
CLARK, MELVILLE............................... 57-60
CLARK, S. E................................... 89
CLEVELAND, GROVER............................. 186
CLUETT & SONS................................. 121
COLLINS, WM. P................................ 109
CONNOR, FRANCIS............................... 60, 61
CONOVER, J. FRANK............................. 39-42
CONWAY COMPANY................................ 93
CONWAY, CARLE C............................... 95-96
CONWAY, EARLE E............................... 94-95
CONWAY, E. S.................................. 94, 95, 107, 108
COMSTOCK, CHENEY COMPANY...................... 215, 216
COOPER, WM. F................................. 49
CROWN COMBINOLA............................... 22
CROWN PIANOS.................................. 21, 22
D'ALBERT...................................... 111
DAVENPORT-TREACY CO........................... 61-63
DECKER BROS................................... 70, 108, 109
DECKER, FRANK C............................... 63
DECKER, FRANK C. JR........................... 63
DECKER & SON.................................. 63

PAGE

DEVEREAUX, I. E. 121

DOLL, CHARLES. 65

DOLL, FREDERICK. 65

DOLL, GEORGE. 65

DOLL, JACOB. 63-65

DOLL, JACOB, JR. 65

DOLL, JACOB & SONS. 63-65

DOLL, OTTO. 65

DORMAN & FRENCH. 77

DUTTON, WM. D. 99, 100

DOUD, L. L. 49

DOWLING, GEO. J. 36-39

DOWN TOUCH ACTION. 59

ELVYN, MYRTLE. 108

EMERSON PIANO CO. 37, 111, 143

ENGELHARDT, ALFRED D. 66, 67

ENGELHARDT, FRED. 66

ENGELHARDT, F. & SONS. 66-68

ENGELHARDT, WALTER L. 67

ERARD, SEBASTIAN. xix

ERICSSON, C. A. 132

EUPHONA PLAYER PIANO. 45

EVERETT PIANO COMPANY. 68-73, 81, 143

FRENCH, JESSE, SR. 75-78

FRENCH, JESSE & SONS PIANO CO. 75-79

FRENCH, H. EDGAR. 78, 79

FRENCH, JESSE, JR. 79

FOX, HUBERT O. 226

GARDEN, MARY. 97

GABRILOWITSCH, OSSIP. 73, 143, 146

GANZ, RUDOLF. 108

GERTS, JOHN. 26

GERTZ, RICH. W. 4, 134-141

PAGE

GOODSON, KATHARINE................................ 146
GORDON, GEORGE C................................ 130
GRAM, EDMUND.. 80-82
GRAM-RICHTSTEIG METAL FRAME ACTION COMPANY..... 87
GRAM-RICHTSTEIG PIANO CO...................... 80-87
GRIFFIN, GEO. A................................ 126
GRINNELL, A. A................................ 88
GRINNELL BROS................................ 88-89
GRINNELL, CLAYTON A........................ 88-89
GRINNELL, IRA L............................ 87, 88
HACKENHEIMER, J............................ 120
HADDORFF, CHAS. A........................ 89-93
HADDORFF PIANO CO........................ 89-93
HALLETT & DAVIS CO.................... 93-97, 204
HANSING, SIEGFRIED........................ 18, 92
HARDMAN, JOHN............................ 61
HARDMAN, PECK & CO........................ 97-101
HAZLETON BROS............................ 132
HEINTZMAN, THEO. A........................ 28
HELLER, GOTTLIEB........................ 201, 202
HELMHOLTZ........................ 39, 92, 212
HINZEN & ROSEN............................ 33
HOMO VIBRATING SOUND BOARD.................... 93
HUME, A. H................................ 166
HUME PIANO............................ 167
HUPFELDT COMPANY.................... 8
IDE, LAVERNE, M........................ 123-125
INVERTED GRAND PIANO 151
ISOTONIC PEDAL........................ 116
JANSSEN, BEN H........................ 101-102
JEWETT, A. L........................ 154-155
JEWETT PIANO COMPANY.................... 166
JOHNSON, A. E........................ 93

PAGE

JONES, CYRUS F. 160

JONES, EDGAR B. 160

JONES, FREDERICK GEORGE. 158, 159

JONES, GEORGE H. 160

KAMMERER, ROBERT C. 102, 103

KELLMER, GEO. W. 104

KELLMER, PETER. 103, 104

KINDLER & COLLINS. 108-109

KINDLER, OSCAR L. 108-109

KIMBALL, CURTIS N. 104-108

KIMBALL, E. N., JR. 94

KIMBALL, W. W. 104

KIMBALL, W. W. COMPANY. 94, 95, 104-108

KLUGH, PAUL B. 42-46

KNABE BROS. COMPANY. 109-111

KNABE, ERNEST J., SR. 109

KNABE, ERNEST, J., JR. 109-111

KNABE, WILLIAM III. 110-111

KRAFT, BATES & SPENCER. 111-112

KRANICH, ALVIN. 115

KRANICH & BACH. 112-116

KRANICH, FREDERICK. 115

KRANICH, HELMUTH. 112-114

KRANICH, HELMUTH, JR. 116

KRELL, ALBERT. 116, 117

KRELL PIANO CO. 116, 117

KOHLER & CAMPBELL. 109

KROEGER, HENRY. 33, 84

KURTZMANN & CO. 117-122

KURTZMANN, CHRISTIAN, SR. 119-120

KURTZMANN, CHRISTIAN, JR. 130-131

KURTZMANN, LOUIS S. 130-131

KUHNS, J. M. 156

PAGE

Kuntze, Joseph G............................... 23
Laffargue Company............................ 122-125
Lane, Walter.................................. 28-30
Lawson, Chas. B.............................. 125
Lawson Piano Company......................... 125
Lhevinne, Josef............................... 167, 187
Liebling, Emil................................ 108
Lindeman, Henry & S. G........................ 126, 128
Lindeman, Samuel G............................ 126
Liszt, Franz.................................. 97, 136
Lohr, Fred W.................................. 100, 101
Long, Frank B................................. 126, 127-130
Louismann-Capen Co............................ 130-131
Ludwig Company................................ 132-134
Manualo Player Piano.......................... 12
Mason & Hamlin Company........................ 55, 134-148
Mason, Henry.................................. 145
Mason, Henry Lowell........................... 146, 148
Mason, Lowell................................. 145
Mason, Dr. William............................ 145, 146, 185
Mehlin, Charles............................... 152-154
Mehlin, H. Paul............................... 152
Mehlin, Otto Frederick........................ 154
Mehlin, Paul G. & Sons........................ 148-154
Mehlin, Paul G................................ 18, 148-154
Melodigrand................................... 126, 128, 129
Meikle, Ernest G.............................. 23
Metronome Motor............................... 58
Merrill Piano Company......................... 155
Moessinger, Geo. H............................ 122
Morenus, Howard B............................. 46
National League for the Maker's Name.......... 25
National Piano Company........................ 154

PAGE

NEFF, THEODORE J............................ 37
NEW YORK PIANO CLUB...................... 125
NEITZEL, DR. OTTO........................... 73
NICKEL, HENRY.............................. 224
NIKISCH, ARTHUR............................ 146
NORRIS & HYDE PIANO CO.................... 155
OKTAVEC, JOSEPH........................ 122, 123
PACKARD PIANO CO...................... 155, 156
PAINE, JOHN K.............................. 146
PAUR, EMIL................................. 203
PECK, ALFRED L.............................. 98
PECK, CARL E............................ 98, 99
PECK, LEOPOLD.................. 18, 97, 98, 100
PEERLESS ORCHESTRION........................ 67
PERRY, LYCUS D............................. 133
PIANISSIMO DEVICE........................ 35, 36
PFAU, EDWIN B.............................. 116
POOLE PIANO COMPANY....................... 156
REIDEMEISTER, F............................ 184
REISENAUER, ALFRED...................... 73, 144
RICCA & SON............................ 157, 158
RICCA, LUIGI............................... 157
RICHTSTEIG, MAX........................... 81-87
ROYAL PIANO............................... 117
SCHARWENKA, XAVER.......................... 18
SCHELLING, ERNST........................... 187
SCHEIMAN, C. J............................ 156
SCHILLER PIANO CO.................. 158, 159, 160
SCHLOSSER, JACQUES BACH.................... 116
SCHMIDT, DAVID H.......................... 219
SCHOMACKER PIANO CO............. 113, 206, 207
SCHUMANN PIANO CO...................... 160-163
SCHWAMB, W. C............................. 207

PAGE

SEEBERG, JUSTUS PERCIVAL........................ 163, 164

SEIDEL, ANTON.................................. 203

SIEVEKING, MARTINUS............................ 146

SIMPLEX PLAYER ACTION CO...................... 97

SMITH, EDGAR C................................ 108

SPERRY, R. W.................................. 156

STAIB, ALBERT................................. 216

STAIB-ABENDSCHEIN COMPANY..................... 216-220

STEEL ANGLE RAIL ACTION FRAME................. 85, 86

STEINERT, ALEXANDER........................... 165-167

STEINERT HALL................................. 167

STEINERT, M. & SONS COMPANY................... 164-166

STEINWAY, CHARLES H........................... 169-175

STEINWAY, FRED T.............................. 175, 176

STEINWAY & SONS.......... 1, 70, 81, 89, 113, 138, 167-187

STEINWAY, THEODORE E.......................... 181, 183

STEINWAY, WILLIAM R........................... 180, 181

STETSON, NAHUM................................ 184

STRAUCH, ALBERT T............................. 221

STRAUCH BROS.................................. 220, 221

STRAUCH, PETER D.............................. 220, 221

STRAUCH, WILLIAM E............................ 221

STRICH & ZEIDLER.............................. 187, 188

TECHNICAL SCHOOL MAX-RICHTSTEIG 84

TENSION RESONATOR, GERTZ...................... 137-140

TREACY, DANIEL F.............................. 61-63

TSCHAIKOWSKY 111

TUNING PIN, CONOVER........................... 42

UHL, EDWARD H................................. 213

UNIT ORCHESTRA............................... 208-210

URCHS, ERNEST................................. 186

VAN MATRE, WILLARD NAREMORE................... 160, 161

VIOLYN PLATE, KRANICH......................... 116

PAGE

VIRTUOLA PLAYER PIANO............................. 97

VOTEY, E. S.. 7, 8

WANAMAKER, JOHN.............................. 205-207

WATERS, HORACE & COMPANY..................... 190-192

WATERS, HORACE................................ 190-191

WATERS, MERRILL K................................ 192

WESER BROS.................................... 192-196

WESER, JOHN A................................. 193-196

WESER, GEORGE W.................................. 196

WESER, WINFIELD S................................. 196

WESSELL, ARTHUR............................... 221, 222

WESSELL, FERNANDO A........................... 222, 223

WESSELL, NICKEL & GROSS....................... 221-225

WILCOX & WHITE CO............................. 196, 199

WHITE, FRANK C................................ 197, 199

WHITE, SAMUEL T............................... 191, 192

WINTER & COMPANY............................. 199-202

WINTER, JULIUS................................ 199-201

WISSNER, OTTO................................. 202-204

WISSNER, OTTO R.................................. 204

WISSNER, WILLIAM O............................... 204

WRIGHT, A. M.................................. 141-145

WOOD, CHARLES RAYMOND........................ 225, 226

WOOD & BROOKS COMPANY........................ 225, 226

WOODFORD, JAMES B............................. 204-207

WOODEN PLATE, BAUER.............................. 13

WORLD'S FAIR EXHIBITION LONDON 1851.............. 1, 3

WORLD'S FAIR EXHIBITION, PARIS, 1867.............. 1

WORLD'S FAIR EXHIBITION, VIENNA, 1873............. 1

WORLD'S FAIR EXHIBITION, PHILADELPHIA, 1876........
.................................... xix, 2, 3, 4, 97

WORLD'S FAIR EXHIBITION, CHICAGO, 1893........... 4, 21

WORLD'S FAIR EXHIBITION, ST. LOUIS, 1904.......... 4, 11

PAGE

WURLITZER, HANS ADAM.......................... 208, 213

WURLITZER, HOWARD E.......................... 209, 210

WURLITZER, FARNY R........................... 212, 213

WURLITZER, RUDOLF H.......................... 210, 212

WURLITZER, RUDOLPH COMPANY................... 207-213

WURLITZER RUDOLPH MANUFACTURING COMPANY, 208, 209, 213

YOUNG, FRANCIS................................... 7

ZIEGLER, HENRY.............................. 176-181